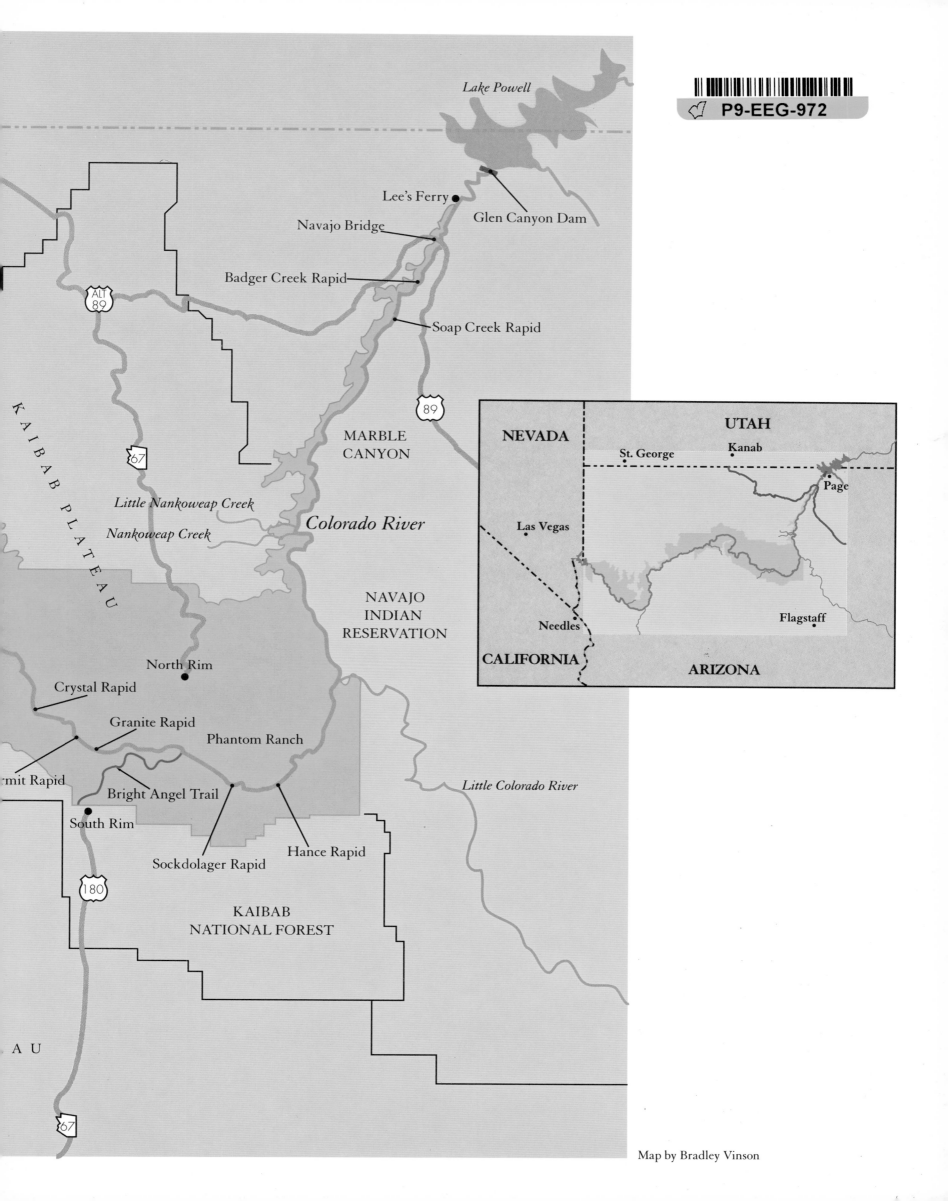

Lake Powell

Lee's Ferry ●

Glen Canyon Dam

Navajo Bridge

Badger Creek Rapid

Soap Creek Rapid

ALT 89

67

MARBLE
CANYON

89

Little Nankoweap Creek

Nankoweap Creek

Colorado River

NAVAJO
INDIAN
RESERVATION

K A I B A B P L A T E A U

Crystal Rapid

North Rim ●

Granite Rapid

Phantom Ranch

rmit Rapid

Bright Angel Trail

Little Colorado River

South Rim ●

180

Sockdolager Rapid

Hance Rapid

KAIBAB
NATIONAL FOREST

A U

67

NEVADA

UTAH

St. George

Kanab

Page

Las Vegas

Needles

Flagstaff

CALIFORNIA

ARIZONA

Map by Bradley Vinson

BENEATH THE RIM

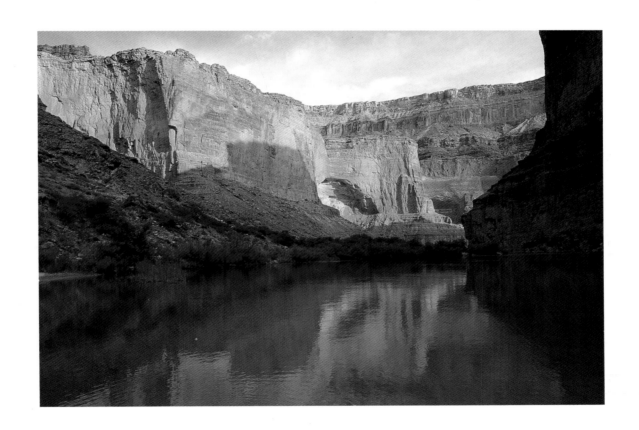

BENEATH THE RIM

A Photographic Journey Through the

GRAND CANYON

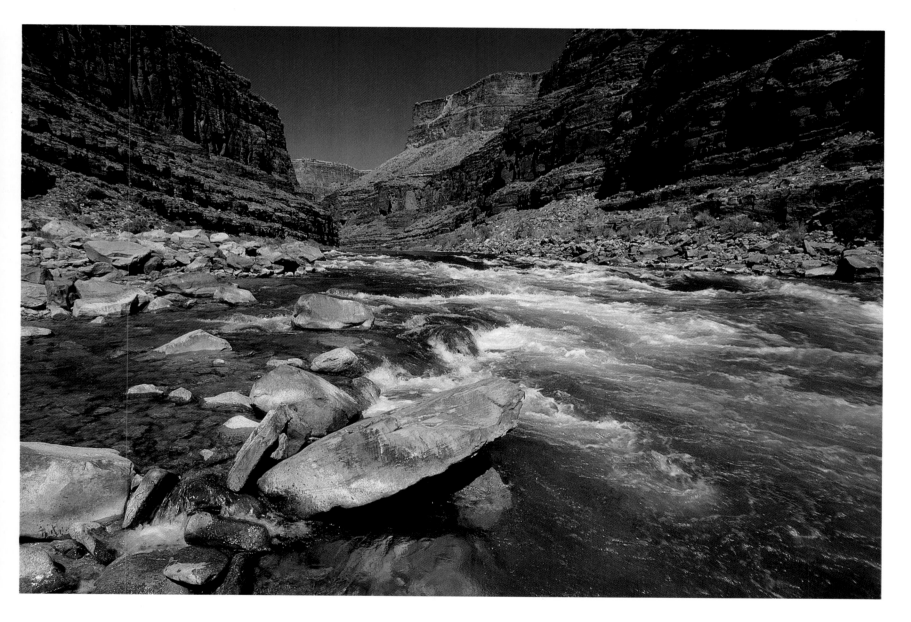

Photographs and text by

C. C. LOCKWOOD

LOUISIANA STATE UNIVERSITY PRESS

Baton Rouge and London

To Mike and Roxanne Denoyer, whose love of the Canyon led me there

OTHER BOOKS BY C. C. LOCKWOOD

Atchafalaya: America's Largest River Basin Swamp

The Gulf Coast: Where Land Meets Sea

Discovering Louisiana

The Yucatán Peninsula

C. C. Lockwood's Louisiana Nature Guide

Copyright © 1996 by C. C. Lockwood
All rights reserved
Manufactured in Korea
First printing
05 04 03 02 01 00 99 98 97 96 5 4 3 2 1

Designer: Laura Roubique Gleason
Typeface: Granjon
Printer and binder: Sung In Printing

Library of Congress Cataloging-in-Publication Data:

Lockwood, C. C., 1949–
 Beneath the rim : a photographic journey through the
Grand Canyon / photographs and text by C. C. Lockwood.
 p. cm.
 ISBN 0-8071-2063-4 (cl : alk. paper)
 1. Grand Canyon (Ariz.)—Pictorial works. 2. Grand
Canyon (Ariz.)—Description and travel. I. Title.
 F788.L77 1996
 917.91'32—dc20 96-4964
 CIP

The paper in this book meets the guidelines for perma-
nence and durability of the Committee on Production
Guidelines for Book Longevity of the Council on Library
Resources. ∞

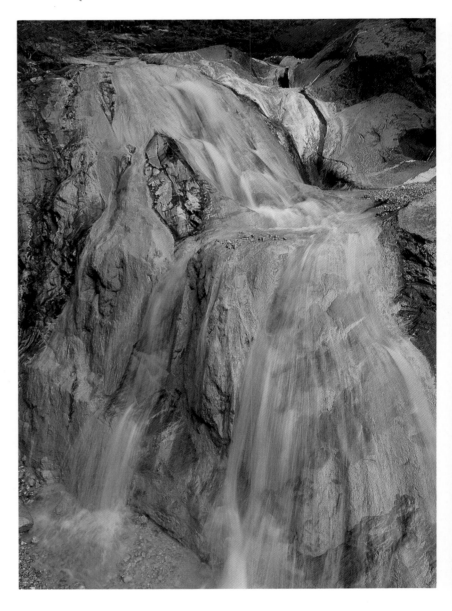

ACKNOWLEDGMENTS

What led me into this project was the people associated with the Grand Canyon, especially those who are boatmen and boatwomen on the Colorado River. Mike Denoyer essentially forced me to go on my first river trip, saying I wasn't going to get across Arizona and Utah without photographing a sunset in the Grand Canyon for my book *Skywatch*. This started me on a course that led me to meet hundreds of adventuresome, interesting, and caring people . . . people who love the Grand Canyon. Each and every one of them has a special part in this book, and I heartily thank them all. What follows is a list of some of the Colorado River people to whom I'm deeply indebted. Memory may, of course, falter in some instances, but I'm no less grateful to those I fail to list than to those I name.

I want to give special thanks to O. C. Dale, Diane Grua, Marty Mathis, Richard Quartoroli, and Laine Sutherland for help with my research. The folks at Grand Canyon Expeditions—Bob Dye, Andy Hutchinson, Jeanne Johnson, Yvonne Manzanarez, Cliff Roper, Don Saunders, Derald Stewart, Connie Tibbitts, and others I've already mentioned—went above and beyond in various ways to help me. My only private trip gave me time to explore the Canyon in greater detail and at a slower pace, and I'm indebted to those who went: Chuck Wales (trip leader), Dusty and Martha Teal, Russell Hooten, Kathryn Lundsford, and Allen Gilberg. Both the members and the management of Grand Canyon River Guides shared much of their valuable knowledge with me. The Cline Library of Northern Arizona University, Emery Lehnert, and Donald Baars helped me to obtain the older photographs that appear in the book, and Teresa Yates has kindly allowed me to publish her lovely shot of Georgie White.

I also want to express my gratitude to Mary Allen, Cleve Anderson, Ray Anderson, Jeff Aronson, Sue Aucoin, Dugald Bremner, Tom Brownold, Harvey Butchart, Irv Callahan, Don Chamberlin, Sue Cherry, Margaret Chipman, Martha Clark, Regan Dale, Roxanne Denoyer, Dave Edwards, Sue Fisher, Bill Garrett, Michael Geanious, Mary Anne Griffin, Kenton Grua, Dave Guskey, Steve Hatch, Ted Hatch, Trish Hawkins, Blake (Fox) Hopkins, Dewitt Jones, Nathan Jones, Dick Kocim, Jimmy Lee, Martin Litton, Donnie Mackelprang, Kevin Martini-Fuller, Sara Mathis, Melanie Mayeaux, Scott and Julie Meek, Abel Nelson, Rob Newsom, Joshua Mann Pailet, Pat Petty, John Postert, M. L. Quartaroli, Paula Quenemoen, Richard Rudisell, Raechel Running, Renny Russell, Crista Sadler, Butch Schimpp, Neal (the Bear) Shapiro, Don Silva, Andrew Smith, Dave Spillman, Joe Stanley, George Steck, Lew Steiger, Lorraine Tuffs, John Toner, Bob Webb, Sally Wenner, Tim and Pat Whitney, and Jan Yost.

Of course, this book wouldn't be possible without the people at LSU Press: Les Phillabaum, the director; Laura Gleason, the designer; Claudette Price in marketing; and the rest of the staff. Finally, thanks to Michael Griffith, who edited the manuscript.

INTRODUCTION

*M*y first trip to the Grand Canyon was on a family vacation in 1955, when I was six. A few things about that trip stand out in my mind today. One is the native dancers at the Hopi House, whose performance made me (and every other kid there) want a war-bonnet. Another was my mother clutching the back of my shirt as I tried to edge through the safety rail to hang my toes over the rim. What a breathtaking view! I loved rocks, climbing, cliffs, and looking over the big drop. I still do. But my most vivid memory of that first visit is a discussion with my dad about riding mules down to the Colorado River. Dad told me that my brothers, who were four and three, were too young; we would do that next trip, when we could all go together. Dad knew we had more places to visit than we had summer vacations, so he was safe: he would never have to sit atop a mule for six hours. I didn't hold a grudge, but my father had set the idea to simmering in my head. I waited patiently for my opportunity.

So in 1970, when two college buddies and I headed west in search of adventure, my only request was a mule trip into the Grand Canyon. We did a little in Texas, then a lot in Mexico before I beelined it from Juarez to the San Francisco Peaks. It was August, and though it was brutally hot in the desert, we shivered by our mountain campfire as I tried to pump up my friends about the mule ride. At dawn I got them up and drove as fast as I could to the South Rim; I wanted to be there in time to do the mule ride that morning. My memories from fifteen years before told me exactly where the reservation counter was. Sprinting to the desk, out

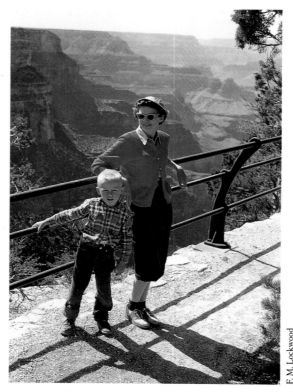

Summer, 1955. The author (with his mother, Spring) gets his first view of the Grand Canyon.

F. M. Lockwood

of breath and grinning ear to ear, I asked for three tickets to the bottom. The crew-cut student employee stared at me. "We have," he said matter-of-factly, "a few openings in October and many in November." I backed away, dumbfounded, bumping two people behind me. Unable to speak, I made my way back to the Volkswagen to try to apologize. My friends didn't seem to mind, and before dark we made our way toward our real destination, California.

The next summer I finished my degree and headed to the Rockies to help a friend film bighorn sheep. We looked for desert bighorns in the Kofa Mountains of Arizona and on the Sheep Range of Nevada. (On a few occasions we talked of filming them in the Grand Canyon, but we never did it.) Soon I was hooked on this life-style and decided to forgo a career in finance and become a wildlife photographer.

For the next three years I photographed only wildlife. I admired every flower and vista, but I never used a single frame of film on them: if it wasn't an animal, I didn't click the shutter. I visited the Canyon a couple of times during those years to photograph the kaibab squirrel and other wildlife, but I only marveled at the views. I developed no interest in a book project having to do with the Grand Canyon.

A few years later, having added underwater photography to my repertoire, I ended up in Belize, on a beautiful little island called Half Moon Cay. Mike and Roxanne Denoyer were there with Henry Falney and other folks from White Water River Expedi-

1

tions. Mike and Henry had set up this diving deal to keep their Grand Canyon rafting employees and gear working during the off-season.

They had brought along three Grand Canyon Modified S-Rigs (an S-rig is a configuration designed by Ron Smith). The sixty-mile ride across the Caribbean was remarkable in those boats. The giant rubber tubes bent with the twelve-foot swells, making the voyage, though ten hours long, comfortable for even the queasiest person. For our explorations of a nearby reef, we dove from these same Grand Canyon "baloney boats"—the strangest dive boats I've ever used. One was even outfitted with a glass bottom to entertain the non-divers. At night we heard stories of the Canyon. The river tales made a rafting trip sound intriguing, and another seed was sown in my mind. I went back to Belize for three weeks the next winter and became close friends with Mike and Roxanne.

For the next ten years I had one excuse or another for turning down their invitation to raft the Colorado. Finally, in 1989, I had finished up all I could do on the swamps, marshes, and the Gulf of Mexico in my home state of Louisiana. Over the years I had become a complete natural history photographer; I was shooting flora, fauna, landscape, recreation, and environmental images—and trying to combine them all with my new passion, nice-light photography. That summer I decided to do a project I called *Skywatch*. It would include the sun, moon, stars, rainbows, lightning, and all other phenomena to do with the sky. I would head west first.

Passing through Kanab, Utah, I visited the Denoyers and told Mike of my project. He said my book would never be complete without a sky as seen from the Grand Canyon. He was leading a training trip in a few days, and he threatened to kidnap me if I didn't go willingly. So I made my first run from Lee's Ferry to Pearce Ferry. It was outrageously fun, and more than productive.

I took some pictures, a lot of them, because I thought it would be my only venture down the Colorado. But no way; I was hooked. One thing led to another, and soon I took a dory trip. Star shots were excellent there: every night a great, sparkling sky with no artificial glow. *Skywatch* was an excuse to go again and again.

Soon I was teaching photography workshops for Mike's company, Grand Canyon Expeditions. I got to row a few riffles and motored some of the bigger rapids. The subtle line between Muav Limestone and Redwall Limestone became apparent to me. I could remember that Serpentine Rapid was before Waltenberg but after Crystal. I learned what *ABC* meant, Alive Below Crystal. Every bend in the river meant something to me, and I was accumulating a drawerful of good photographs.

So I said what the heck, there are only about seventeen trillion books about the Canyon: what's one more? I started to plan. The pictures would be easy; I'd pick out a diverse group of my best. The text was a different story. I was stumped. I ruled out geology, history, archaeology; they'd been done again and again. As I looked over the literature of the Canyon, I realized that few books have

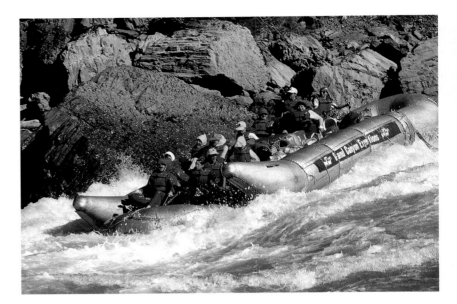

Passengers exult as their S-rig hits the big wave at Lava Falls Rapid.

portrayed it from the boatman's perspective, on the river and beneath the rim. I decided that would be my focus.

In previous books I've written mostly about my travels. Anyone who's spent twenty years paddling the swamps of Louisiana has no shortage of tales to tell, and those stories, interlaced with facts about natural history, have made up the heart of my books. But I realized that my adventures in the Canyon, gleaned from just a few trips, would seem tame and insignificant to experienced rivermen and -women, some of whom do twelve trips a year. I wanted to concentrate instead on the history of photography inside the Canyon, from the first known photo (taken by Timothy O'Sullivan in October of 1871) to the millions snapped there each year now.

Since I first conceived of doing this book, I've made several more trips. Actually, quite a few: winter, summer, spring, and fall; private and commercial; long and short; as a teacher, helper, and/or photographer; complete or hiking in at some point along the rivercourse. My experience has broadened and deepened, and I've had a small taste of river adventure. Not as much, though, as my friends, the boatmen and boatwomen of the Colorado: Mike, O. C., Marty, Derald, Andy, Dusty, Mary Anne, Rennie, Bob, Chuck, Connie, Kenton, Theresa, Allen, Martha, Tim, and many others. These folks—great people living great lives—get more excitement in a summer than most city-dwellers do in a lifetime. So I'll try to weave their stories, mine, and those of some early photographers and their expeditions down the Colorado to give an impression, however faint, of what a special place the Grand Canyon is from my favorite perspective, river level.

Photographers are in relentless pursuit of the perfect Grand Canyon photograph, just as the boatman's quest is for flawless runs in every rapid. But if either goal is set too seriously, it will frustrate even the most skilled. Only your eyes and your mind can capture the Grand Canyon's magic, and then only if you take the time to explore it peacefully and away from the crowded rim.

Boatmen work the Canyon because they want to be there. Most

I have met are multitalented people, fun-loving, energetic, and high-spirited. Generally they wear wide smiles. They can row, motor, hike, climb, sing, dance, cook, write, photograph, draw, play instruments, and tell great stories besides doing what they used to do in the so-called real world.

Some are sons or daughters of old-time boatmen, and some just happened by, got hooked, and stayed. Many have finished college, or even graduate school. All of them have a thorough knowledge of the history, geology, and ecology of the Grand Canyon.

One of these unique river people was Georgie White, the woman credited with getting the masses into the Grand Canyon. Before her triple rigs, boatmen like Norm Nevills could only bring a few people down at a time in rowboats, and the trips were prohibitively expensive. But Georgie's share-the-expense expeditions opened up the canyons, both Glen and Grand, to people of modest means. There is a marvelous picture of Georgie along the riverbank, holding a Coors can on which a butterfly has lit. It's one of my favorite people pictures from the Canyon, and it offers a mesmerizing view of Georgie: her sun-weathered skin is set off perfectly by her piercing blue eyes, and the photo gives an idea of what an unalloyed joy it is for her to float the Colorado.

It was taken by Teresa Yates, an exuberant boatwoman for Arizona River Runners (and a good amateur photographer) who shares Georgie's passion for the Canyon. Teresa has spent as many as 250 days per year down there. I was curious to know how she came to shoot this picture, so I arranged to see Teresa at her home in Flagstaff. She related the story: it was in August of 1986, and Teresa was on her third commercial trip swamping for Georgie. The passengers were fed and settled, and Teresa was in Georgie's motor well with the rest of the crew, talking. The motor well is essentially the boatman's private quarters, and it's usually off limits to passengers once camp is set up. As they relaxed with a beer, a butterfly landed on Georgie. Teresa's camera, a Canon AE-1, was on shore and empty, so she slipped off to fetch it and to load a roll of Kodachrome 64. A few moments later she was back on the boat, where Georgie was still cooing at the butterfly, saying things like "Aren't you beautiful?" and "You like Coors, too." Oblivious to Teresa, who took thirty pictures over the next few minutes, Georgie looked up only once. Click.

Teresa told me that she chased down her camera only because of the butterfly; she already had plenty of nice shots of Georgie. Like most great photographs, this one came from a magic moment. Teresa was lucky; she had a sluggish butterfly and lots of time.

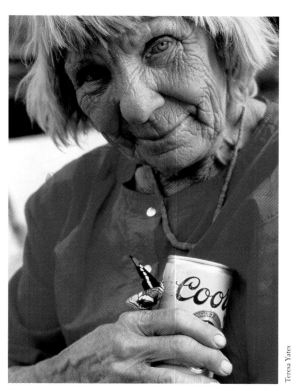

Boatwoman Georgie White.

Two of the shots turned out great, and I've included one of them here.

Georgie, who died in 1992, was one of those people with an infectious positive outlook, an attitude captured in her favorite saying, "Just the way you like it." Her leopard-skin print pants and initiation ceremonies were famous on river trips. Georgie's own first outing on the Colorado was unforgettable. In 1945 she swam from above Diamond Creek to Lake Mead with "Upstream Harry" Aleson. Aleson was determined to motor a boat up the Grand Canyon, a goal he never reached; but he did manage to introduce Georgie to the joys of the river. The next year they hiked eighty miles from St. George, Utah, down Parashant Wash, then floated the same stretch to Lake Mead in a one-man raft. By 1954 Georgie was experimenting with strapping three rafts together. This triple rig soon led to the motor-driven G-rig (*G* for Georgie), and the tour bus of the river was born.

⸺

A word about boats. There are several ways to navigate the Colorado that involve paddling, rowing, or motoring. Most visitors see the river on motor rigs, which range from thirty-five to thirty-nine feet in length. Some of these are named after their designers, like Ron Smith's S-rigs; some, like "baloney boats," are known by nicknames. A rowing raft is usually sixteen to twenty feet long. It accommodates four passengers and a guide, who does all the rowing. For the customer who wants to participate, the paddleboat is a good choice: in these rubber rafts, the guide only steers from the back. Some companies offer baggage boats to supply river adventurers while they paddle canoes or kayaks.

Last but not least is the dory trip, which I recommend as the most intimate way to see the Canyon. Dories are ideal for photography. My friend and fellow photographer Dewitt Jones teaches his workshop on dory trips because, as he says, "Dories have the right pace with the river. They're elegant, and they're the most photogenic boats in the Canyon." Dories, too, are sixteen to twenty feet in length, and they usually hold four passengers and one guide, who rows.

Martin Litton told me a few Georgie tales. In 1956 he was on a trip with P. T. Reilly, and Georgie was a day behind. Moulton Fulmer broke an oar in Seventy-Five-Mile Rapid and lost the blade. That night at camp the bottom half floated up. Someone grabbed it and threw it into the fire. P. T. plucked it out; he had an idea. He carved *1869* and *JWP* (for John Wesley Powell) on it. Then he bat-

tered and partially burned it and left it on the beach. Next thing they knew, the oar was being displayed at the South Rim as a legitimate artifact of the Powell expedition. When the cat got out of the bag, Georgie, who had "discovered" the counterfeit oar, was blamed.

If Georgie was mother of the motor rig, Martin Litton was father of the dory. As travel editor for *Sunset,* he illustrated most of his stories with his own photos. An expert photographer, Martin has been shooting pictures since he was seventeen, when he took a cover photo for *Arizona Highways* magazine with a twenty-five-dollar folding Kodak camera. Of Martin's Grand Canyon photographs, he told me his favorites are detail shots of Matkatamiba, a sublime side canyon; Bob Webb, a hydrologist and rephotographer, favors Martin's views of Lava Falls Rapid, which he considers not only lovely but important. Even more significant has been Martin's work to stop the dams within Grand Canyon National Park. With the help of the Sierra Club, he has been a moving force in this regard.

The 1956 trip with P. T. Reilly was his first. Shortly thereafter, Martin ordered some McKenzie River dory hulls from Oregon. He was the first to run a true dory through the Canyon, and soon he founded a river company, Grand Canyon Dories. Except for a few movie shoots, Martin has always rowed the river. He has been featured in numerous films and magazine articles (for example, the 1978 *National Geographic* story).

I asked Martin what dory design he liked best and found out he likes them all. He owns six: one aluminum, one fiberglass, and four wooden. He has a Briggs, a Paul Butler, and a Don Hill, all the handiwork of well-known dory builders. He's heard of my friend Derald Stewart, maker of Cañonita dories. Derald, who not only rows a good boat but also makes some of the best dories in the Canyon, built all three that we took on a private trip.

───────

Once, what intrigued me most about the lunar cycle was the full moon. Who can gaze without joyful surprise as the pumpkin-orange disk appears on the horizon? Watching it climb above the haze into the clear night sky, growing ever whiter and brighter, is enthralling. But recently a new phase has taken my fancy, the one I saw on a winter dawn at our Granite Park campsite in the lower Grand Canyon.

It was a January trip, and for our first sixteen days the skies were gray and cold. At our previous camp it had rained for twenty-four hours, but this morning was different. As I pulled my sleeping bag off my face I could feel the dry, cold air. The sound of Chuck's crackling fire warmed me in anticipation of a fireside cup of tea. Sliding into my Patagonia fuzzies, I somersaulted out of my tent. And there, for the first time in almost three weeks, I saw the moon gleaming in the sky.

To an astronomer it was a waning crescent, five days before the new moon, but to me it was a dory in the sky. The boatlike sliver looked just like a dory, its bow down as if diving into the hole of a

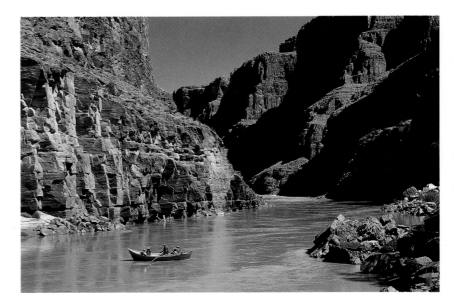

A dory drifts through a quiet section of the Grand Canyon.

rapid. The moon was almost touching Venus, and it was chasing Jupiter across the southeastern sky. A trace of pink and powder blue shone over the canyon walls, hinting that morning was on the way.

The moon reminded me most of Dusty Teal's dory, *Stringbean,* a slim, sixteen-foot Cañonita. It was tied securely to a tamarisk tree. Nearby were our other two dories, the *Raoul* and *Whiptail,* similar but wider boats. All three had had good runs through the action-packed rapids of the ruddy, muddy Colorado, pleasing this photographer's lens many times over despite the somber skies.

A dory, as defined in the dictionary, is a small boat with a flat bottom and high sides. As I've said, many river guides consider it the ideal boat for the Grand Canyon. Once they've rowed a dory, they're spoiled. Crista Sadler, a boatwoman for Canyon Explorations, puts it this way: "The Canyon is the focus, and a raft is just a way to get down the river, but a dory is like another person, part of the river. The dory is elegant and exciting, incredibly connected to the Colorado River."

Sitting by Chuck's homey fire, I continued my thoughts on the

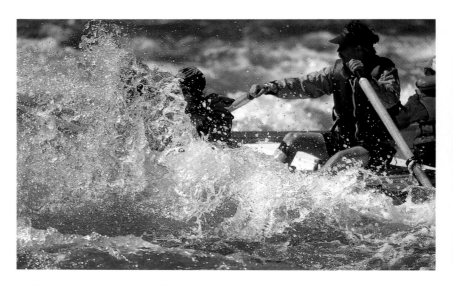

A dory battles a wave in Badger Creek Rapid.

crescent moon and the dories it represented to me that morning. Our trip had been great despite small hardships of rain, ice, cold, mud, sand, and clouds, all of which tend to be rough on my cameras and to make my work more difficult. But compared with Powell's first trip through the Canyon in 1869, we hadn't had even a speck of hardship.

Powell's boats, with their round bottoms and narrow beam, weren't really suited to the rapids. He had no guidebook to describe what was ahead. We, on the other hand, had first-class dories, waterproof bags, a generous pantry of food, and clothes scientifically designed for any weather. An excerpt from Powell's journal account of the voyage helps to underscore the differences between the fun of our river trip and the anxieties and privations on early attempts to run the Colorado:

> We are now ready to start on our way down the Great Unknown. Our boats, tied to a common stake, are chafing each other, as they are tossed by the fretful river. They ride high and buoyant, for their loads are lighter than we could desire. We have but a month's rations remaining. The flour has been resifted through the mosquito net sieve; the spoiled bacon has been dried, and the worst of it boiled; the few pounds of dried apples have been spread in the sun, and reshrunken to their normal bulk; the sugar has all melted, and gone on its way down the river; but we have a large sack of coffee. The light[en]ing of the boats has this advantage: they will ride the waves better, and we shall have but little to carry when we make a portage.

> We are three-quarters of a mile in the depths of the earth, and the great river shrinks into insignificance, as it dashes its angry waves against the walls and cliffs, that rise to the world above; they are but puny ripples, and we but pigmies, running up and down the sands, or lost among the boulders.

> We have an unknown distance yet to run; an unknown river yet to explore. What falls there are, we know not; what rocks beset the channel, we know not; what walls rise over the river, we know not. Ah, well! we may conjecture many things. The men talk as cheerfully as ever; jests are bandied about freely this morning; but to me the cheer is somber and the jests are ghastly.

Much has been written about that greatest of all adventures. Only six of the ten men who began the voyage finished it. One quit, and three walked out at Separation Canyon and were never seen again. The conditions were miserable, and those who completed the trip did so while having to fight off both fear and hunger. It was no easier two years later when Powell came back, this time with a photographer.

My favorite character on the second expedition is John K. Hillers, sometimes called Jolly Jack by Major Powell. I like Hillers not only because he ended up being the photographer, but also because he was such a fun-loving, hard-working guy, like the boatmen of today. Hillers came to join the expedition by accident. He was working as a teamster in Salt Lake City when he happened to meet J. W. Powell, who was there finalizing preparations for the trip. When one man, Jack Sumner, could not go, Powell hired the red-haired, good-natured Hillers to take his place. When they em-

barked on May 22, 1871, Hillers was rowing the *Emma Dean,* Powell's boat. In the next few months, as they made their way from Green River City to Lee's Ferry, where the expedition stopped for the winter, he rowed, repaired boats (as well as boots), and helped E. O. Beaman with his photographs. At Lee's Ferry, Beaman, a fine photographer, left the crew after a disagreement with Powell.

The major's young cousin, Walter Clement Powell, was promoted to photographer, and Hillers was installed as assistant. Clem Powell could not handle the job; he blamed the equipment, even claimed that Beaman had sabotaged the chemicals. Once, on an overland trip to explore Kanab Creek, his packhorse fell off a cliff and landed on top of the camera.

In search of a new photographer, Powell found James Fennemore of Salt Lake City, who took over the job for the rest of the winter. Both Clem Powell and Hillers were assistants. When Fennemore took sick before the relaunch from Lee's Ferry, Hillers became, by default, the chief photographer.

Many of the men on these early expeditions kept journals or wrote books about their experiences. Frederick S. Dellenbaugh, at seventeen the youngest member of the second Powell group, was hired on as the artist. Later he wrote two books and collected and preserved the diaries of several other members of this expedition. In a letter to Robert Taft, author of *Photography and the American Scene,* Dellenbaugh wrote of Hillers:

> Sitting by the fire, Hillers asked me about photography— about the chemical side. I explained the action of light on a glass plate coated with collodion and sensitized with nitrate of silver, the bath to eliminate the silver in hypo, and so on.

> "Why couldn't I do it?" he said. I replied that he certainly could, for he was a careful, cleanly man, and those were the chief qualities needed. I advised him to offer his help to Beaman whenever possible (and aid was then necessary to transport the heavy boxes), and perhaps Beaman would let him try a negative. He did, and in two or three weeks had made such progress that he overshadowed Clement Powell.

> When Beaman left at the end of our first season of river work, the photography fell on Clement. He made a trip with Hillers as assistant and returned with nothing. He declared Beaman had put hypo in the developer. Beaman, who had lingered in Kanab, where our headquarters for the winter was established, said he had not done so—that the trouble was Clem's carelessness.

> Meanwhile, Powell had sent to Salt Lake City to see if a photographer could be found there who would come down and who would go through the Grand Canyon with us the next summer. James Fennemore came. He was an excellent photographer and a genial fellow. . . . He was good to Hillers and gave him much instruction, with the result that Hillers became expert in the work; became assistant, in fact. . . .

> Hillers did some excellent work with Fennemore's guidance. When we were preparing to enter the Grand Canyon in the summer of 1872, Fennemore was taken sick. . . . This left us with only seven men. One boat had to be left behind. All the boats were badly battered. We discarded the *Nellie Powell,* which was in the worst condi-

tion. Well, what I am coming to is this; there was nothing for it but to make Jack Hillers photographer-in-chief. He was equal to the job. In spite of enormous difficulties, great fatigue, shortage of grub, etc., he made a number of first class negatives.

I can't imagine putting such words as "a careful, cleanly man" in a recommendation for one of my students looking for a photography job. The art was different then. Beaman began the expedition with one thousand pounds of equipment: bulky large-format cameras with numerous glass plates, gallons of chemicals, a dark-room tent, spares of everything, plus substantial cases to protect the gear. So care with fragile glass plates and meticulous cleanliness with chemicals would be necessary attributes for an expedition photographer in a wilderness environment.

On August 17, 1872, the group left Lee's Ferry and headed into the Grand Canyon. They camped eleven miles downriver, at Soap Creek, to make a portage. The next day, probably at the foot of this rapid, Hillers made the first photo of the Canyon on a downstream trip. He was the first boatman photographer.

There is some controversy about who took the first still-extant photograph of the Grand Canyon, but most agree that it was Timothy O'Sullivan. O'Sullivan's pictures were made between October 7 and 19, 1871, on the George M. Wheeler expedition. Lieutenant Wheeler planned a trip that would cover two hundred miles up the Colorado, from Fort Mohave, Arizona, to Diamond Creek. The last fifty-one miles of that route fall within the present-day boundaries of Grand Canyon National Park. Though Lieutenant Joseph C. Ives had already done this upriver run in 1857 and Powell had been by in 1869 headed downstream, Wheeler wanted to determine the limits of practical navigation and to measure the velocity and breadth of the river.

On August 15, 1871, four flat-bottomed boats started to push their way upstream. O'Sullivan's was, appropriately, named the *Picture*. The journals of G. K. Gilbert, a geologist on the trip, say that "O'Sullivan was constantly on the move, lugging his heavy camera equipment up and down the steep washes that hugged roaring rapids." As they progressed, the rapids got steeper and the portages harder, so hard, the journals report, that the men often fell onto the sand and slept like the dead. Between portages, O'Sullivan continued to photograph. By the nineteenth day, provisions were so low that Wheeler was forced to guard them with a rifle.

Only twenty of the thirty-nine men who started made the entire voyage. O'Sullivan's job as photographer was far from sedentary; he not only took hundreds of plates and stereoviews but helped haul the heavy boats up rapids. Twice he was forced to swim rapids to help save boats and equipment.

The trip upriver took thirty-three days; the return, only five. Afterward Wheeler sent O'Sullivan to Washington, D.C., to show off his images. Sadly, most of O'Sullivan's plates from the trip were mysteriously lost en route to San Francisco. Dr. William Bell took over as the Wheeler group's photographer in 1872 and did some rim views and hikes into the Grand Canyon in the fall. Then, in

1873, O'Sullivan rejoined this massive expedition of scientists, soldiers, and Indian guides. A portfolio of fifty photographs was later published depicting the Wheeler survey. There is some question as to which should be credited to Bell and which to O'Sullivan.

E. O. Beaman also contends for the first photograph of the Canyon. Beaman was hired out of New York by J. W. Powell on the recommendation of the E. and M. T. Anthony Photographic Company. He did much good work in the upper reaches of the Green and Colorado Rivers. Beaman was at Lee's Ferry in October of 1871 when the Powell expedition finished the first leg of its trip. Though no photographs seem to have survived from that period, it's hard for me to believe that Beaman didn't take some while at Lee's Ferry. John D. Lee, the Paria Riffle, and the Vermillion Cliffs would have been excellent subjects, and Beaman was reputed to be a doggedly patient and determined photographer. Once, in Desolation Canyon, Beaman badly wanted to make a photograph of a sandstone amphitheater named after Jack Sumner of the first Powell expedition. Professor Thompson, Powell's brother-in-law, was in charge while Powell was in Salt Lake City, and Beaman cajoled him into waiting two full days until the weather was right for the photograph. Nevertheless, it didn't turn out well.

It is documented that on April 15, 1872, Beaman was at the mouth of Kanab Creek on the Colorado, and there are existing photographs from this site. So the second photographs in the Canyon can be attributed to him. Beaman hiked up to Deer Creek, where a spectacular waterfall pours almost directly into the river. This fall is seen by every boatman or river passenger who traverses the Canyon.

There is another contender. In 1857 Lieutenant Joseph Ives (who was, incidentally, the first expedition leader to bring an artist into the Canyon) made a steamboat run and march to Diamond Creek. Some believe that a daguerreotype may have been taken in canyon during this trip. If so, it is lost.

The first picture of the Grand Canyon still in existence was taken by Timothy O'Sullivan on or about October 7, 1872. Few images from that trip survive; in fact, we have fewer than two hundred pictures from the first three years of Grand Canyon photography. But that situation would change dramatically with the next successful expedition down the Colorado.

In 1889 an entrepreneur named F. M. Brown, president of a newly formed company, hatched a plan to build a railroad from Denver to San Diego through the Grand Canyon. The idea came from a prospector named S. S. Harper, and Brown embraced Harper's peculiar vision and set to planning.

Brown hired Robert Brewster Stanton as chief engineer, and the two immediately got into a logistical dispute. Stanton wanted strong oak boats; Brown chose cheaper, lighter craft of thin red cedar, so fragile that two of them cracked during shipment. Stanton wanted to hire experienced oarsmen; Brown insisted that he and two lawyer friends could handle the rowing. Stanton tried to

insist on cork life preservers for all the crewmen, but Brown refused to buy them.

In May, Brown's group began its descent of the Green River with five new cedar boats and one older boat towing zinc-lined waterproof boxes. These boxes were designed to store gear, but the containers wouldn't fit in the boats. The party consisted of sixteen men: surveyors, engineers, boatmen, guests, a cook, and the photographer, Franklin A. Nims.

F. M. Brown was an incorrigible optimist, and he had little inkling of the dangers ahead. He and Stanton continued to wrangle over logistics and supplies, with Brown refusing to outfit the boats as thoroughly and safely as Stanton thought necessary. By the nineteenth day of the voyage, all but one of the zinc boxes had been lost, and most of the stoves and cooking gear were gone. Despite the loss of his equipment, the cook was unfazed, and with characteristic cheer he announced, "Never mind, sir, leave me a tomato can and a frying pan, and I'll get you a good supper." This he managed for several days, until the food began to dwindle.

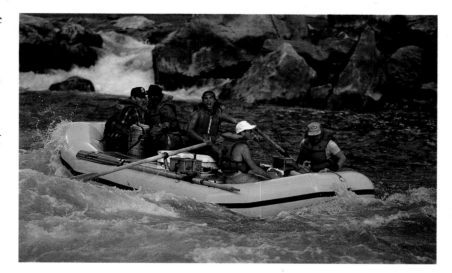

An exuberant boatman navigates 24½-Mile Rapid in a rowing rig. This is the rapid where Peter Hansbrough and Henry Richards met their deaths in 1889.

In order to demonstrate the severity of the situation, Stanton had the cook divide the food into sixteen piles, each of which was composed of a twelve-inch-round slab of bread an inch and a half thick, a can of condensed milk, a little coffee, and a handful of beans. Brown, finally persuaded of the crisis, agreed to go ahead for more supplies.

After almost a month (and after much discomfort), the expedition was resupplied at Lee's Ferry; it entered the Grand Canyon with only three boats intact. On their first night in the Canyon, the men camped at Soap Creek Rapid after their portage. After supper Brown called Stanton over to smoke and talk; despite their differences, they had become friends. That evening Brown seemed troubled and lonely, a mood Stanton attributed to the departure from the expedition of Brown's lawyer friends.

The next morning, July 10, 1889, Brown announced to Stanton, "I dreamed of the rapids last night, the first time since we started." After breakfast Brown, along with Harry McDonald, was the first to leave. They entered what is now called Brown's Riffle, where, after they had pulled into the eddy, a wave overturned them. McDonald made it to shore; F. M. Brown drowned. The notebook he always carried in his shirt pocket floated up, but Brown was never seen again: those who know the river say that it seldom gives up its dead.

Today boatmen eddy out below Soap Creek Rapid, after giving their passengers a thrilling ride, and tell them Brown drowned

here. Most guides point out the inscription Peter Hansbrough carved into the Supai Sandstone there on the day of Brown's disappearance, a memorial that's still visible more than a century later.

Five days after his death, Brown's bad judgment brought disaster again. Hansbrough and Henry Richards drowned when their boat flipped in 24½-Mile Rapid, now sometimes known as Hansbrough-Richards Rapid. Without life jackets, the two men had little chance. Demoralized by the deaths, underequipped and undermanned, Stanton called off the expedition a few miles downstream and stashed the boats and gear in what is now called Stanton's Cave (at river mile 32). The remaining men hiked out of South Canyon and walked to Kanab, Utah.

Stanton was determined to finish the surveying work they had started, and to do so immediately. He raised more money from the original investors and kicked in some of his own. He designed a new boat—twenty-two feet long, with a four-and-a-half-foot beam, and made of solid oak—and had three of them built in Waukegan, Illinois. To see that the boats were constructed according to specifications, Stanton sent Harry McDonald, one of three men he rehired from the first expedition, to Waukegan.

The other holdovers from the spring expedition were assistant engineer John Hislop and the photographer, F. A. Nims. Nims's role in the second attempt would be far more important. Because of limited time and resources, Stanton had decided to survey only the most treacherous stretches of the rivercourse; the rest of the railroad route would only be photographed. For Stanton the purpose of having a photographer along was practical, not aesthetic: he needed pictures in order to conduct his survey efficiently.

Stanton obtained two 6½ x 8½-inch cameras for Nims, along with one 4 x 5-inch detective instrument and two thousand films in rolls. The film was stored in tin boxes sealed with plaster and enclosed in heavy rubber waterproof bags. Stanton bought forty-eight such bags, each of which would hold seventy pounds, and his boat design included ten airtight and waterproof compartments in which the bags could be stashed. Each boat was also equipped with two five-gallon kegs for foodstuffs. Most important, each man had a life jacket and was required to wear it.

On December 10, 1889, the second expedition began at the mouth of Crescent Creek, Utah. By Christmas they made it back to Lee's Ferry, where Stanton surprised his men with a hearty dinner, including three soups, salmon, turkey, beef, ox heart, chicken, game pie, potatoes, onions, tomatoes, rice, breads, desserts, bever-

ages, and even cigars. After three days of digestion, they began their second attempt at navigating the Grand Canyon.

The water level was ten feet lower, and rapids still had to be portaged or lined. This was grueling work, as each boat (with gear) weighed 3,200 pounds. Stanton frequently instructed Nims as they worked "that the object of our photographs was to show the nature of the canyons for the purpose of illustrating the railroad route, and not to risk anything in his work, simply to get a pleasing picture." But Franklin Nims couldn't resist, and on January 1, 1890, he fell while climbing to get a better view. After bouncing off twenty-two feet of rock, he landed on his head in hard sand. Given the extent of Nims's injuries, which included a broken leg and bleeding from the mouth, there was no choice; he would have to be carried out.

As they finished first aid on Nims, Stanton worried that no one remained in the party who had so much as focused a camera, and there might not be another photographer in a thousand miles. It was too late in the day to move the boats, so Stanton made his first picture. The next day the men rowed to House Rock Rapid, portaged it, and made camp. On January 3, Stanton and two others scouted for a route out of Ryder Canyon, and the next day eight men began to haul the makeshift stretcher up the canyon. Along the way they had to climb a 1,700-foot escarpment, and without jostling or further harming their unconscious friend. Nims had to be roped up ledges and pushed through cracks in the rock. Reaching the top took longer than they had thought, so the men had to sleep in the snow, without provisions, while waiting for Stanton and a wagon.

Two weeks later Nims made it to Winslow, Arizona, where a doctor patched him up. It took six months for his injuries to heal, and Stanton did not—from the day of his accident—pay any expenses or salary. Meanwhile the chief engineer forged on, taking over the photography duties himself.

On a Grand Canyon Expeditions photo workshop I taught, we had an accident that required a stretcher evacuation. Billy, an ex-Vietnam helicopter pilot and a budding photographer, broke his heel by jumping off the front of our raft onto the unforgiving sand. Within minutes his foot was swollen to a gross and pudgy state, and he couldn't walk at all. For two nights we carried this good-natured invalid to dinner, to the porto-potty, to his tent, and to the boat before our trip leader, Sally Wenner, decided that he needed to be flown out.

Billy was a big boy, and it took twelve men taking turns to carry him to the helipad. The Bell helicopter needed only seven minutes to transport him to the South Rim Clinic . . . at a cost of $1,300. Four days later our group arrived in Las Vegas. In the hotel lobby we found Billy, jovial as ever, on crutches. Behind him was a singing-telegram girl doing a tap dance; she was dressed up like Shirley Temple.

These days evacuations aren't, it seems, quite the same as what Nims and his litter-bearers went through.

Foot injuries are common on river runs through the Canyon. There's been one on every trip I've taken, mostly sprains, broken toes, and puncture wounds. Punctures—by partially buried sticks, stones, and cactus spines—are prevalent because most people wear flip-flops or go barefoot around camp. But more serious injuries happen infrequently, and river-related deaths are rare. The Brown-Stanton expedition was definitely the unluckiest (or the stupidest) in this regard. Since then, 500,000 people have made the downstream trip, and only 14 have died in the river.

Stanton's men found Hansbrough's body as they pulled into camp one evening a few days later. They buried him under the overhanging cliffs, which formed a headstone seven hundred feet high, and they named the magnificent outcropping of Redwall Limestone across from his grave "Point Hansbrough."

As he took more photographs, Stanton began to soften to the beauty of the Canyon. He had no way, though, of knowing whether his pictures were turning out well. One of the eleven remaining men knew that the film should not be exposed so long in a bright sun as in shadow or darkness, but that was the extent of their knowledge of photography. A few days downriver, near the Tanner Trail, the Stanton group met a prospector named Felix Lantier and gave him two rolls of film to transport to Denver. At Diamond Creek the expedition received a message from W. H. Jackson (one of the foremost western photographers of the era), whose lab had processed the film: "Negatives all right." Stanton was ecstatic.

Upon entering the Upper Granite Gorge, the area the Powell expedition had most feared, Stanton hiked up high to get a better look. "I thought," he reported later, "it was the most wonderful sight I had ever looked upon." But as Stanton's appreciation of the Canyon's beauty increased, so did his hardships. At Sockdolager Rapid, where Powell's boat had flipped, the water was low enough to try a portage. But one boat caught a crosscurrent, turned sideways, capsized, then filled with water and started to sink. Finally it lodged between two rocks. Two men worked frantically in the frigid water, but they were unable to free the boat.

Stanton's party was stuck halfway down a major rapid in the Granite Gorge. Two-thirds of their blankets were wet; there was precious little firewood; the only place to sleep was atop jagged rocks. During the night they heard the boat move, and they made another unsuccessful attempt to extract it. By morning the river had risen two feet, and they were able to free it; but one side was half-gone, and the other was hopelessly broken.

The only crewman with boatbuilding knowledge was Harry McDonald. He sawed the damaged craft in two and shortened it by four feet. This painstaking job took five days. The rest of the men ranged as far as they could to get firewood to keep warm at

this inhospitable camp. During the last two days they were forced to use shavings from the broken boat in order to cook.

———————————

I had a little adventure that involved sleeping on the rocks, though my situation wasn't nearly as miserable as that of Stanton's crew. It was at Hance Rapid, about three miles above Sockdolager. Early expeditions portaged or lined their boats through many rapids modern-day boatmen run, and Hance falls into this category; Stanton, for example, had portaged it. Hance is a tortuous, gnarly rapid, about as rocky as any in the Canyon. For this reason boatmen usually scout it carefully—that is, they stop above and observe the flow to plan the best route through the treacherous white water.

After scouting, my buddy Marty lost an oar at the top, and he got sideways, bumped a rock, and flipped. Marty swam to shore, only to see his dory hung up on a boulder. Once we got the other boats safely to the bank, Operation Rescue Dory began. Marty's was an eighteen-foot craft painted blue and named the *Supai,* after one of the most beautiful layers of Canyon sandstone. It was caught in swift water, so it was impossible to swim to. Luckily a kayak came by, and soon we had three ropes tied to the stuck dory.

We arranged Z-lines—a configuration that allows a rope to work like a pulley system—and after much on-site engineering and strain of muscle, we managed to free the *Supai* . . . only to have the current move it downstream and snag it on an even more forbidding rock. This time the underwater gunnel was wedged in, and the full force of the Colorado was pouring over the top of the dory. We rerigged two lines, and added more muscle when another rafting company arrived and offered help. For two hours we pulled from all directions, but we succeeded only in stretching the ropes beyond future usefulness.

It was decided to move down to that night's campsite, dropping Marty, Chuck, and me off at Phantom Ranch so that we could summon a river rescue unit equipped with the needed winches, chains, and ropes. After a wait of about an hour, they picked us up; we put on used combat boots and hard hats in order to conform with park regulations for flying, and then the helicopter buzzed us up the Granite Gorge to Hance Rapid.

I've flown over the Canyon doing aerial shots, way above the rim, from a helicopter with its rear door off; it was so cold that I could hardly get my fingers to work at changing the lens aperture. Today I was below Tonto Platform, about two hundred feet above the river, the schist and granite outside the window so close that I couldn't have taken a decent picture even with a wide-angle lens. I don't know why I thought it, but I wondered what J. W. Powell would have said if he were sitting beside me. I couldn't imagine it would go much beyond what I was thinking: "Wow! Cool!"

After a couple of minutes, the pilot made a great landing on flat rock, his skids at the water's edge on one side and his blades near the canyon wall on the other. River rangers Jim Traub and Dave Desrosier, along with Craig Patterson, a backcountry ranger with extensive knowledge of ropes, were already hooking up anchor straps. Dave, wearing a wet suit and helmet in the fifty-degree water, was rigging a chain around the *Supai.*

Soon we had three anchor points consisting of five straps each, with a large sailboat winch attached to one and a thousand-pound come-along hitched to the other two. After all the to-do of setting it up, we discovered that we couldn't budge the dory by pulling downstream, so we reversed the anchors and retied them. It was getting dark, and Jim radioed the helicopter for food: we might be there all night.

All six of us were in pretty precarious positions as we cranked at the winches. I was on the sailboat winch, whaling away. It was tethered to the five anchor straps with a two-inch safety strap made up of about twenty rows of stitches, and designed to tolerate one thousand pounds per stitch. Stitches were popping like firecrackers; six rows snapped at once. The winch was hanging, now, over the rapids. I was balanced on two slippery rocks, eight feet above the flow, and still cranking. It was almost dark, and a feeling of danger came over me . . . especially after the safety stitches had given way. All three lines were as taut as tree bark.

We had a life jacket hung on each line, so—at least theoretically—a broken rope wouldn't snap back like a whip and slap us. At last we heard a creak as the stern began to move. With slight adjustments to our gear, we were soon able to pull the dory straight up into the air. Balanced on its bow, secured by three ropes, it stood like a monument to our efforts. We gently rolled it upstream until it was floating; then we emptied and bailed it. Finally we lined it upstream to the only small eddy around.

After the dory was secure, the six of us perched on a large, flat rock overlooking the rescue site and had a picnic. The rangers went down to where the helicopter had landed and picked up the box of food the pilot had left. It contained a dozen Persian Gulf War MREs, "Meals Ready to Eat." Our contribution was some bagels, tuna fish, and peanut butter that Chuck had thrown into his pack. I wondered whose food tasted better . . . ours or that of Stanton's men.

Jim told the story of a stuck thirty-seven-foot motor rig that they'd had to saw in two. Craig detailed the rescues he makes every day on Bright Angel Trail. Dehydration and heat prostration, Craig told us, are the most common problems on Bright Angel, one of the most-hiked trails in any national park. But you never know what you'll see; one ranger told of finding a novice hiker stranded four miles down . . . in high heels.

After dinner the rangers went to the landing area, hoping to find a soft spot to sleep. Marty, Chuck, and I had to bed down on the rocks, like Stanton's men, in order to watch our dory as the river rose.

We were up at dawn, and Marty took his place at the oars "on the horse that threw him." The full moon was setting over the rim directly downstream, above Captain Hance's asbestos mine. The

granite walls and ruddy river glowed in the twilight. The bow hatch cover was gone, and with it Roxanne's pack. (Amazingly, another river company found and returned the pack, which contained her wedding ring.) The rest of the hatches were tweaked, and the boat was six inches narrower at the beam than before; but she rowed OK. We did fine in Sockdolager, took a big wave in Grapevine, and caught our group just as they were pulling out of camp near Phantom Ranch.

Our adventures were the talk of the trip, and on the last night two couples composed and performed a song about the trials of the *Supai,* sung to the tune of "The Tennessee Stud." (It's important to note that Marty, on this first dory experience, later aced Lava Falls Rapid; the *Supai* has, incidentally, been repaired, and it's since made a couple of runs down the Colorado.)

One night during that two-week-long trip, several people gathered around veteran boatman O. C. Dale, who was using the "f-word": *flipping.* Most watermen refuse to say it, and some are so superstitious that they won't allow pancakes or fried eggs to be cooked on the morning before Lava Falls, the biggest rapid in the Canyon; it's bad luck to flip *anything.* O. C. was warning those gathered around about false confidence: "There are two types of boatmen in the Grand Canyon, those that have flipped and those that will." O. C. fits, he claims, in the second category: he's never flipped a dory. But he's a man who likes to weave a tale or two, so I wonder. Sometimes I think he must be related to Captain John Hance, the first white resident of the South Rim. The Captain spent his declining years in a hotel there, put up for free by the Fred Harvey Company because he was such a great storyteller.

According to one of Captain Hance's best-known stories, one time the clouds were so thick below the rim that he walked across on snowshoes. But as he neared the North Rim, the clouds started to dissipate, and Hance was stranded atop a wilderness mesa. It took, he said, two whole days for enough cloud cover to build up so that he could walk home again. These clouds were thinner, a little perilous, but Hance made it back without mishap: he hadn't eaten in two days, after all, so he could walk on lighter clouds.

O. C.'s cousin Regan Dale, manager of Grand Canyon Dories, is one of many talented boatmen photographers. He told me about the summer of 1983, when high water set off an epidemic of flipping. Regan was camped at Bass, about nine miles below Crystal, when he saw a Georgie White boat float by upside down with eight hysterical people on top. The water was a raging torrent, surging to 92,000 cubic feet per second, and from their dories Regan and his friends could do nothing to help. Fortunately the rig hung up at mile 110, and the folks were rescued by helicopters. Big boats were flipping that summer in minor rapids like Nankoweap. Regan told of a boatman who fell out in Hermit Rapid. The boat stayed straight and made it through, and the passengers in front and back didn't even realize they had lost their guide.

The gravest danger was at Crystal, where the hole was so big and so gruesome that the Park Service temporarily closed the rapid. When they reopened it, commercial passengers were re-quired to walk around. Just before it was closed, Jeff Aronson arrived on a rowing trip for AZRA (Arizona Raft Adventure). He and his party camped above the rapid, planning to row the beast in the morning. Jeff told me that the hole was inconceivably huge: you could have a helicopter lower a diesel locomotive into it, without touching the water, and still be below the big wave. Their crew played guitar and drank all night, trying to stave off the Crystal Rapid jitters.

The next morning two Tour West thirty-eight-foot motor rigs pulled in to scout. Jeff and one of his passengers, Dick Kocim, walked downstream to watch the big boats going through. They were watching from just about the level of the big hole, and the noise was thunderous. When the big rig moved into view, the passengers were hunkered down as the boat slid inexorably toward the hole. Dick started shooting with his Minolta SRT; it had no motor drive, so he was cocking and shooting as fast as he could. The boat tilted, and by the time it hit the hole it was upside down. The seventh picture of the thirteen Dick shot shows the heavy straps snapping . . . straps meant to hold the four-thousand-pound rig together. Straps elephants could walk across, but Crystal Rapid just ate them.

Jeff said the boat disappeared into the hole for a second, then reappeared in pieces. He never saw the swimmers, but they all popped up and were plucked out of the water, some of them miles downriver. Dick modestly claimed that his brother, who was nearby, is the better photographer of the two. But while the brother's camera was empty at the decisive moment, Dick was ready . . . and that, as much as anything else, is how you judge a photographer.

Four big rigs flipped that day; eighty people were rescued and evacuated. One man died of a heart attack while in the water. Jeff's group made it through Crystal safely, but without the passengers, who walked.

Jeff had one more interesting tale about this dangerous rapid. In 1993 he rowed into the tongue of Crystal with his girlfriend. He leaped into the front of the boat and proposed to her, adding that she might want to answer quickly if she wanted him back at his oars. She accepted.

Jeff is a director and cofounder of Jumping Mouse Camp, a group that helps handicapped people make river excursions. I saw one of his groups in Redwall Cavern: seven folks with various disabilities, lying in the sand or sitting in their wheelchairs as they listened to three boatmen playing Canyon music on guitar, banjo, and mandolin. The joy on their faces was touching, and I was even more impressed when I saw one of Jeff's passengers rowing hard later that day.

My friend Mike Denoyer was still working for Henry Falney and White Water River Expeditions in 1983. During that extraordinary summer, Henry wanted his most experienced boatmen on every trip, so Mike ran the entire Canyon eighteen times. At the conclusion of one trip, he would hop into a plane with Earl Leesberg at Pearce Ferry and fly up to Marble Canyon to join the next.

Roxanne would be waiting with a bag full of clean clothes, and the boats would be fully rigged and ready for him to take off with a new group of passengers . . . all this before lunch.

Mike had terrific runs all summer. The thing he recalls most vividly is the eerie feeling he got passing the wreckage below Crystal, especially around mile 110. There would be a battered boat tied here, a capsized dory there, and piles of coolers, ammo cans, and other equipment stacked above the high-water line by passing samaritans. He said the Park Service would fly over in helicopters dropping little notes sealed into baggies. The notes said such things as "92,000 cfs released this morning. Camp high, be safe."

Because of the exceptional flow, 1983 was the year to try for speed runs. Henry Falney made it to Lava Falls in eighteen hours, but he failed to keep the pace. Three other boatmen—Kenton Grua, Rudi Putschek, and Steve Reynolds—did manage to set a new record, and on an illegal run, with neither a permit nor a motor. They took off just before midnight on my birthday, June 26. They planned to row continuously, using the light of the full moon (plus a couple of searchlights, if necessary). The late-night departure served a dual purpose. They could do the easy stuff in the moonlight, hitting the gorge rapids after daybreak; and a dark start would help them evade the Park Service.

All went well until they got to Crystal, where there was a ranger on the bank. If the ranger tried to summon them, the illegal three planned just to wave back. Ranger John Thomas immediately knew what was going on and realized they wouldn't stop, so he simply climbed up to the scout rock to watch. Kenton was rowing; it was his boat, a dory named the *Emerald Mile*.

As I've indicated, Crystal in 1983 was—given the hellacious hole and the high water—a rapid that demanded to be scouted. But they couldn't afford to. For one thing, this was a run at the record, and there was no time to spend on caution; for another, scouting might give the ranger a chance to intervene. Kenton wasn't terribly worried; he'd rowed Crystal three weeks before, and he thought he was prepared. But conditions had worsened, and the lateral wave shoved the *Emerald Mile* into the monstrous hole. They flipped in a millisecond. Kenton and Rudi made it to the boat without much effort. They got on the bottom, prepared the flip lines, and leaned back, almost righting the dory before the ropes snapped. They were upside down again. Finally the boat caught up with Steve, and the three of them flipped it over, bailed, and rowed onward.

After 36 hours, 38 minutes, and 29 seconds, Kenton, Rudi, and Steve completed the 277 miles of the Colorado through the Grand Canyon. They were fined $500 for their trouble, but it was an adventure that will probably never be had again for any price.

———

Robert Stanton and his men had more than their share of trouble. Eleven miles below Sockdolager, they were lining the *Marie* (the boat they had just repaired) down Horn Creek Rapid when she overturned. As Stanton wrote: "When she righted, half full of water, she was shot to one side, struck against a rock where the whole force of the current was beating, sank in the heaviest part of the rapid, and came up in pieces about the size of tooth picks—our five days' labor and our boat all gone together!"

With eleven men left and only two boats, Stanton asked his group to jettison everything that wasn't absolutely necessary. They would press on . . . but without one of the most valuable crewmen. The *Marie* debacle, along with the gold stories he was hearing from prospectors, made Harry McDonald decide to hike out despite heavy snow. Though McDonald was one of the most skilled men on the expedition, Stanton did not hold him to his contract. (The two remained friends, and they would work together again in later years.)

Meanwhile, Stanton continued his transformation from engineer to photographer. He, John Hislop, and Elmer Kane made the hard climb to the top of the Canyon with a camera, some biscuits, and bacon; thinking they were headed for the snowy rim, they brought no water. But they ended up on the Tower of Ra, which was far from the rim and snowless. They slept by their fire without water or blankets. Stanton's rhapsodic description of the morning, the sunrise, and the Grand Canyon as seen from the summit of Ra occupies three pages in his book, and he seems to have taken more pictures here than in any other place. He'd come a long way since the beginning of the first expedition; he was no longer the ruthlessly practical engineer who insisted that photography was merely a useful tool for the survey.

Later in his life, in Washington, D.C., Stanton often gazed at the Thomas Moran painting of the Canyon that hangs in the Senate Gallery—a study from Point Sublime, which is quite near the Tower of Ra. "To me," he wrote,

> Moran's painting—grand as it is in outline, wonderfully beautiful as it is in detail and color—is a disappointment. . . . Even with the artistic life like painting of the storm, it does not move. It is quiet. It is still. The Grand Canyon is never still, it is never quiet. It is a living, moving being, ever changing in form and color. Out of unseen depths its pinnacles and towers suddenly spring into view. . . . How can such a shifting, animated glory be caught and held on a canvas? Much less, how can such life and color be represented in the simple black and white of a silver print?

Robert Stanton made 1,600 pages of notes, and he was responsible for 1,600 of the 2,200 negatives the expedition produced. Robert Webb, author of a book retracing Stanton's steps, believes that the engineer/photographer learned to love the Grand Canyon after taking the time to look at it through a lens. Stanton's affection for the place is reflected in those images, some of the best early photographs of the Canyon.

Those pictures did not come easily, however. The trek up Ra was tough, and the three men chose a different route back down, hoping it would be less trying. No luck. Kane and Hislop had to help the less agile Stanton down one drop-off by using camera straps and a limb from a dead tree. After thirty hours without

water, they found a little pool in Crystal Creek and made coffee.

By March 1 Stanton's men were worn out and hungry. Their diet was monotonous: graham mush for breakfast, fried mush for lunch, mush hash for supper. They stopped at what they thought was Diamond Creek, where it would be possible to hike out for supplies, but they couldn't locate the road to Peach Springs that their map had promised. They crowded back onto the boats and continued. Five miles below, Stanton stopped to examine a rapid and realized that *this* was Diamond Creek. The men rejoiced by tossing their hats; one, upon finding a footprint made by a woman's boot, kissed the sand.

A couple of footnotes to this voyage: ironically, after two Colorado River expeditions and a torturous trek across frontier Alaska, John Hislop died in a streetcar accident. F. M. Brown's railroad was, of course, never built.

— ◆ ◆ —

The next serious attempt at photography in the Canyon came on the sixth successful run of the Colorado, in 1908. Charles Russell and Edwin Monett made it despite losing one of their boats along the way. Russell considered taking pictures a way to capitalize on the publicity surrounding their jaunt, but he got only a few poor negatives. He tried several more trips down the Colorado, each of which ended in disaster. One of his boats, the *Ross Wheeler,* is still in the Canyon, chained to a boulder high above the beach at mile 107, where he quit in disgust and walked out on his last doomed expedition. The unlucky Russell ended up in a mental institution.

A wealthy industrialist named Julius Stone was the first to take the voyage for pure pleasure, in 1909. Because he thought the Colorado River was known and appreciated by too few people, he brought along a photographer, his brother-in-law—Raymond Cogswell. They took two thousand images during their trip, five hundred in the Grand Canyon. Cogswell intended to tint his prints later, so he took copious notes about the colors of the Canyon; those notes often hinted at the photographer's sadness that he couldn't capture everything on black-and-white film.

What got the Stone party through was the skill and grit of Nathaniel Galloway, a hunter, trapper, boatbuilder, and the leader of the fourth successful voyage down the river. Stone had met and become hunting buddies with Than Galloway while visiting his mining operation at Glen Canyon, where Galloway worked. (Coincidentally, the mine was managed by none other than Robert Brewster Stanton; it seems as if boatmen stick together.)

Galloway supervised the construction, in Detroit, of four flat-bottomed craft—sixteen-foot boats that weighed only 243 pounds apiece. The group consisted of five men, and there were only four boats. Cogswell (whom Stone did not particularly like) took advantage of this discrepancy and his status as photographer to evade rowing and camp duties. (Perhaps Stone should have hired Emery Kolb, the South Rim photographer, in Cogswell's place. Kolb had applied for the job.) The remaining members of the expedition were C. C. Sharp and Seymour Sylvester Dubendorff. Sharp quit

before the Grand Canyon, and his boat was abandoned; but Dubendorff, a handyman at the Vernal, Utah, newspaper, turned out to be a terrific boatman.

In Stone's book about the trip, he writes about Dubendorff's likable stubbornness:

> In the meantime Dubendorff, who so suddenly decided to run this one without a boat, and succeeded, has crawled out about three hundred yards below where the spill occurred. He comes down to help us. His head is pretty badly cut and with the blood streaming down his face he surely looks unhandsome. Still, his first words are, "I'd like to try that again. I know I can run it!" He is as gritty as a flapjack rolled in sand.

The Birdeye expedition of 1923 would name this rapid "Dubendorff."

Galloway is credited with the innovation of entering rapids stern first, which allowed him to see oncoming rocks and to use a backward oar stroke to hold down his speed. When the voyage was over, "Dubie" had high praise for Galloway's idea: "This trip goes to prove the efficiency of Mr. Galloway's method of running fast water, which has been much disputed." Galloway was the first to complete two trips through the Canyon, and would have made a third, Stone's planned 1910 expedition, had it not been canceled after S. S. Dubendorff died of Rocky Mountain spotted fever.

As usual, the Stone group suffered from a scarcity of food, particularly when a badly needed fifty-dollar food cache was not left at Lee's Ferry as it was supposed to be. Julius Stone lost thirty-five pounds along the way.

The Kolb brothers, Ellsworth and Emery, met and befriended Stone when he hiked up to the South Rim. In 1912, using boats adapted from the blueprints for Galloway's flat-bottomed skiffs, they ran all the way from Green River to Needles, California. Forty-three years after Powell had done it, the Kolb brothers became only the twenty-sixth and twenty-seventh to complete the voyage through the Canyon.

The Kolbs were the first to make significant commercial use of their photographs. They were far less interested in scientific aspects of the Canyon than in fame, picture sales, and adventure. Both were photographers by trade, and their studio was a South Rim fixture from 1904 until Emery's death in 1976. They were remarkably prolific: the Kolb collection at Northern Arizona University's Cline Library contains a quarter of a million negatives. Most of these are of tourists starting down the Bright Angel Trail on mules. The Kolbs—especially Emery, who eventually bought out Ellsworth—made a photo of every person who took a ride; these mule train photos originally sold for seventy-five cents. If my dad had only relented, our picture would be in the Kolb Collection along with those of Teddy Roosevelt, William Jennings Bryan, John Muir, and many others.

The brothers' studio had no water, and developing pictures at the South Rim was rigorous work. After the mule train had passed, one of the Kolbs would jog down to Indian Gardens, where

they had outfitted a darkroom by the spring. He would develop the film, make proofs, then hurry back to show them to the returning tourists. Once Emery made this hike—four-and-a-half miles, with a 3,200-foot vertical drop—three times in one day.

The Kolbs were tenacious little men. Besides their 1,200-mile trip along the Green and Colorado rivers and their daily film-developing run, they also hiked the farthest reaches of the Canyon. When in 1917 both Army Aviation and the Signal Corps rejected Ellsworth's application for service because he was forty-one, he decided to prove to them that he wasn't over the hill. He trained for three days, then finished 378th out of 1,200 in a marathon in New York City.

Early in their careers, the Kolbs bought a lot of equipment. They relied primarily on view cameras, but they dabbled with many others, among them panorama, stereo, folding, and amateur box cameras. Later in life Emery preferred to maintain old gear, and he stopped buying new cameras. Just ten years after motion picture cameras became available—and most likely with their river run in mind—the Kolbs purchased one. In his master's thesis on the Kolbs' collection of equipment, Christopher Everett speculates that they bought a Williamson Type 4 35mm because it was wooden, and would not sink as fast as a model made of metal. On their 1911–1912 trip, they used a hand-cranked Pathe-Bray camera.

The Kolbs were the first to make a movie about a river expedition; it showed continuously at the South Rim studio for sixty-one years. Their trip took 101 days, and it was full of excitement. Altogether, they flipped five times in the Grand Canyon, both doing so in the Waltenberg Rapid on Christmas Eve of 1911. My favorite Kolb photograph (*this page*) was taken after this accident. It shows Emery's head poking through a gaping hole in the hull of his boat. The Kolb brothers had a flair for showmanship, and they fully realized the sales value of risk and adventure. Many of the photographs in their collection show them in conspicuous danger. One is of Emery, ostensibly in pursuit of a unique photo, dangling over a scarp from a rope held by his brother. I suspect that the unprecedented photo they were in search of was none other than this one.

Both Ellsworth and Emery became respected river consultants; for thirty years after their trip, river-runners called on the Kolbs' expertise. In 1923, and after sensitive negotiation, the Claude Birdeye Colorado River Survey expedition hired Emery as its lead boatman. Birdeye and Emery haggled intensely about the circumstances under which Emery could take photographs and movies. At first Birdeye said that if Kolb could not concentrate solely on his duties as lead boatman, he'd find someone who could. But he needed someone with experience, so eventually he acquiesced to Emery's demands. The government even supplied Emery with film, under the condition that he give them one print of each shot he took.

Emery was the feistier Kolb, and if the fate of the studio had been left up to his less confrontational brother, the Park Service or the Fred Harvey Company would probably have run them off the South Rim. Correspondence shows the crotchety Emery in unend-

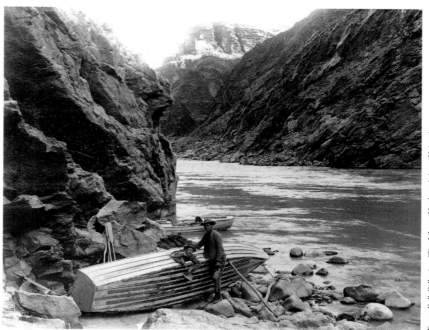

Emery Kolb Collection, Cline Library, Northern Arizona University

ing battles with all comers over lecture, studio, and/or photo rights.

Lewis R. Freeman, the first to bring a typewriter down the Colorado, was a boatman on the Birdeye survey. He and E. C. LaRue, a hydraulic engineer, were in charge of photography. Predictably, Emery got along with neither. But despite the personality conflicts, the Birdeye expedition was a great scientific success; given generous funding, a well-organized supply system, and ample time, they were able to amass more information than any previous group.

But it wasn't all hard work. Once they had conquered their fear of the rapids, the Birdeye expedition had fun. Frank Dodge often rode the bow while standing and holding a rope; others would light cigarettes or pipes to see who could weather a rapid while keeping a smoke lit.

The conditions were not easy, of course, and the Birdeye expedition had its share of flips, weather woes, and the like. The water level was above 30,000 cfs at the start, and after a series of heavy rains it soared to 98,000 cfs. When the river crested, the expedition was camped above Lava Falls Rapid. According to Emery Kolb, "There were cows and pigs, horses, everything of the sorts going by us on that flood." The high water made the Colorado extremely muddy, which prompted Lewis Freeman to write, in his 1924 *National Geographic* article about the trip, that the river "was red with mud at its clearest; but it was a clean sort of mud, as mud goes, and came off freely under vigorous toweling." It was 110 degrees at Lee's Ferry, where the men, in search of relief, made numerous plunges into the silty, turbid water.

Another of my favorite Canyon pictures was taken by Freeman in Kanab Creek. The picture (*next page*) shows a crew member bathing in the clearer waters of this side canyon. Besides telling a story about life on a river trip, I like this photo because of its technical accomplishment, its great contrast and pleasing composition. On the strength of that eye for composition, Freeman ranks with John Hillers among my favorite early Canyon photographers.

Freeman's sixty-page piece in *National Geographic* contained

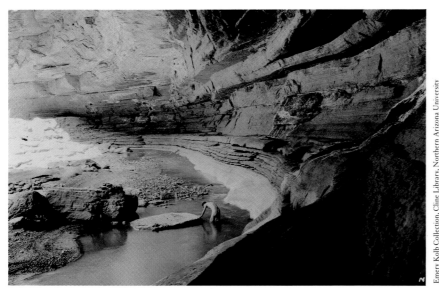

sixty-four photographs, of which only nine were by Emery Kolb. This upset Emery, of course, but among his nine is a classic: it shows the cook, Felix, flanked by his helpers, Leigh Lint and H. E. Blake, and holding two crossed butcher knives.

———— ✦ ————

What Raechel Running excels at is people pictures. Raechel rows baggage boats for various river companies and cooks for science trips. I went to the eccentric studio she shares with her father, John Running, a commercial shooter with rowing and Canyon photography experience, to ask Raechel about her very fine portraits of river-runners. She told me she got the idea while camped at National Canyon for thirty-nine days when she was serving as cook for a research trip. Between meals she thought she could be productive by shooting portraits of passing boatmen and -women. National is the ideal spot for such an enterprise: it's a big camp where two or three river trips can park for the night, and it's just before Lava Falls Rapid, so people arrive there with a good deal of nervous energy, excitement, and high spirits.

Raechel hung a sign at Lee's Ferry asking boatmen to stop at National to have their portraits taken. The Park Service removed the sign, saying she couldn't be carrying on this free-lance work while an employee of a government concession. She sent her father a letter asking his advice, and he returned a pack of film and a National Geographic book, *Stay the Moment*. Her time between meals, he suggested, was hers; she could do what she wanted with it.

John Running also advised his daughter to drag a piece of canvas through Kanab Creek for use as an outdoor studio backdrop. She did, and it turned out marvelously: chock-full of Canyon textures and colors. Raechel saw and photographed it all: private trips, commercial, old, young, rich kids, hippies, and scientists. She told me that she especially enjoys watching people be transformed by the river. They leave the ramp at Lee's Ferry with clean clothes and anticipation, and after six to fourteen days on the rapids they develop the river-worn patina of the veteran.

Raechel Running has never taken a Colorado River picture without a person in it. She believes that a camera, properly used, should be a tool to help people learn to be more considerate and respectful of one another. Raechel should do well. Her studio portraits are exciting, and she finishes them off, in excellent style, with hand-painted touches. In life she'll do well, too; her rich experiences have given her the ammunition to do good things. Raechel was in the Virgin Islands during the devastation of Hurricane Hugo. She told me that some of her father's friends kept asking whether he'd heard from her. "No," he told them, unworried, "the phones are out, but she'll be OK; she's been on the river."

My good friend Andy Hutchinson has also had a wealth of experience, but he's managed to keep more kid in himself than anyone I know. Andy is always leading hikes, astounding the passengers with his knowledge of the Canyon and his ability to have fun on the water, in the water, or anywhere else. He always makes a point of tossing pebbles into the wormholed limestone at National Canyon; a hit means a good run in Lava. Horseshoes, jumping off waterfalls, Frisbee, manufacturing thunder at Matkatamiba with a rolled flat rock, playing pots and pans at camp or banjo while drifting through Marble Canyon: all these are part of his repertoire.

Andy takes only a few photographs per trip, using a waterproof Nikon that's so river-beaten and dirty that I've begged him to let me clean it. He knows the Canyon, knows boats, and is one of the most confident and tireless dorymen I've seen. Andy will joke with the rest about flipping pancakes before Lava, but if he has genuine anxieties they're well hidden.

One of my favorite Andy stories took place at the Green Room, under Beaver Falls up Havasu Creek. This gorgeous canyon is part of the Havasupai Indian reservation. In the space of eight miles, from the village of Supai to the Colorado, Havasu Creek drops 1,410 feet. Its cliffs of Travertine Limestone form four large waterfalls and numerous cascades along its course, making this one of the Canyon's most dazzling hikes. At 196 feet, Mooney falls is the tallest on the creek. It was named, the story goes, after a prospector who fell to his death while roping down the travertine. I've been told that the Havasupai took the name quite literally at the time, and thought it bizarre and a bit funny: "Mooney falls."

Beaver Falls are not near as high as Mooney, but their double pour makes them just as beautiful. Beneath the east side is an underwater tunnel leading to a small chamber with an air pocket. This chamber is known as the Green Room. Sharp travertine protrusions drip down into it as stalactites.

My trip into the Green Room with Andy Hutchinson was, after a few hairy moments, hilarious. (A word of warning, though: the Green Room is cold, claustrophobic, and dangerous, and our hilarity had a good bit of nervousness and relief in it. Cave diving is not for everybody.) Andy had taken Mike Denoyer in during a June dory trip, but Mike—who after much coaching from me in still photography had just become interested in video—had not brought his camera with him. Mike and Andy planned to return in

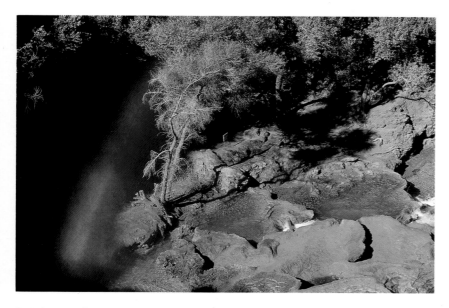

Rainbow in the mist over Havasu Falls, one of the falls on Havasu Creek.

September, and I came along. For the six weeks before our trip, Mike called me what seemed like six jillion times to discuss our video-camera strategy. In retrospect I should have left it up to him; I made it too complicated. It never occurred to me to worry about the practical difficulties of getting into the cave. I counted on my scuba skills to get me in without trouble, so I was more interested in teaching Mike how to get a good shot that told a story. I've seen too much bad video, and I'll watch amateur footage these days only if I have control of the fast-forward.

The plan was for Andy and Derald Stewart to enter the room first. Then I would go to the bottom of the tube with two underwater lights, lock my legs onto a protuberance of limestone, and light the tunnel. Mike would swim by, filming, and then I'd follow him up with the lights, revealing Andy and Derald's faces. I had a two-pound cylinder called Spare Air, a safety canister carried by divemasters. It's supposed to be good for thirty breaths, more than enough for me to hang there to light the scene.

A good plan . . . but it immediately went awry. To get into the Green Room you jump off a five-foot ledge next to the spray, swim to the bottom (which is around six feet deep), and wriggle under a limestone ledge to keep out of the turbulence of the falls. Then you feel your way into the dark tunnel and swim up, being careful not to bump your head on sharp travertine. It's scary: even though I'm a certified cave diver, it gave me the willies. And well it should have. We were breaking every rule of cave diving.

Once inside, all you can see is a green glow at the bottom of that eight-foot tunnel. It's the sunlight reflecting off the sand under the falls. When the sun goes behind the Redwall cliffs, the glow goes with it: the Green Room becomes the Black Room.

Anyway, Andy took us in on a trial run, and we made it easily. Mike and I went back to our packs to prepare the video gear while Andy tried, to no avail, to show a few of the passengers how to get in. Soon we were ready. Andy and Derald jumped and entered. I followed, chewing on the Spare Air mouthpiece and holding two

softball-sized spotlights, one in each hand. As soon as I hit the water, I realized I had a problem. In the turbulence it was necessary to have firm handholds, but my hands were occupied. I kicked for the tunnel as hard as I could. Using my head, back, elbows, and chest, I monkeyed my way in far enough to kick Derald, and he flushed out. I tried to get upside down to lock my legs. To this point I had been holding my breath, but now I took a draft of the Spare Air. It was a weak gulp. I took another labored one. After four shallow breaths, the canister was empty: I guess the big rapids—Hance, Sockdolager, Granite, Hermit, and Crystal—had taken a few breaths each. Before I knew it, the current had pushed me under the second pour-over, which spun me around like a mouse in a Maytag and spat me out so far and fast that I almost tumbled over the next cascade before I could make it to shore. This took some time, and when I staggered out none of the guys was in sight; they must be in.

I dropped the exhausted air cylinder, ran back to the entry, jumped in, and kicked directly for the tunnel, arriving completely out of breath and cold. But I wasn't as cold as Andy, who'd been in the Green Room five times on this trip, and for a lot of minutes. When I burst in, Andy's teeth were chattering madly. He said, giggling, "Where you been, knucklehead?"

The lens on Mike's camera was fogged over, but the audio worked fine, so we were able, afterward, to relive our echoey, gasping conversation. Punctuated by shivery and nervous laughter, it ended this way:

Derald: "What a cool place. This has probably never been filmed, huh?"

Andy, laughing: "For a reason."

All of us at once: "Let's get out of here."

<hr />

Horror stories about cameras—ruined, lost, swept away—are a dime a dozen in the Canyon. The river has eaten thousands. And even when the awestruck photographer succeeds in holding onto his or her camera, the Colorado treats it brutally. I try to get my students to maintain their equipment daily. With mud, sand, water, and wind to contend with, daily care is a necessity; one's hands are always dirty, and there's usually a film of sediment on the boats. Charley Craighead, who also teaches workshops, likes to give his students a scare. He asks if anyone wants a camera cleaned. After taking the volunteer's, he removes the lens and hands it back. Then, while the student is distracted, he picks up an old camera body he's stashed away and yells, "Oops, I dropped it!" The student hears the splash and sees his expensive outfit sinking. That's heart attack material.

Butch Schimpp, who now guides for Grand Canyon Expeditions, has taken a lot of photos here since 1976, so many that he says he doesn't bring his 35mm anymore, just a point-and-shoot camera to get shots of people. The one he used to bring, a Pentax, was bought with a special promotional deal: the store was offering a

lifetime cleaning policy for five dollars. They lost a load of money on Butch. Nine river trips each year will really trash a camera.

Every Canyon photographer has stories of camera woes; I have my share, too. Once, on the way through Waltenberg, the rapid that punched a two-foot hole in Emery Kolb's boat, my tripod fell off the food box into a crack. This crack between the box and the weenie tube is the flex point of a thirty-seven-foot S-rig, and the result was a snapped-off leg. With hand tools, Allen Gilberg and Derald Stewart bored, drilled, clamped, and screwed that leg back on. They did a good job, but I know everyone on the trip must have been sick to death of that tripod: it was my second mishap with it in just a few days.

A week earlier, we'd been at Nankoweap for lunch. A few of us wanted to get the view from the granaries in better light, so while five dories and the S-rig continued downriver to camp at Kwagunt Rapid, three of us hung back in one dory. We had a nice hike up Little Nankoweap Creek, then climbed to the granaries for the evening light. We had a peaceful afternoon enjoying one of the most beautiful views of the Canyon, and afterward we had a great twilight row down to camp. Kwagunt is one of the best places to get circumpolar star trails, so after dinner I started to set up my night shot. To my chagrin, the quick-release mount was missing. I knew immediately that I had left it at the granaries.

This was day three of a fourteen-day trip, and the tripod is useless without its quick-release. The only solution was to hike up to get it the next morning. Mike Denoyer told me to leave by 5:30 A.M. and to take Chuck Wales with me to make sure I didn't lollygag along, taking pictures. In fact, Mike tried to dissuade me from taking a camera at all. The trail is a four-mile roller coaster; you're always at a forty-five-degree angle and on small, ball-bearing-like pebbles.

We arrived to find that a Western River Adventures group had come in and camped after we left. One of their guides had found the missing piece, which was now on the kitchen table, next to a pile of hot western omelets. After breakfast we headed back, bloated. Two hours and seventeen minutes later, after a double-time hike through a drizzle, Chuck and I arrived at Kwagunt only to discover that the dories had left. We hopped on the motor rig and chased after them.

Another lost-camera story involves a Hopi legend. About four miles up the Little Colorado from its confluence with the Colorado is the Sipapu, a travertine dome with a hole in the top where a freshwater spring has a hidden pool. It's a sacred site to the Hopi, a man's place, and according to legend any woman who visits it can expect three bad things to happen.

Michael Geanious and his frequent companion Margaret Chipman were guiding a science trip. They were camped at the LCR while researchers were installing solar panels for a hydrology study. With free time on their hands, Michael and Margaret decided to hike up to the Sipapu. Margaret told me that she had heard of the legend, but because it was told to her by a non-Hopi,

she'd decided to go anyway. She went—respectfully—and thought the site was incredible.

The first bad thing happened as Tim Whitney and Teresa Yates pulled into Michael and Margaret's camp. They were on an AZRA deadhead to Phantom Ranch. As the hosts walked to the beach to greet their friends, a fifty-mile-per-hour gust of wind swept through the camp. Tim saw a tent take off and tumble toward the water; before anyone could chase it down, it was in the river, sinking. Tim fired up his thirty-five-foot motor rig. Teresa and Michael were stationed on the bow, and they were able to grab hold of the tent just before the rapids. Filled with one thousand gallons of water, the tent nearly pulled its rescuers in after it. This was a well-anchored tent, Michael said, ballasted with boulders on all four corners, and inside were their heavy river bags and a Nikon with its 50mm lens. It must have been some squall of wind. Margaret located the Nikon, which had tumbled out at the water's edge. It was soaked, and they had to throw it away, along with the ruined film inside . . . the film of their ill-fated hike to the Sipapu.

Later that evening the wind kicked up again and blew a heavy aluminum table into Margaret, breaking one of her ribs. That was number two. A few days later they were running Lava Falls when Michael got sideways and the motor swamped and died. A big wave knocked Margaret, the spare motor she was clutching, an empty gas tank, and an ice chest into the frothing rapid. Margaret swam through unhurt, the motor was saved because of the floating tank, and even the eggs in the ice chest came through unbroken. But it was enough to keep Margaret from violating the bans of Hopi legend again. She said the experience had made her "more spiritually aware."

———— ◆ ————

Tim Whitney, a boatman with Arizona River Runners for eleven years, tells his passengers as they leave Lee's Ferry, "This is not a tour, but still an expedition. Though we've been down many times before, we don't know what could be around the next bend." Tim knows the perilous unpredictability of the river all too well: he's had to rescue a woman flushed out of Havasu Creek and into the main channel during a flash flood. This story is well told by Lew Steiger in *There's This River,* a wonderful collection of boatman's tales edited by Crista Sadler.

Lew, a riverman since 1972, has seen a lot in the Grand Canyon, and he wants to preserve some of the tales of the people he's known. He and Brad Dimock and several others got a grant to do "The River-Runners Oral History Project." They are videotaping the stories of men like Harvey Butchart, who hiked 20,000 miles in the Canyon, and Bill Beers, who swam (along with John Daggett) the entire 280 miles of the Colorado.

Bob Webb knows how quickly and dramatically the Canyon can change. This hydrologist has been the principal investigator on the Debris Flow Project. On March 6, 1995, his group was camped just above Lava Falls when, at 1 A.M., they heard a rumble. Ac-

cording to Bob, "The sound was like a white-noise roar and lasted only three to four minutes." At dawn Bob and his crew hiked over a small hummock to see what had happened. In the space of a few minutes, this monster rapid had been permanently altered. Roughly 23,000 cubic meters of rock and earth had piled up fifteen feet above the previous stream bed.

Bob has worked on four books of rephotography, and I can't wait to see his next, *A Century of Environmental Change in the Grand Canyon.* Bob has scrupulously sought out the settings and angles of each of Stanton's 445 photographs and has made new shots; 47 of these "rephotographs" appear in the new book. Bob has taken great pains to record the locations in case some future expedition follows in his footsteps.

I have also enjoyed *The Canyon Revisited,* by Donald L. Baars, Rex C. Buchanan, and John R. Charlton. They tried to re-create the photographs from the Claude Birdeye expedition. About matching the photos, Rex Buchanan says, "Our view and the old photo sometimes match up precisely, everything clicks into place, and we know—know—that we're standing exactly where one of them [Kolb, Freeman, or LaRue] had stood. Matching the photos is at first frustrating, then thrilling, and last a little unsettling, almost as if the ghosts of those 1923 explorers are nodding when we finally get the location right."

I especially like their 1991 rephotograph of a humorous self-portrait taken by E. C. LaRue in 1923. LaRue took the original picture just below the Little Colorado River, in a crevice in the Tapeats Sandstone. Baars used Hatch boatman Billy Elwinger in the rephoto. In 1995 I did a version of the shot, but in my own style; Sally Wenner was my model. I managed to match the photograph, but I used a boatwoman and color film rather than a boatman and black-and-white.

Rephotographing my work and that of other late-twentieth-century photographers will be harder because we have such wide-ranging choices of lens and film formats. Just think of Bob Webb or Donald Baars trying to re-create one of my 16mm full-frame fisheye shots. I took one up National Canyon of a piece of Muav Limestone that resembled a face, and *I've* never been able to find the spot again.

But it's not the equipment that produces a great photograph. I try to impress this upon my students. "It's you," I tell them, "your brain, your clicker finger, and your emotional attachment to the Grand Canyon. Flow with the river, watch the walls, and listen to its moods—if you do these things, the photos will tell a tiny bit of the story of your visit."

Donald Baars has described one of the unique difficulties of Grand Canyon photography, one I've often noticed in my workshops. "As people go down the river," he says, "they become accustomed to the scenery and take fewer photographs. They become numb to the spectacular." One of the most important things to convey to students is that they shouldn't let themselves get complacent or overwhelmed; they need to take pictures all the way down the river, for most will never make this trip again.

E. C. LaRue's self-portrait taken on the 1923 Birdeye expedition.

Billy Ellwanger as photographed by John R. Charlton, 1991 Kansas Geological Survey Expedition.

The author's 1995 photograph of Sally Wenner.

The feeling that no picture can fully capture the beauty of what you're seeing is, of course, not restricted to the amateurs. Stanton felt that way, and Raymond Cogswell; all of us probably feel that way at one time or another. Bill Garrett, past editor of *National Geographic,* is a man who's spent his life around good photographs and photographers, and I've heard him say of the Canyon that it "is one place I know of you can't capture on film. The scale is just enormous."

Lizards and ravens are the most commonly encountered animals along the river. But for those with a keen eye and a ready clicker finger, there's much more wildlife to see. I've heard two stories recently that made me want to have been there. I was just two bends downstream when a student on an Evergreen College geology trip spotted a peregrine falcon carrying a raven. This is an unusual sight both because the peregrine is rare and because the raven is much larger than its usual prey. No one got a photograph, and I understand that the falcon didn't even get its meal. The student was so excited that he let out a spontaneous war whoop, and the peregrine dropped its catch. On another occasion Mike Denoyer saw a cougar drinking at the river's edge. Mike was rowing, and none of his passengers had a camera ready. The cougar, alarmed, bounded up the cliff.

My fondest memory of wildlife in action was on some Muav Limestone ledges in the Lower Canyon. We were drifting on an S-rig when we spotted a herd of bighorn sheep. It was September, the rutting season, so the rams were with the ewes. The sheep were bouncing down the ledges in their surefooted way. We eddied out across the river, and I set up my 600mm and my tripod. The eddy surge was rocking the boat, and the noon light was harsh, but this was a herd, a unique chance, so I was ready. Without warning, two of the rams met in a smashing head-butt; the echoing whack and my click occurred at the same instant.

I got another interesting shot on a sandbar below Crystal Rapid, where we found a rattlesnake swallowing a sparrow. I disturbed the feast momentarily for a photograph. With the bird in its mouth, the rattler was no threat to strike.

My only wildlife scare in the Canyon was minor, a temporary shock that came in part from being awakened from a sound sleep. It was 2 A.M., and I was at National Camp. Suddenly I was rattled awake; something

A look straight down into one of the pools at Elves Chasm.

crawled across my face. With sleepy eyes I got a glimpse of the creature, which appeared to be a wet and sick cat tangled up in a fishnet full of debris. I yelled to wake up my friend.

Though I was now sitting up, awake, I still thought something was crawling across my face. I was dizzy and disoriented, and after a few uncomfortable seconds, I realized that something was in my ear, buzzing around. I shook my head wildly, even stood up and danced, but I couldn't dislodge the insect. I asked for a flashlight, but we couldn't find one. Finally my friend held a butane lighter up to my ear and enticed the gnat to come out.

Now, restored to sanity, I could try to solve the mystery. I hunted up a flashlight and looked for the tracks. When I found ten freshly gnawed willow stumps behind my sleeping pad, I was able to figure it out. What I had felt on my face was a beaver paw, followed by a dragged eight-foot willow sapling. I wish I had a picture of that episode.

If you really want to know the Grand Canyon, take a river trip, preferably a long dory trip, or a multiday hike to the bottom. Savor each bend in the river. Keep your eyes open. Meditate in the glowing red light, and watch it change. Sing to the Canyon's walls. Sleep on its sand. Soak in the starlight. Awake with a grin. Yahoo in the rapids. You can never experience the whole, but you can enjoy each detail, angle, eddy, and rush. And you might want, too, to give thanks to the boatmen and photographers, without whom the Canyon might be a big lake with marinas and speedboats or, if F. M. Brown had been able to realize his dream, the setting for a railroad along the incomparably beautiful rivercourse of the Colorado. The Grand Canyon is timeless. A wilderness available to public view, it's a place for us to watch and let flow.

THE PHOTOGRAPHS

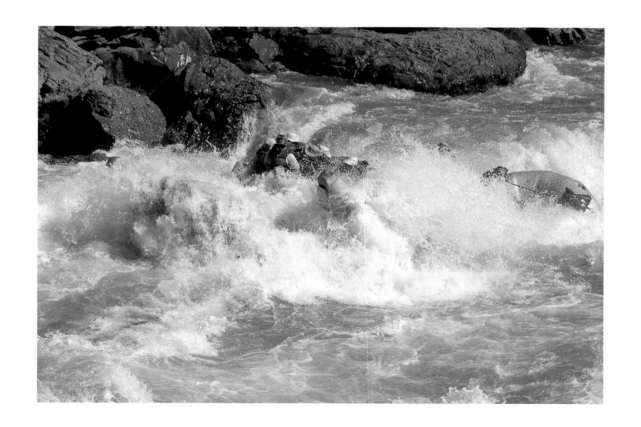

Tranquil Colorado River waters at Lee's Ferry (mile 0), where rafting trips begin. This is the last place an automobile can reach the river until mile 227.

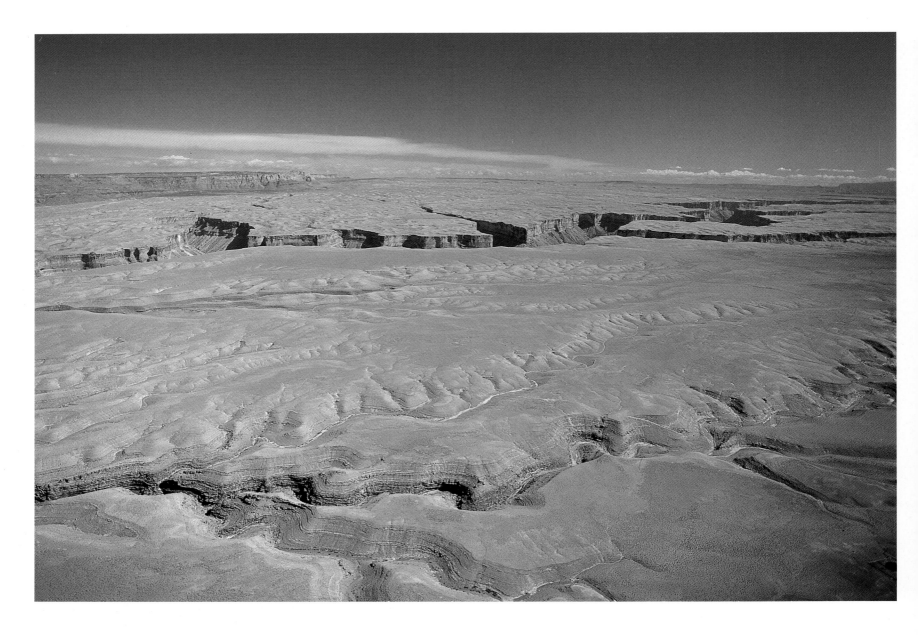

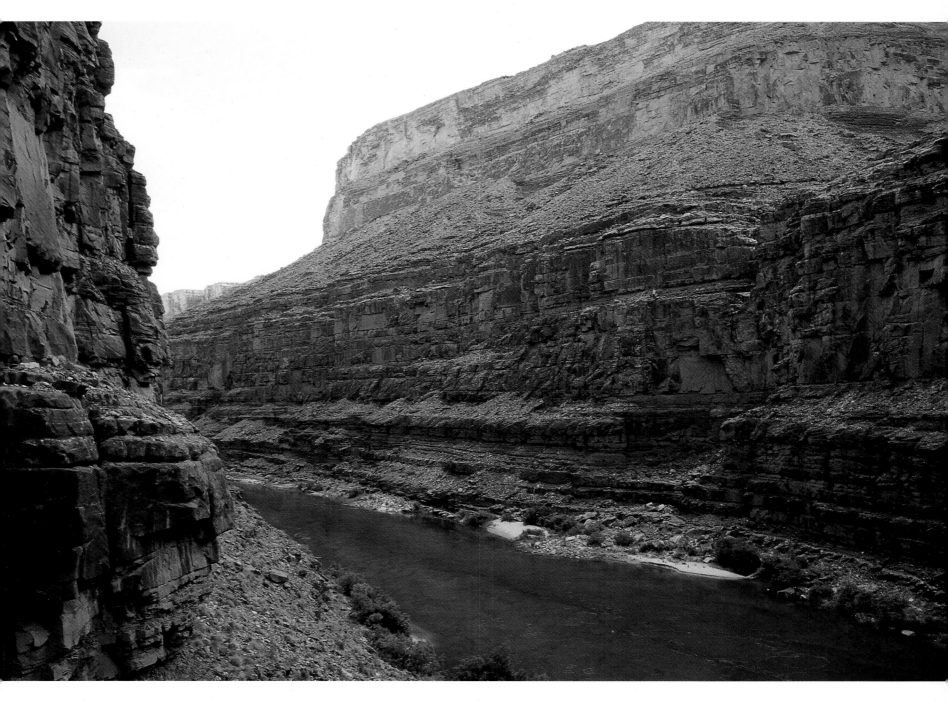

Top left: A view of Marble Canyon from the top of the Vermillion Cliffs. This canyon was named by John Wesley Powell, who thought its Redwall Limestone walls (*above*) looked like marble. *Bottom left:* Utah agave in bloom above Marble Canyon.

Overleaf: Nankoweap Creek was once home to a thriving Anasazi community. They grew corn on the delta and stored it in granaries at the base of the Redwall Limestone. There's a spectacular view of the river here.

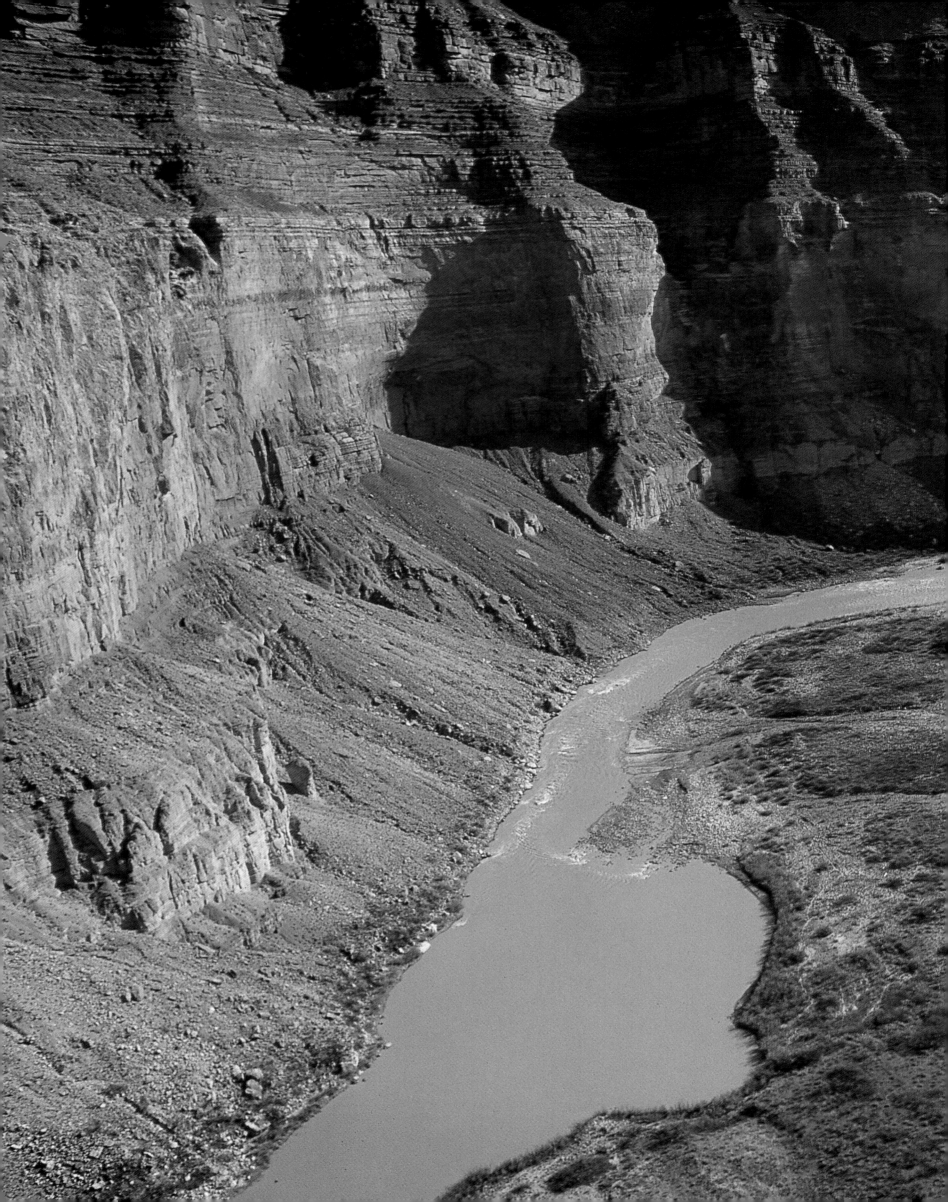

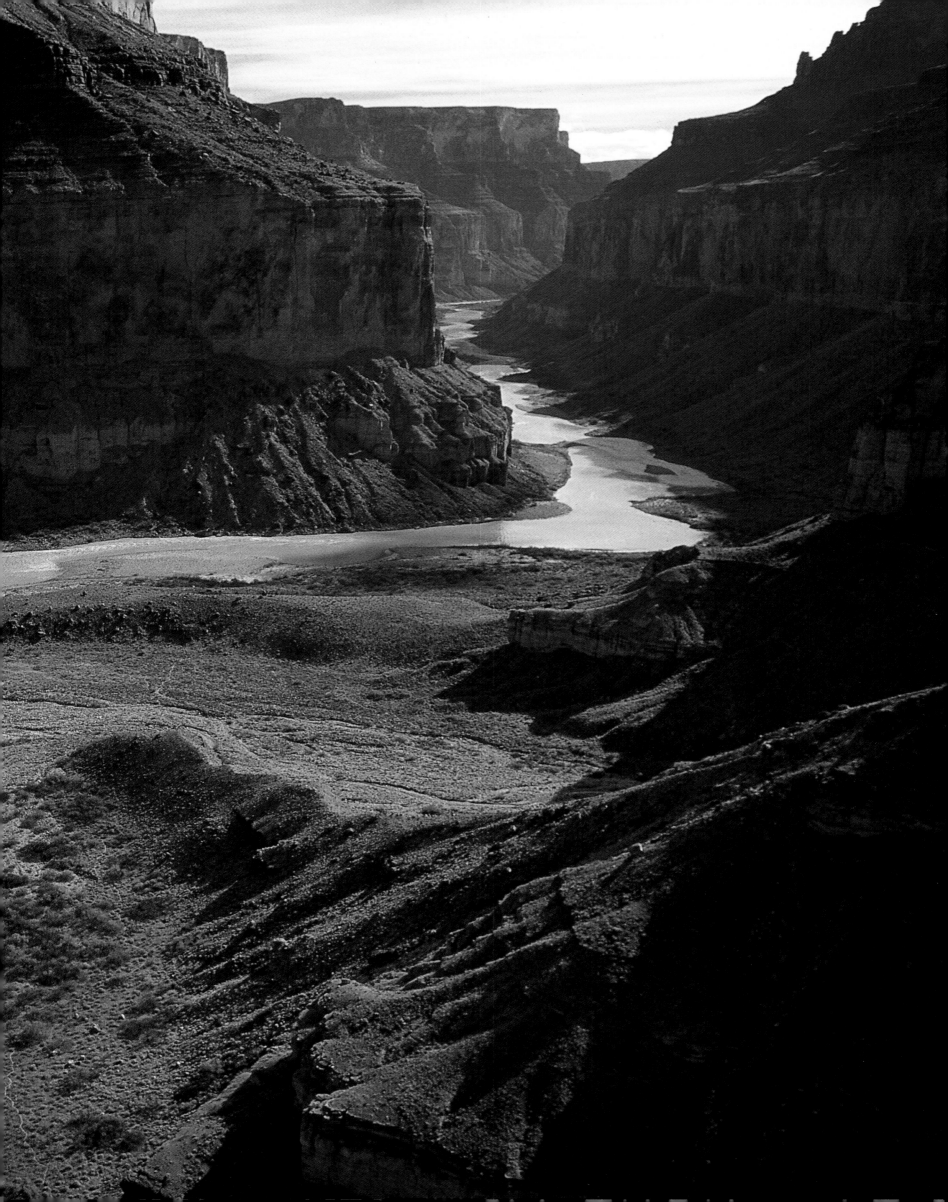

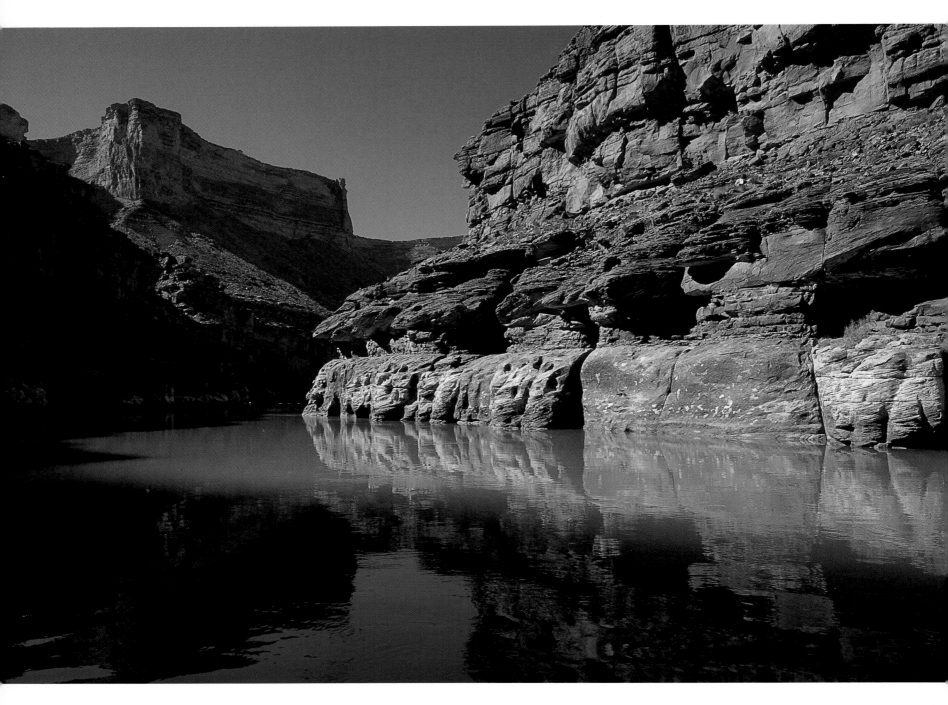

Supai Sandstone along the river, just below mile 11.

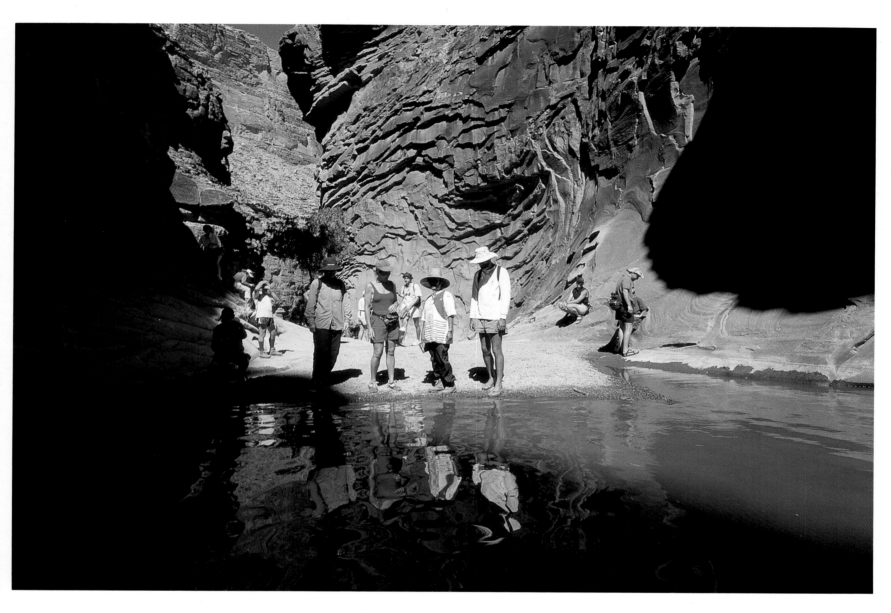

Supai Sandstone's sensuous layers present them-
selves to a group of hikers at North Canyon.

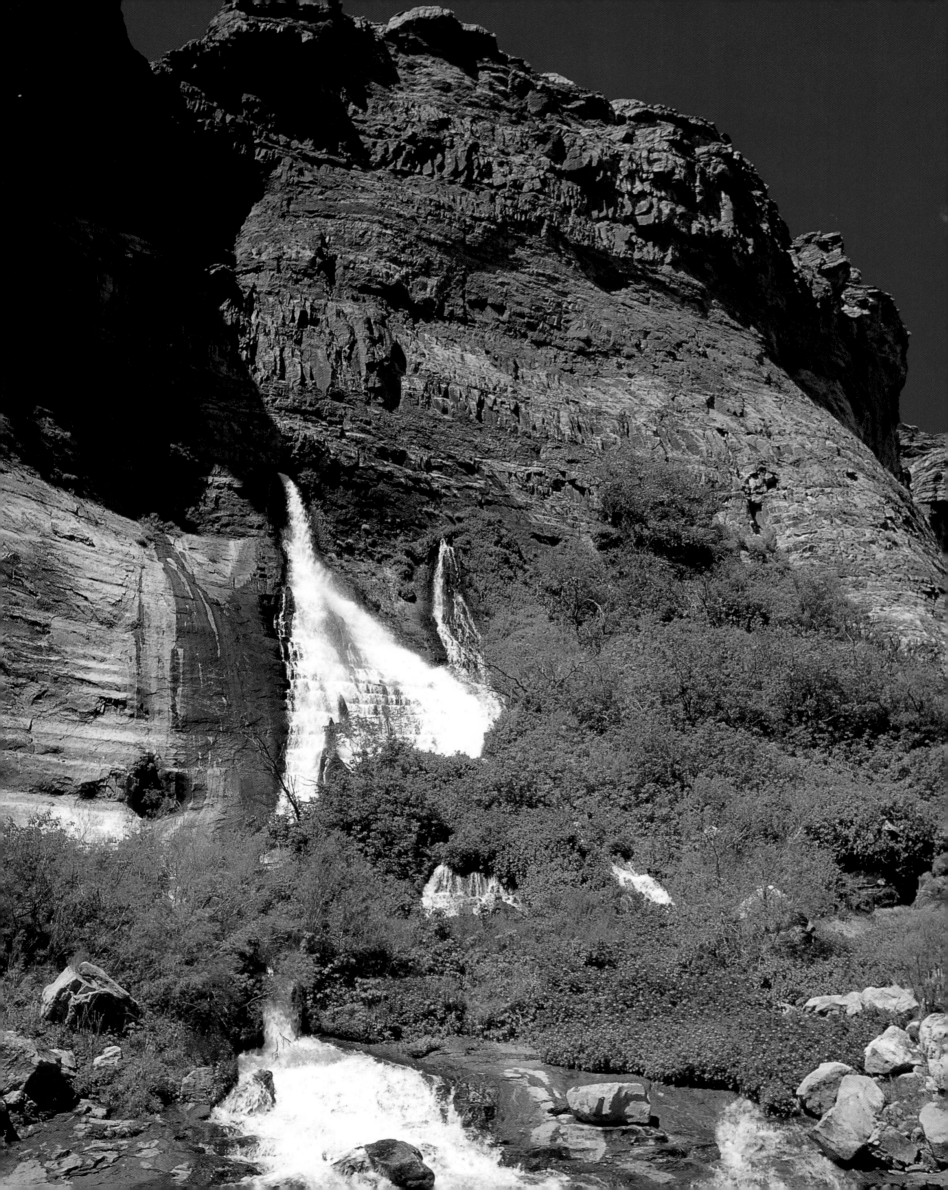

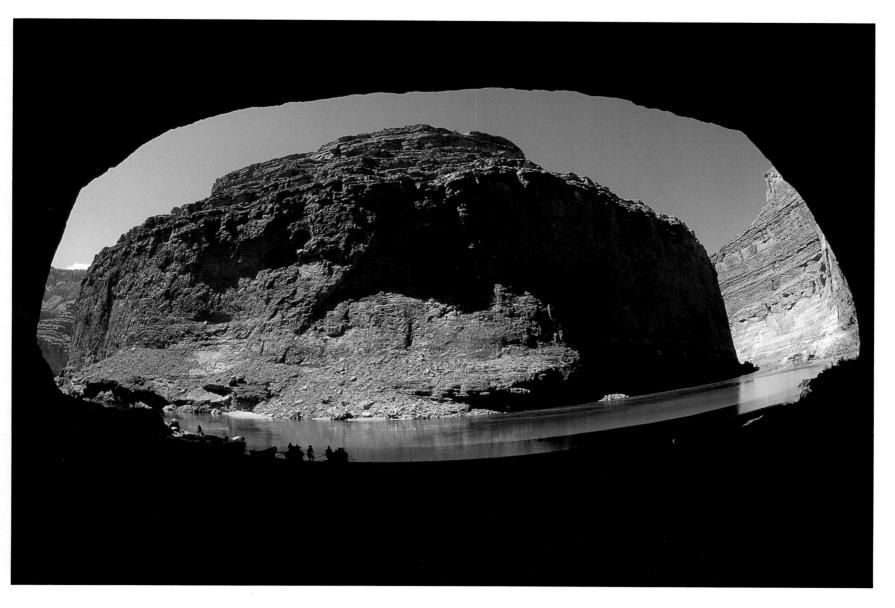

Two of the Upper Canyon's most spectacular sites.
Left: At mile 32 a spring pours out of the porous
Redwall Limestone to make an oasislike landscape
filled with ferns, flowers, shrubs, and mosses. J. W.
Powell named this place Vasey's Paradise, after
botanist George W. Vasey. *Above:* A mile down-
stream is Redwall Cavern, which Powell estimated
could hold fifty thousand people; a more realistic
guess would be five thousand.

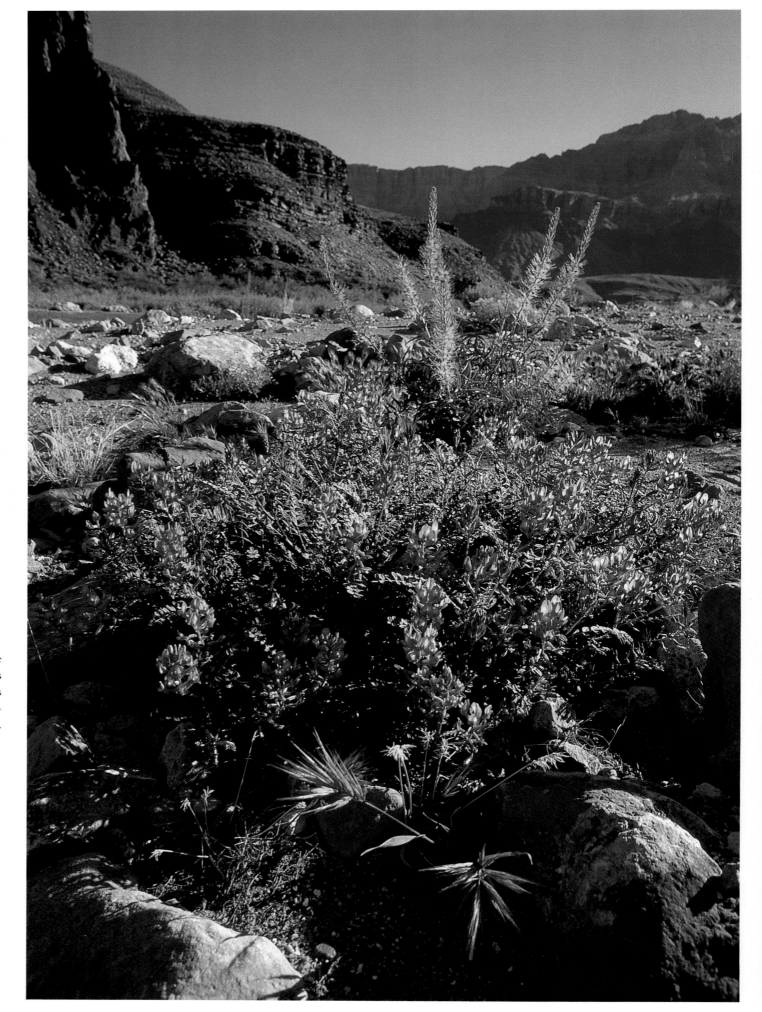

March and April are the showiest months for wildflowers such as lupine and prince's-plume.

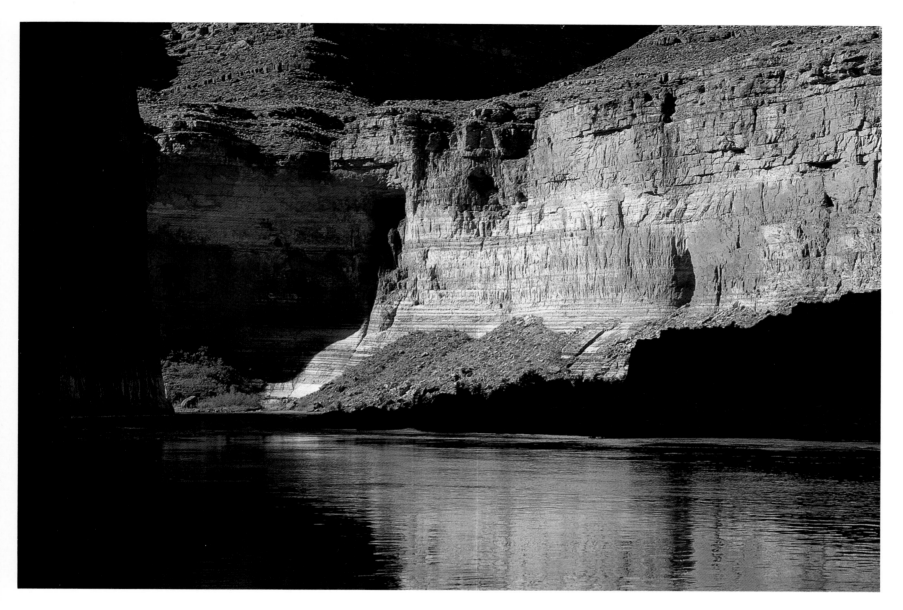

Redwall Limestone.

Overleaf: Soft morning light bathes the canyon walls near the spot where Peter Hansbrough and Henry Richards drowned on the Stanton-Brown expedition of 1889.

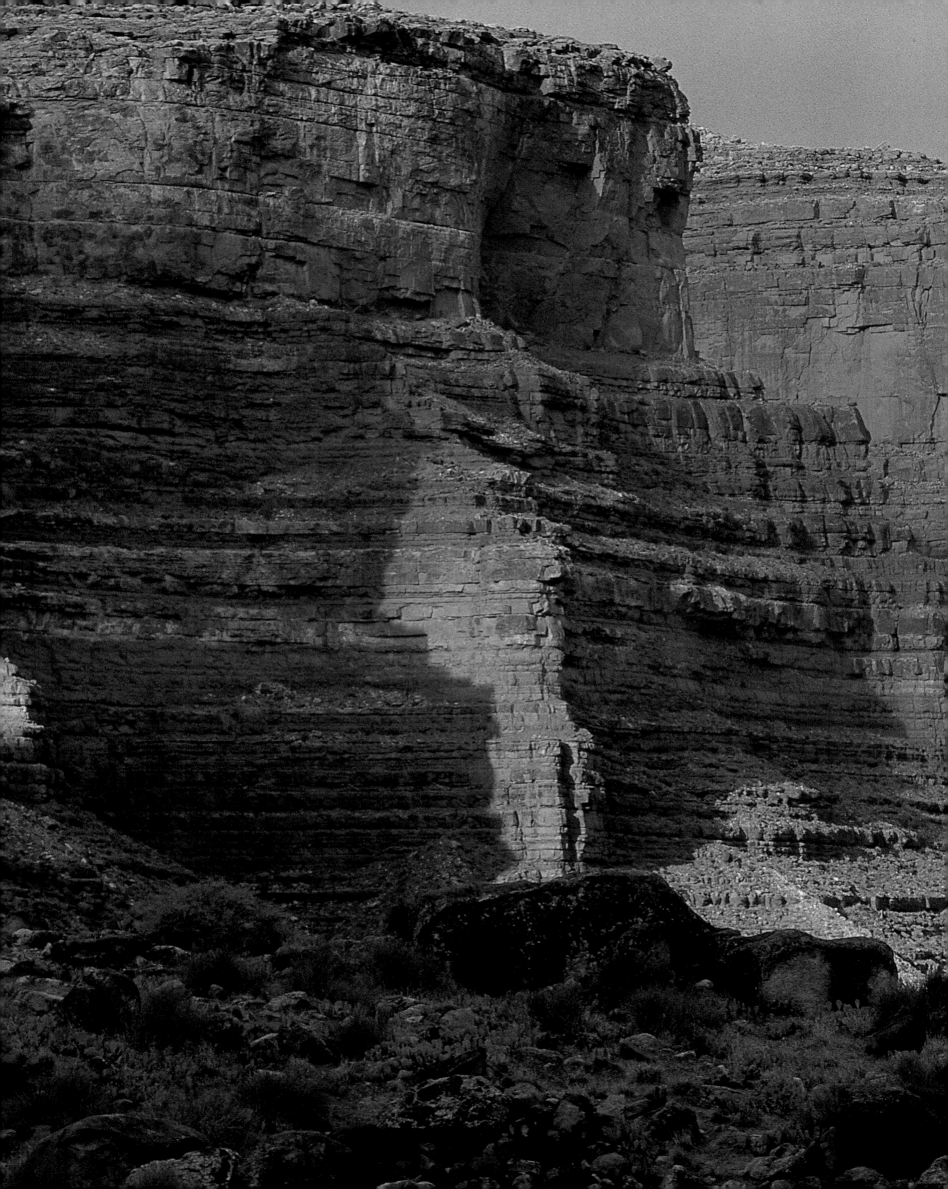

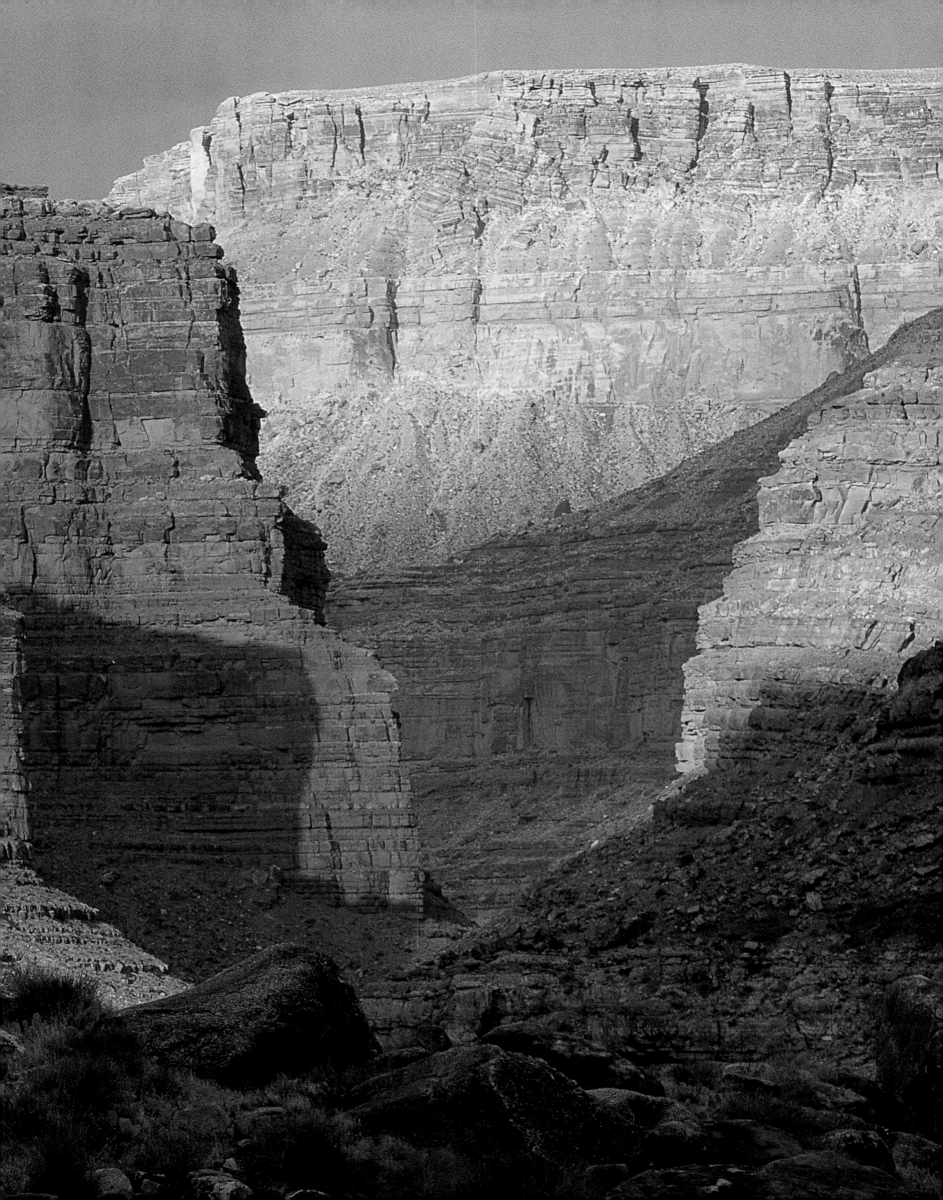

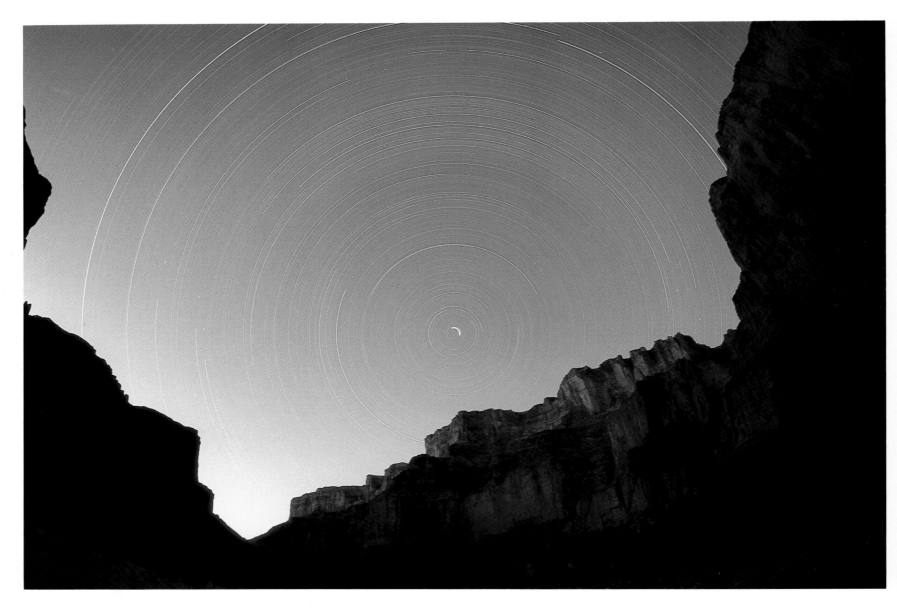

The river flows north to south through Marble
Canyon, making campsites like Kwagunt Rapid ex-
cellent places to photograph circumpolar star trails.

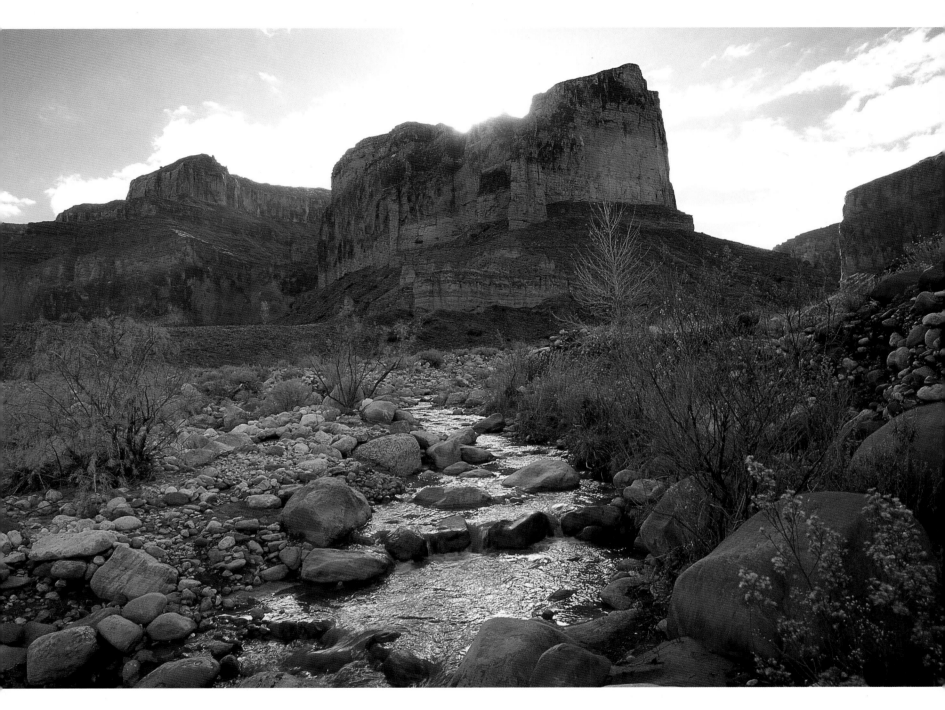

Rainbow trout spawn in Nankoweap Creek each
winter, attracting bald eagles to this part of the
Canyon.

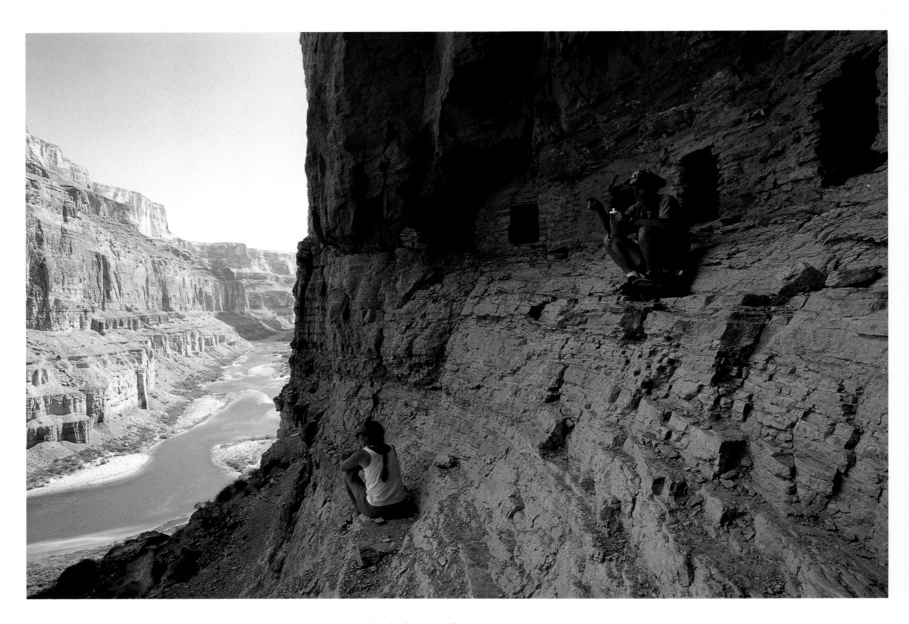

Anasazis built these small grain-storage rooms
about a thousand years ago. The steep hike to the
granaries affords a fine view.

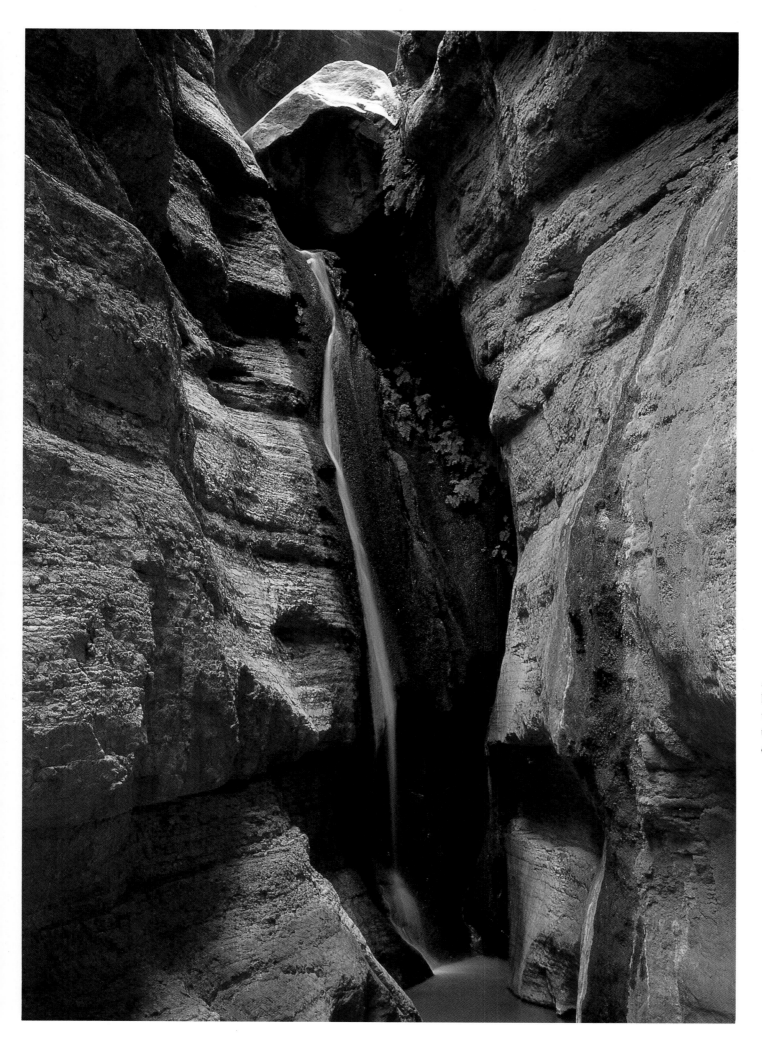

A grotto with a trickling waterfall is the reward at the end of a two-mile hike up Saddle Canyon.

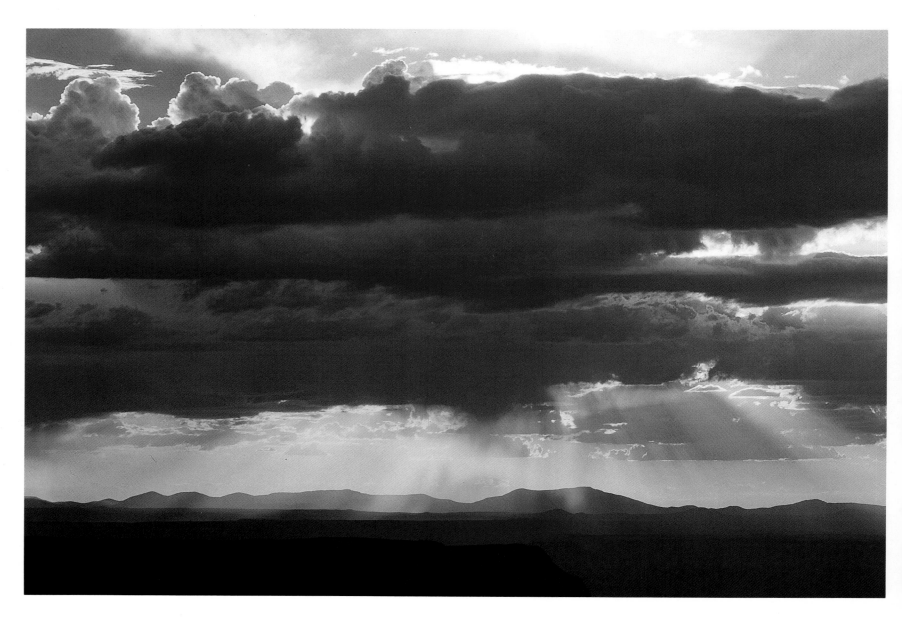

From the North Rim you're more likely to enjoy a
sunset than a view of the river one mile below.

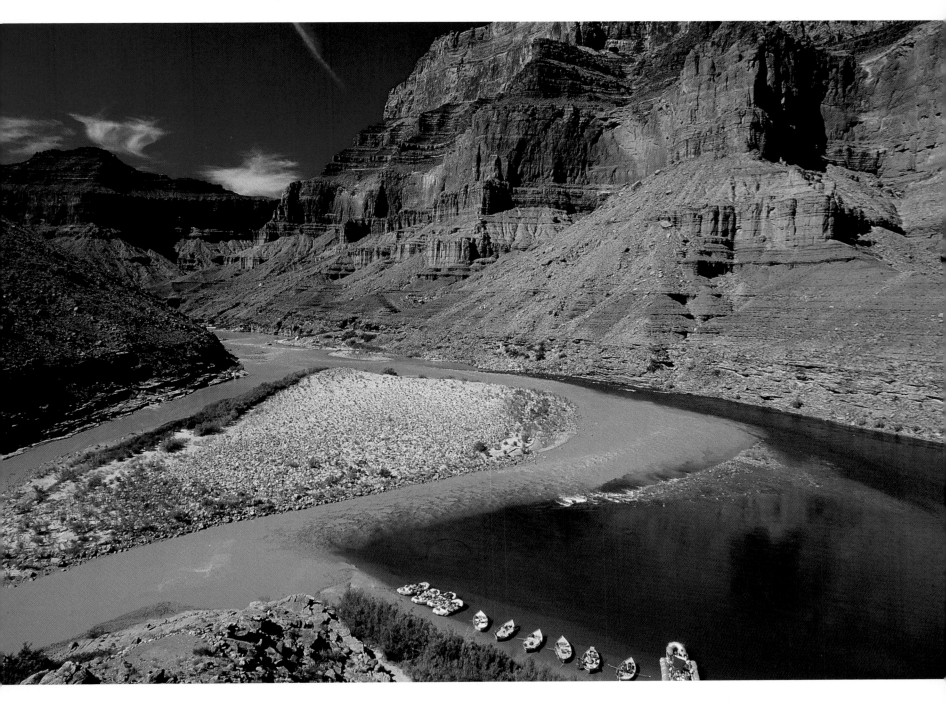

The junction of the Little Colorado and Colorado
Rivers at mile 61 marks the end of Marble Canyon.
The Little Colorado usually runs powdery blue, but
here it's swollen with runoff. The Colorado was a
ruddy, muddy red until the dam was built; now the
water below the dam is sediment-free, clear, and
green.

Overleaf: Marble Canyon at mile 51.

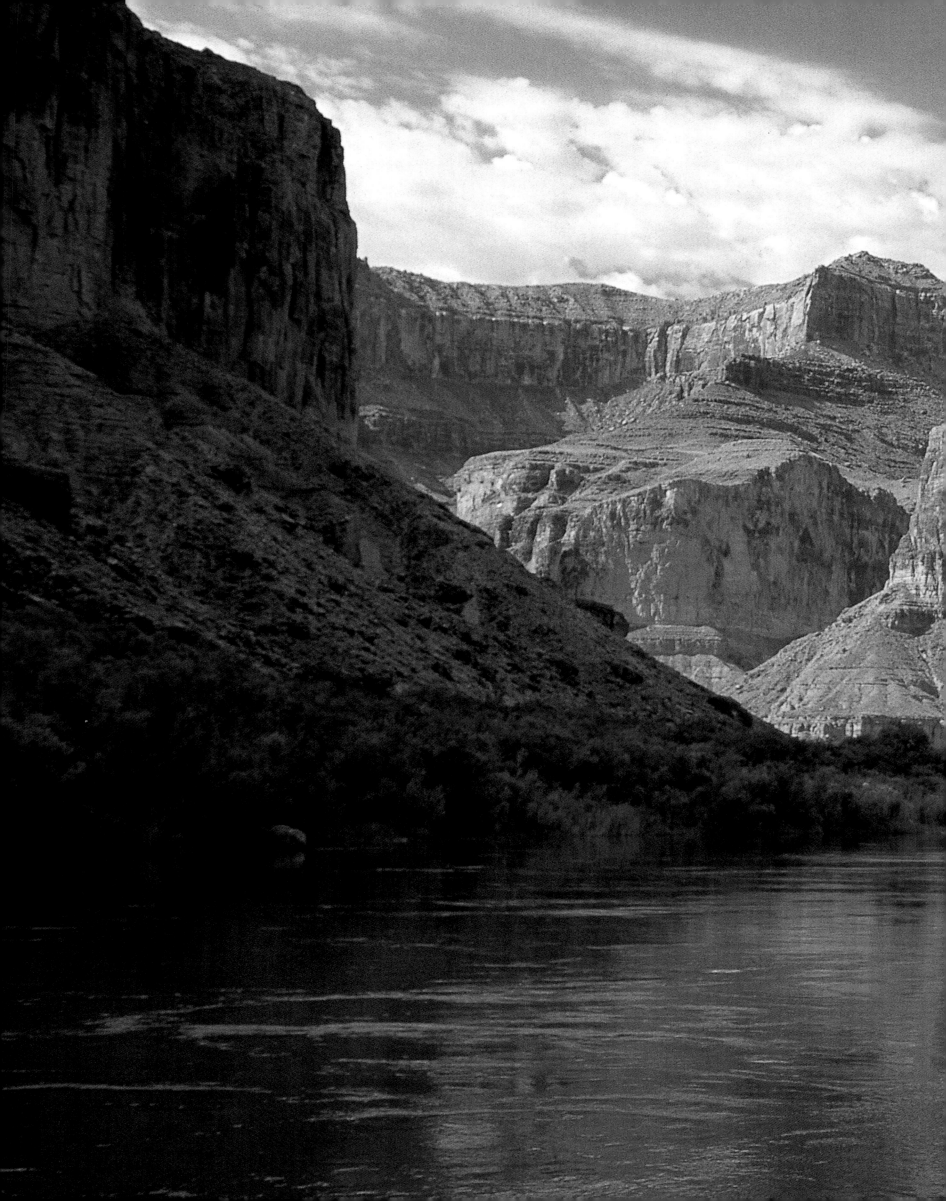

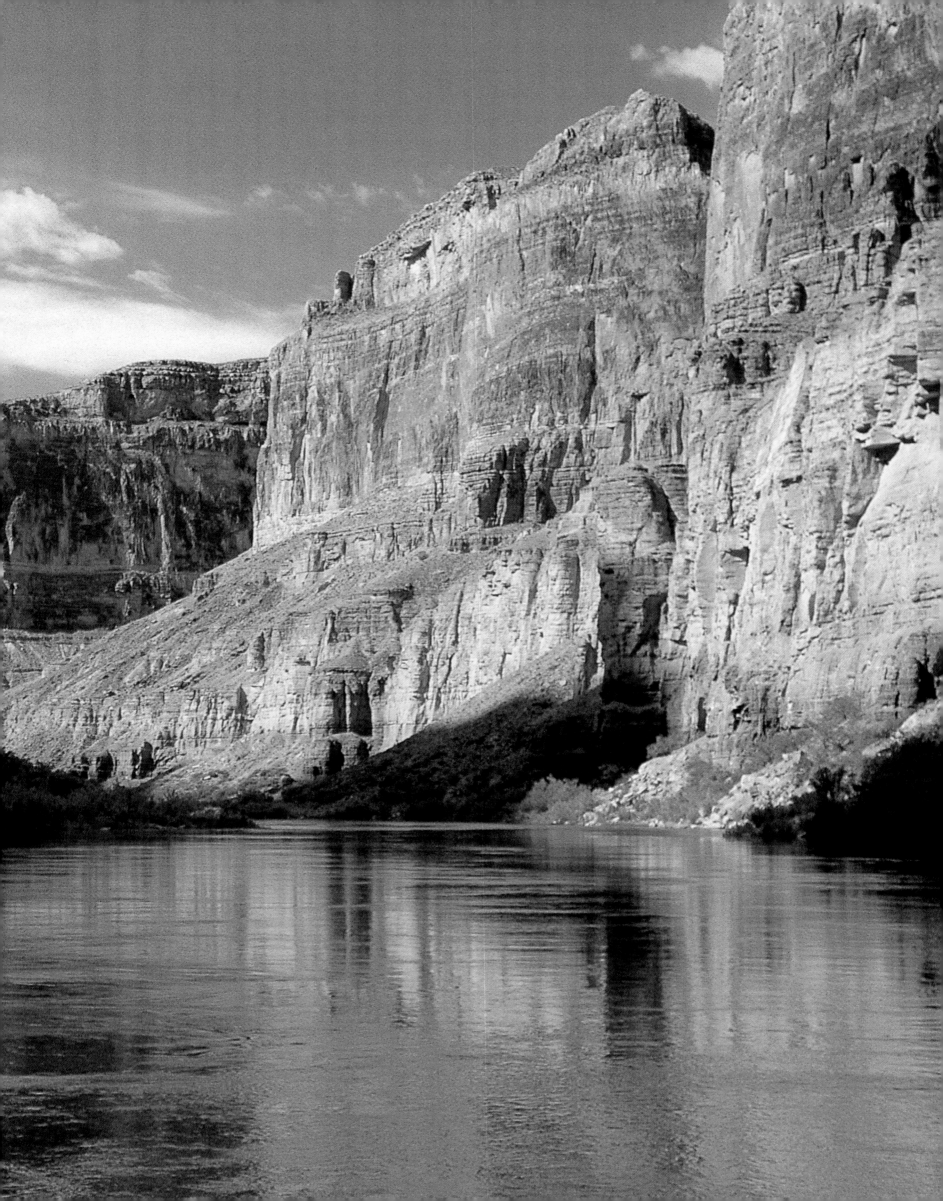

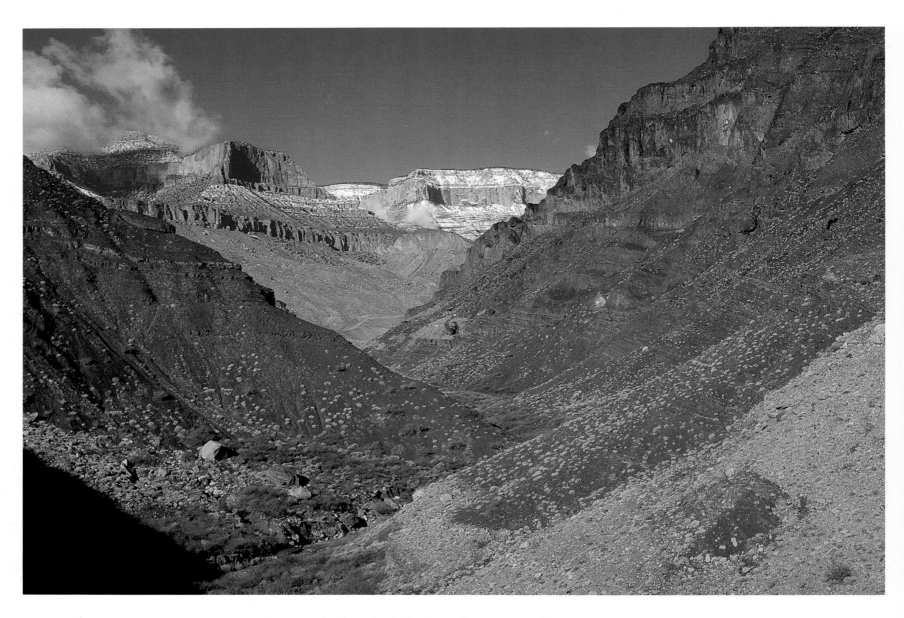

A winter day in the desert shows snow on the
North Rim as viewed from Lava Canyon.

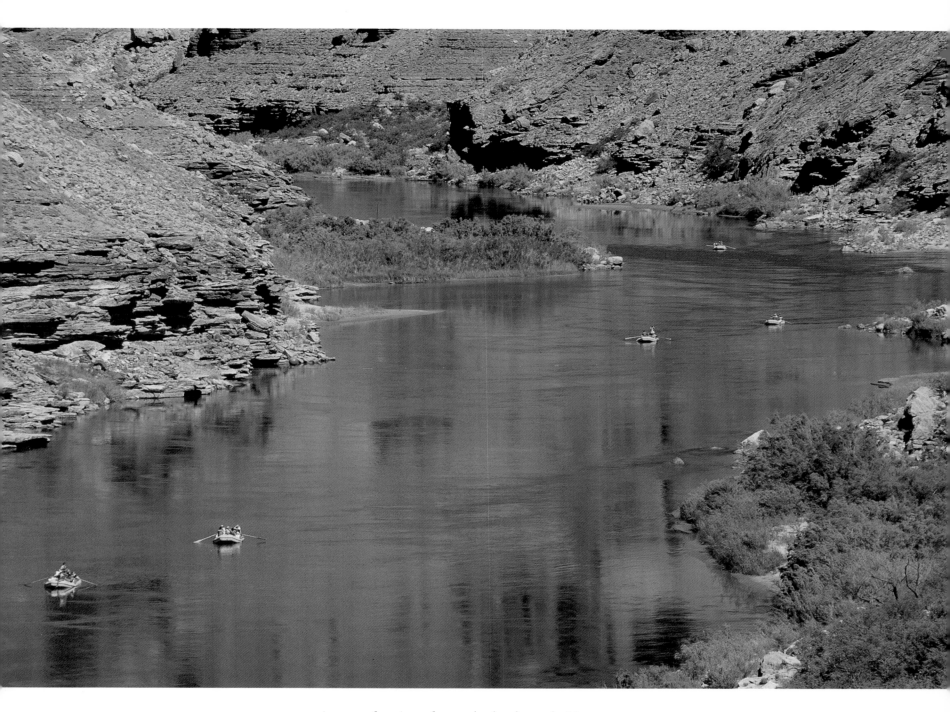

A group of rowing rafts rounds a bend near the Little Colorado River.

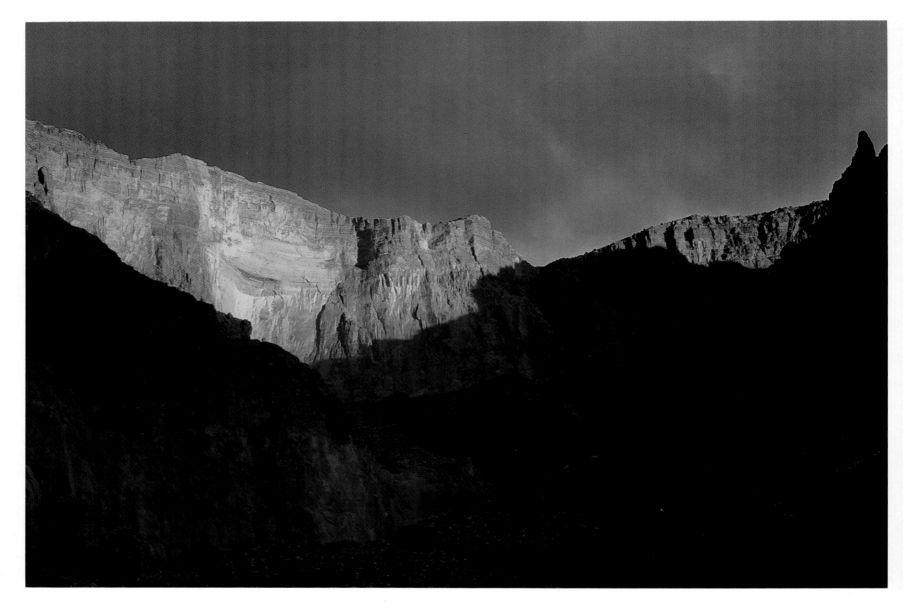

Shafts of sunlight pierce stormy days to light the
walls of the Palisades on two separate trips: looking
east from Lava Canyon Rapid (*above*), and looking
north from Cardenas Creek (*top right*). *Bottom right:*
A tiny yellow crab spider, intent on camouflage,
waits near the bud of a flower of the same color.

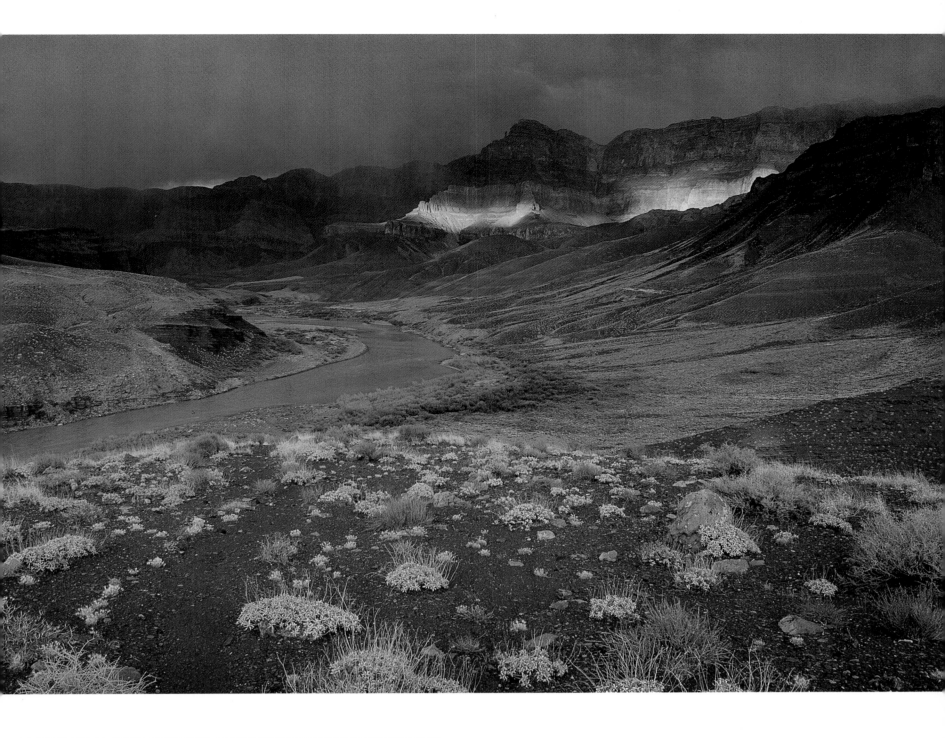

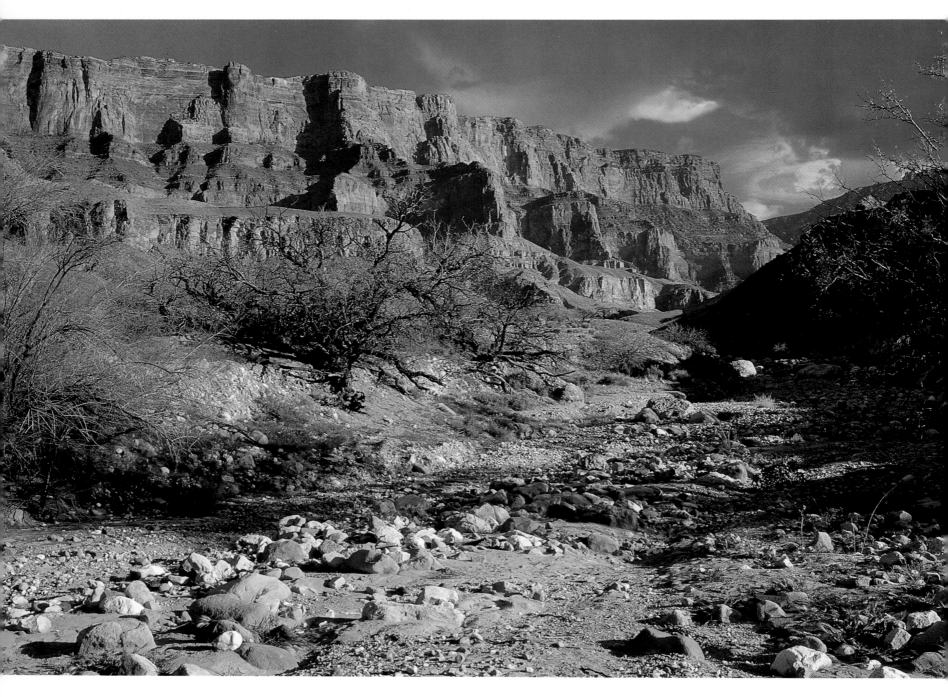

Debris flows from side canyons form most of the
Grand Canyon's rapids. Tanner Canyon looks
peaceful here, but as recently as 1995 a flash flood
pushed massive rocks into the rapid, making it
more treacherous and exciting.

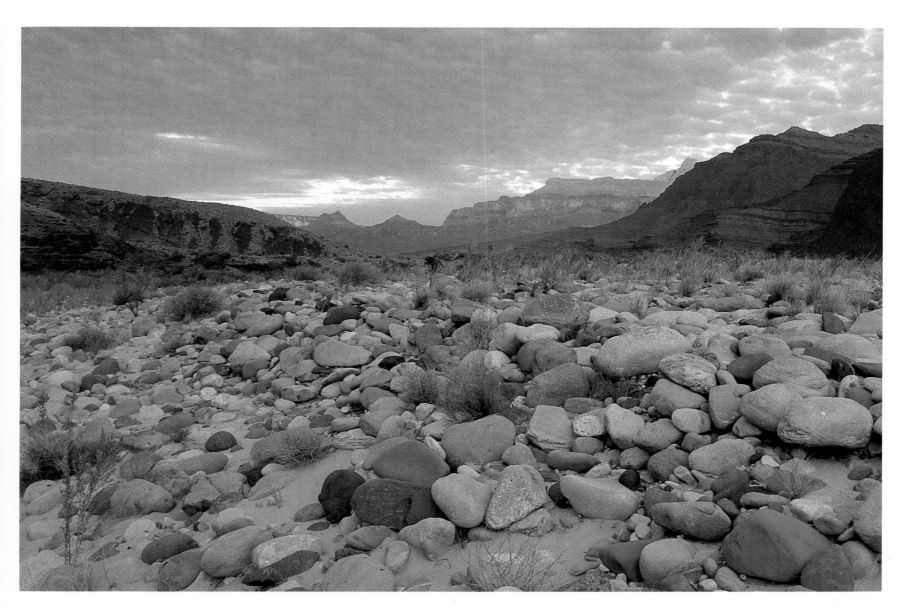

A rock- and sandbar at dawn above Tanner Rapid.

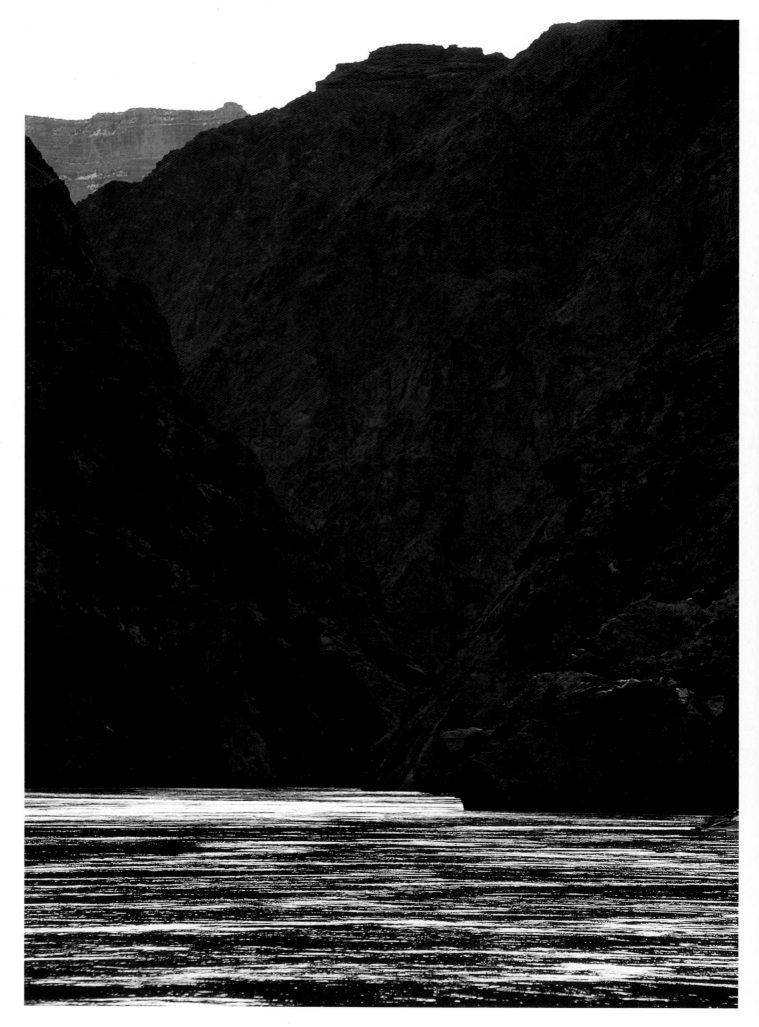

A forbidding view down the Granite Gorge, where polished granite and schist run steeply to the water's edge. It must have been a view like this that led J. W. Powell to write, "We have an unknown distance yet to run; an unknown river yet to explore. What falls there are, we know not; what rocks beset the channel, we know not; what walls rise over the river, we know not."

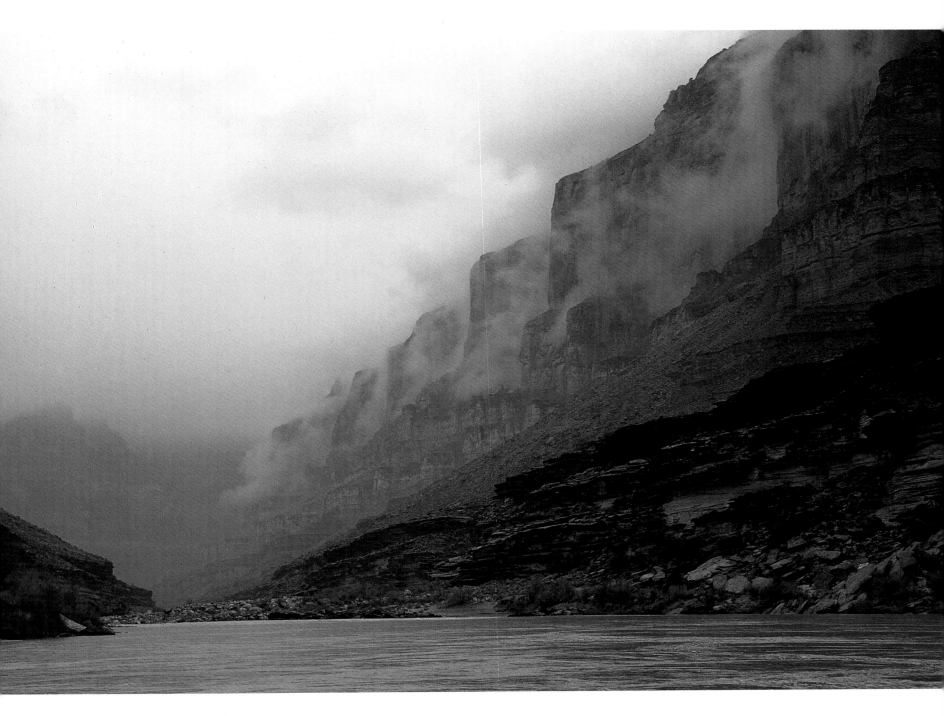

A stormy day in Conquistador Isle.

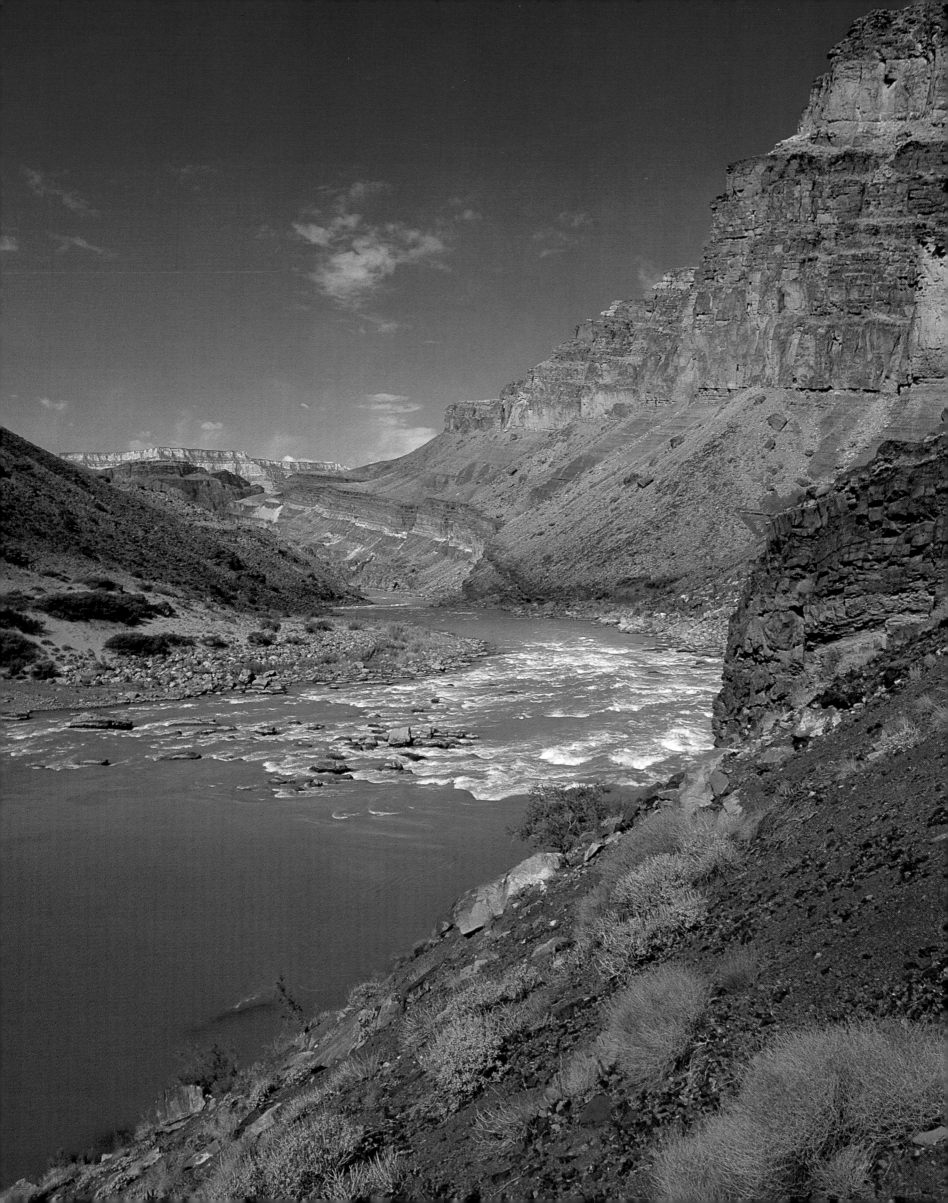

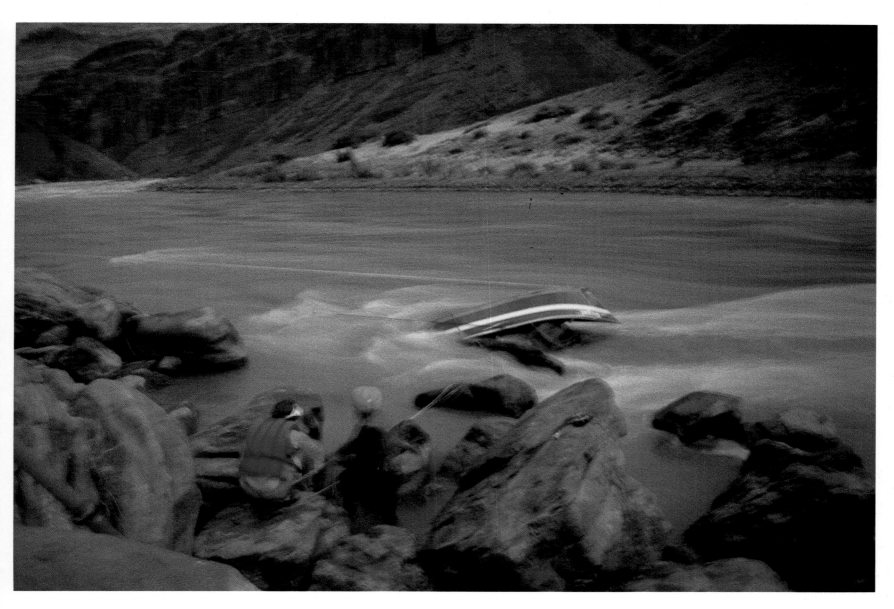

Left: Hance Rapid, one of the gnarliest in the
Grand Canyon, where we worked against the clock
to rescue a dory before dark. *Above:* The powerful
waters held the dory tight for seven hours, until six
men and three winches prevailed.

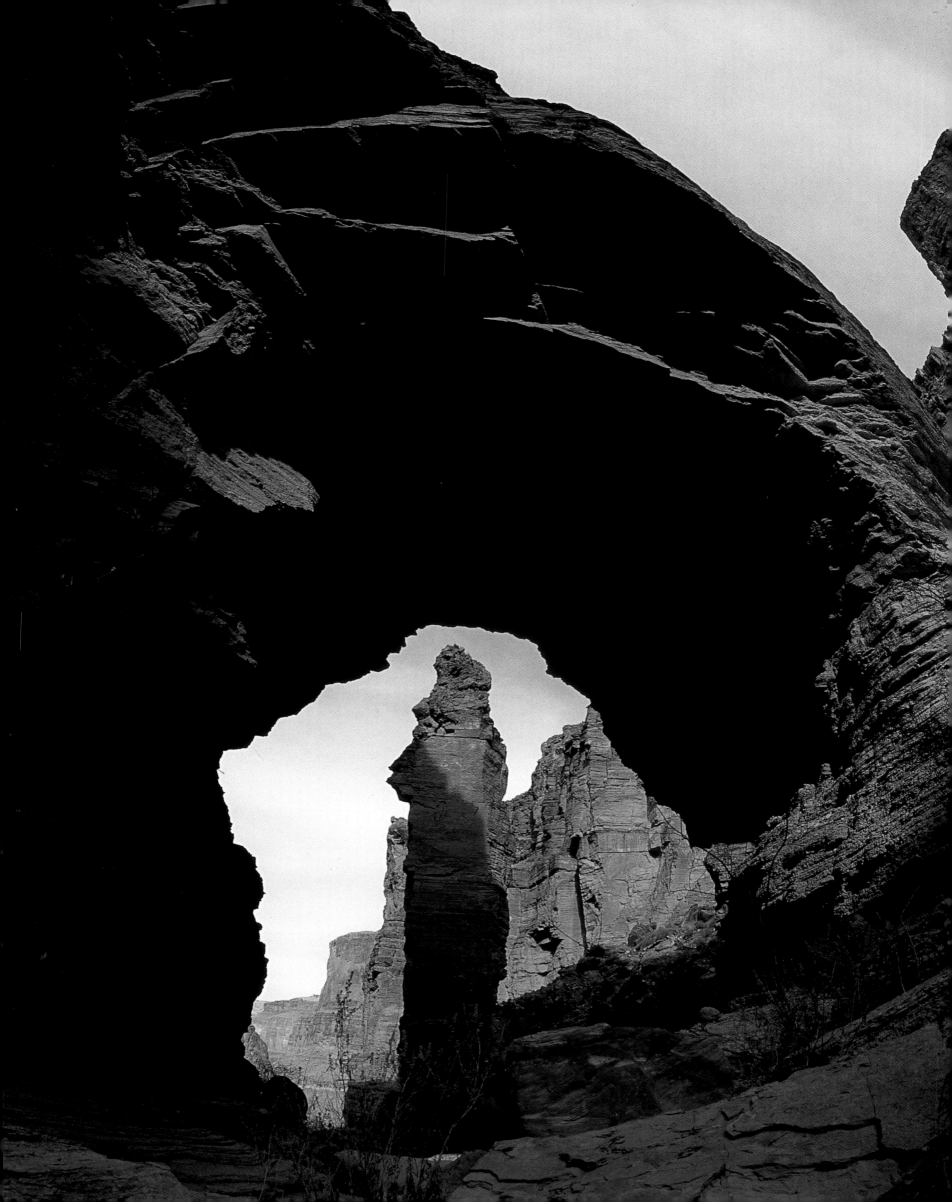

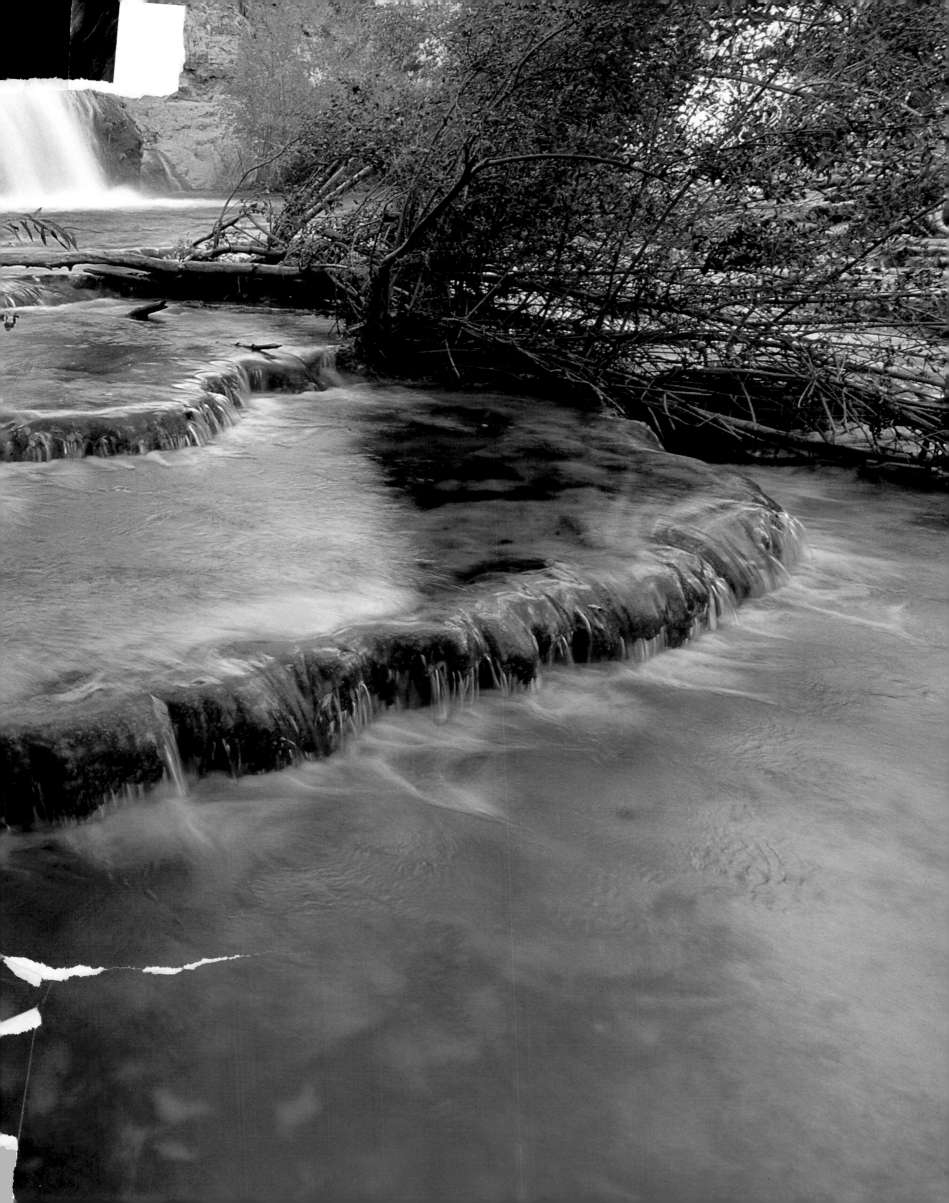

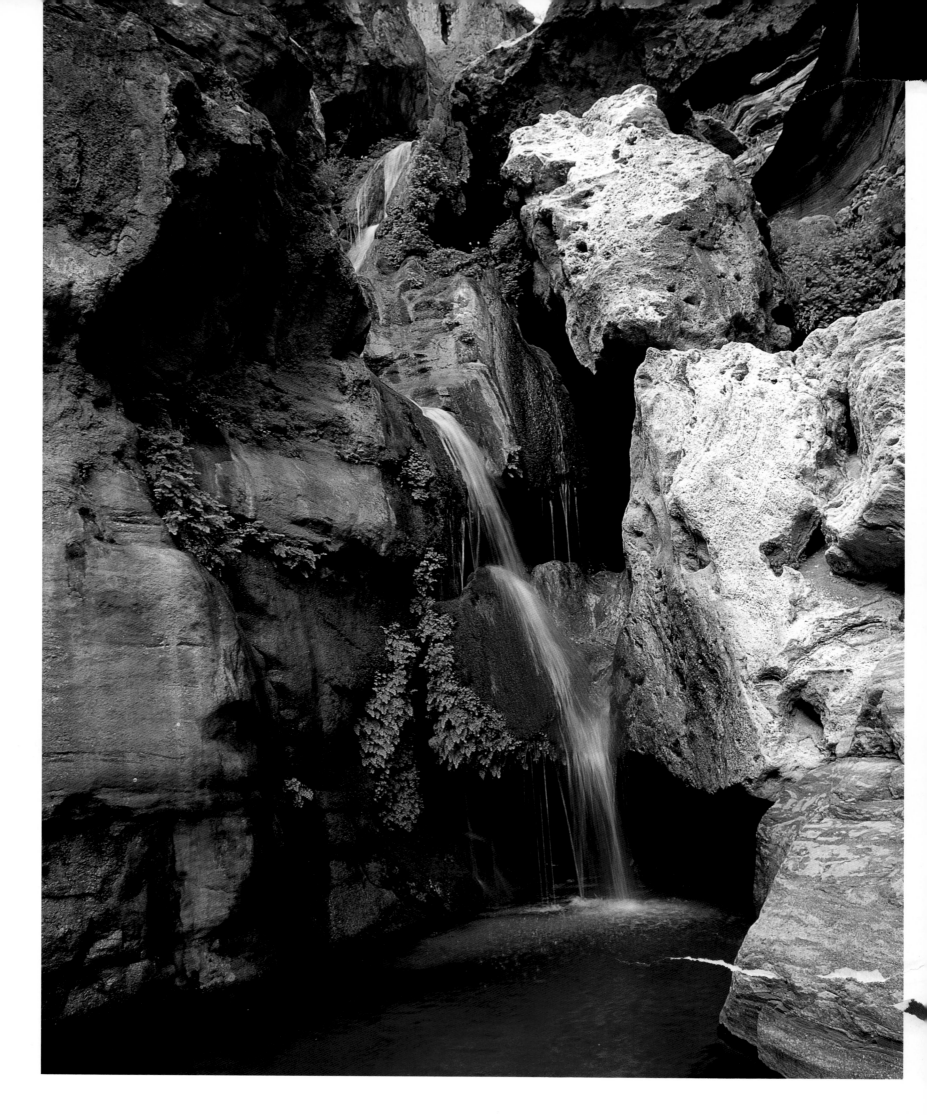

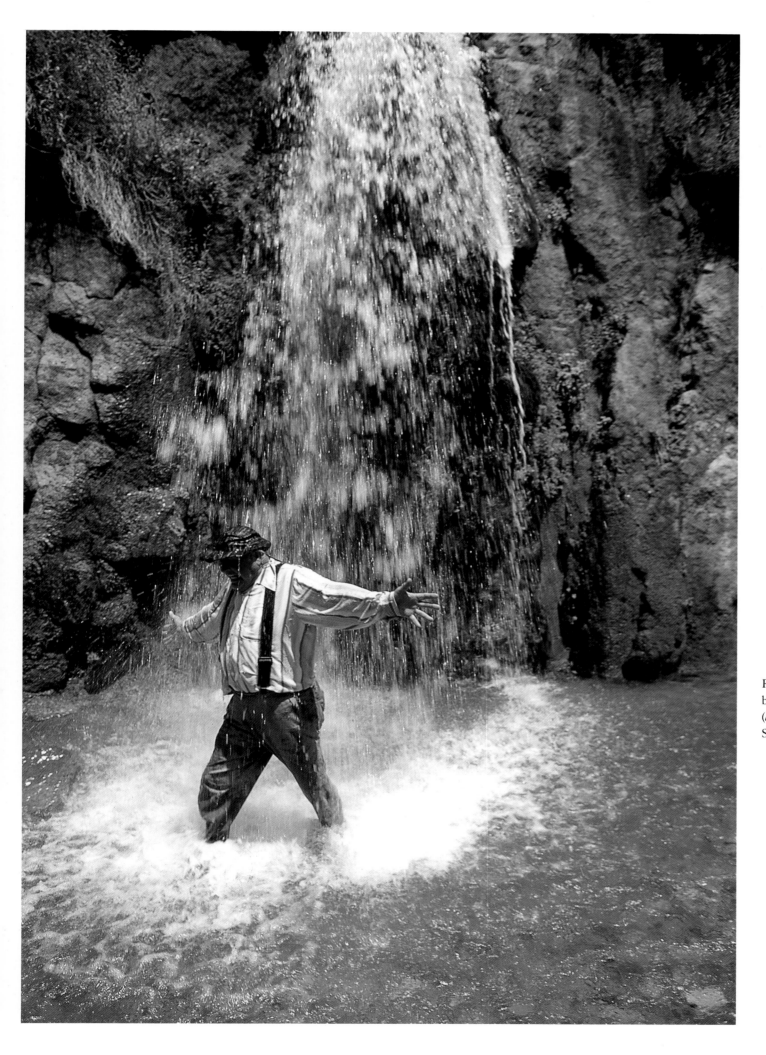

Relief on a hot day can be had at Elves Chasm (*left*) or at the falls on Stone Creek (*right*).

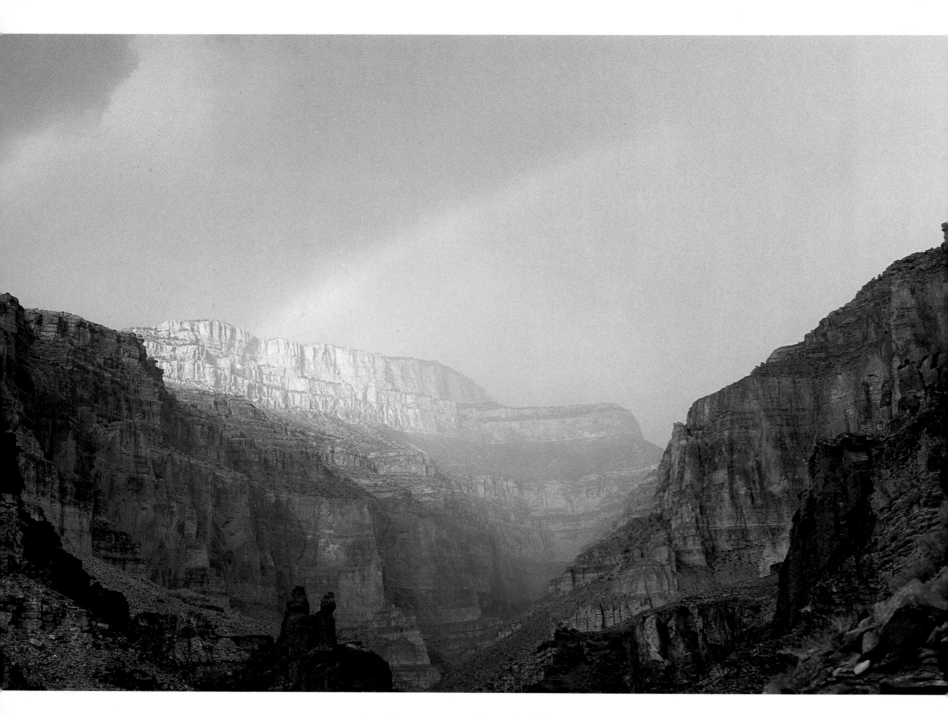

A rainbow over upper Stone Creek Canyon.

Right: Hedgehog cactus in bloom just above Stone Creek Falls.

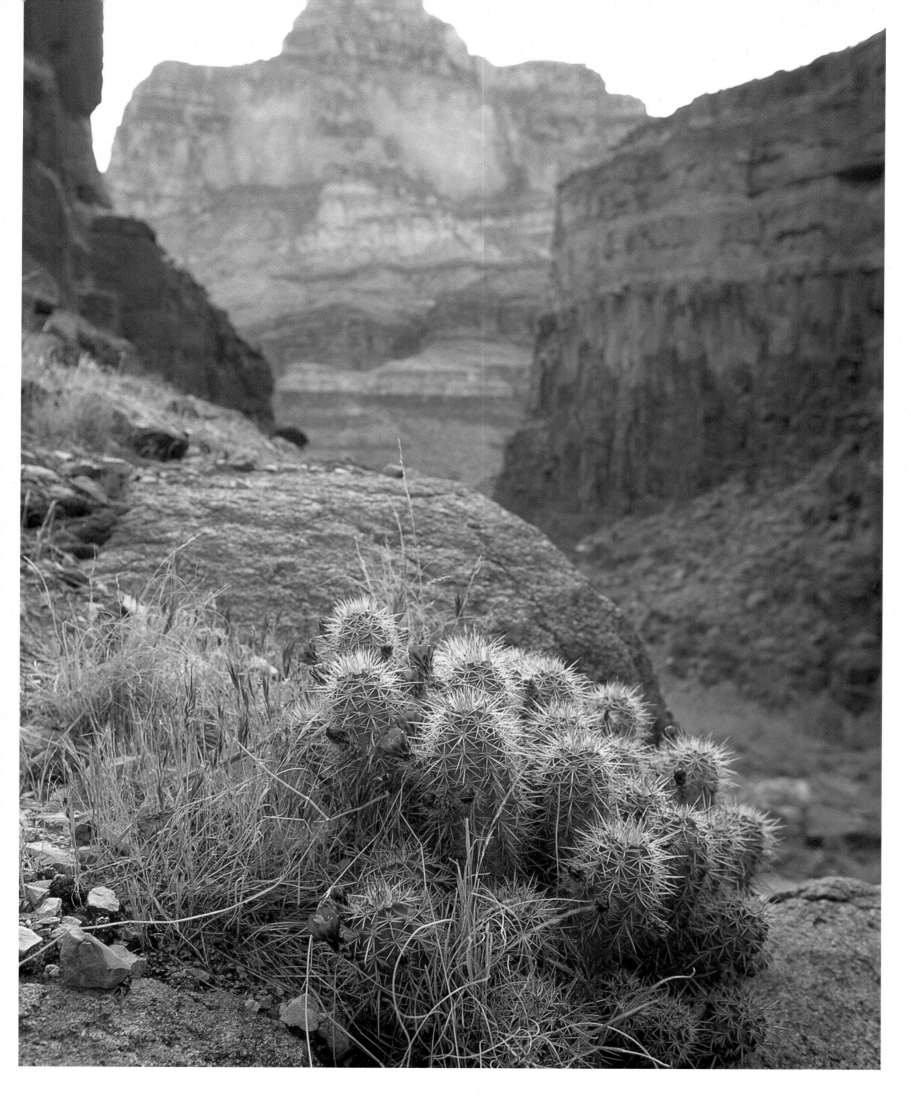

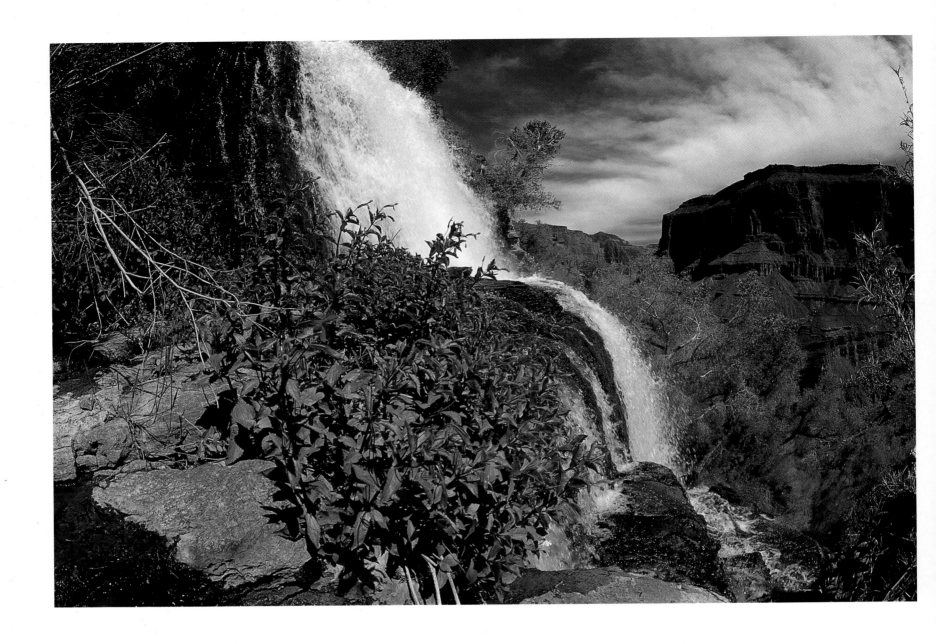

Named for the thunderous roar of water pouring out of a spring in the Redwall Limestone, Thunder River (*above*) drops about one thousand feet in a series of waterfalls until it meets Tapeats Creek (*right*). *Left:* The crimson monkey flower grows all along this route.

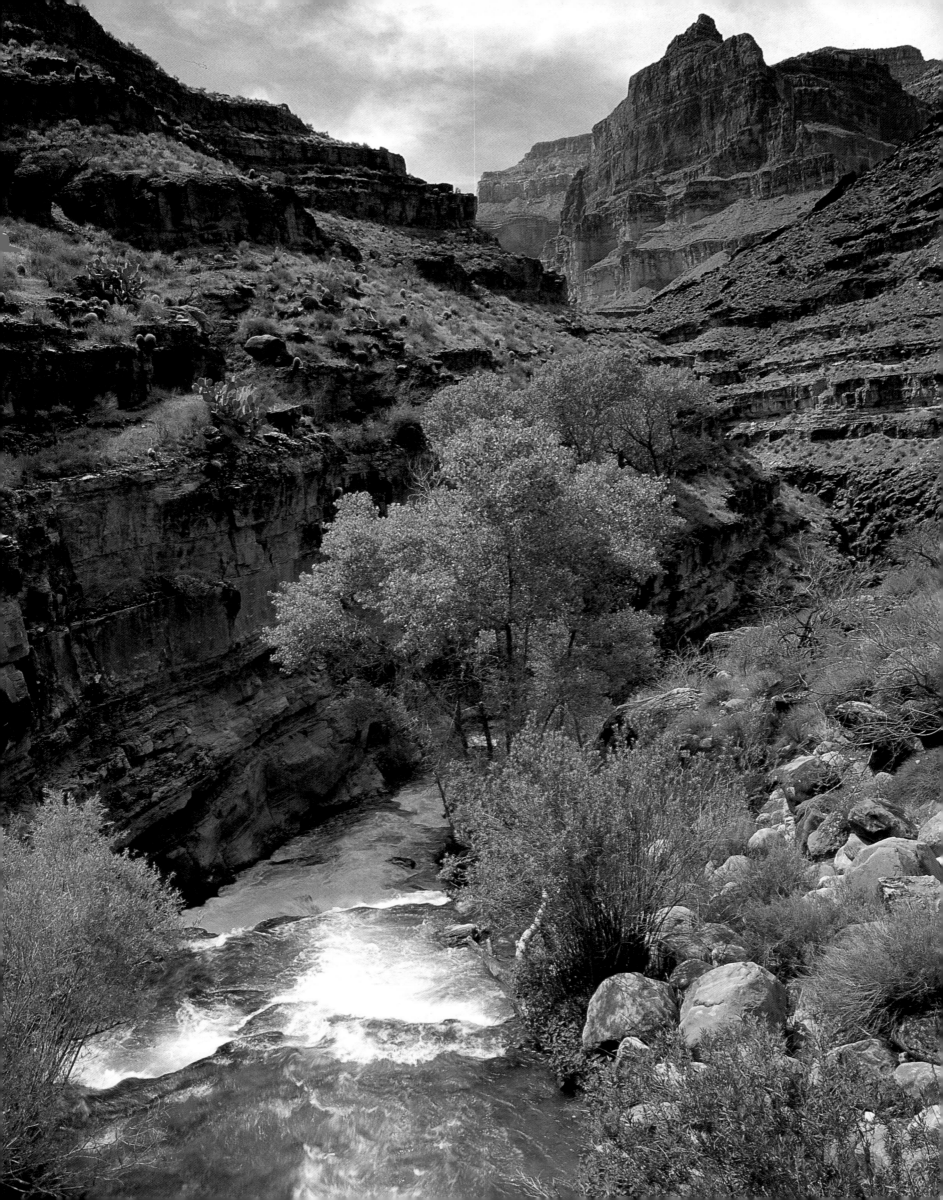

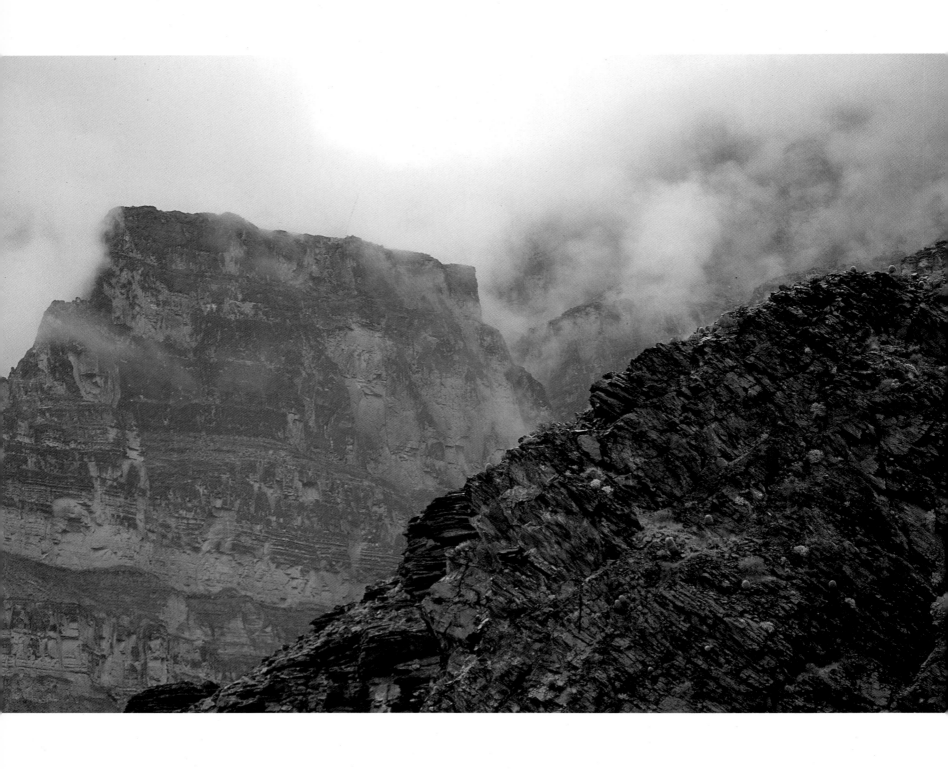

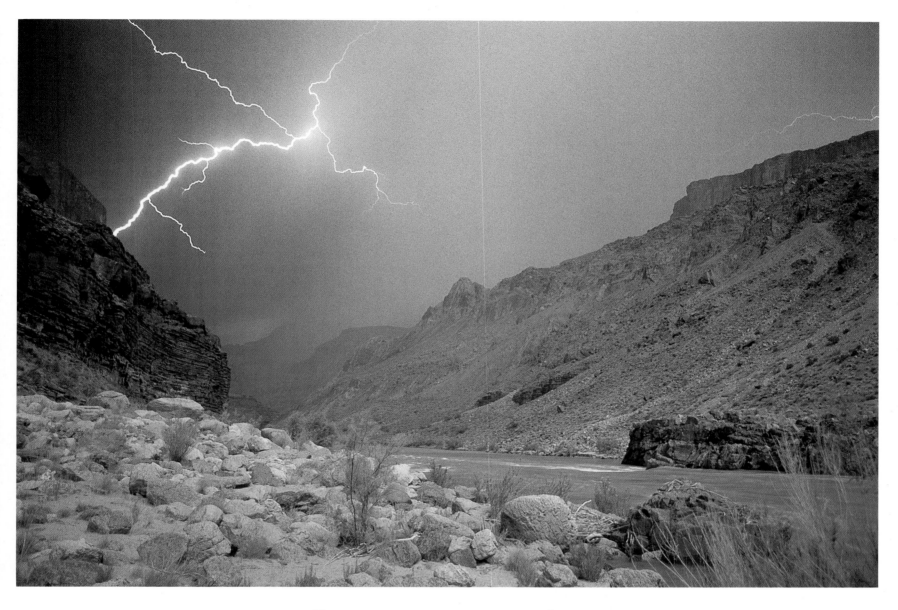

The summer monsoon season creates spectacular
lightning displays.

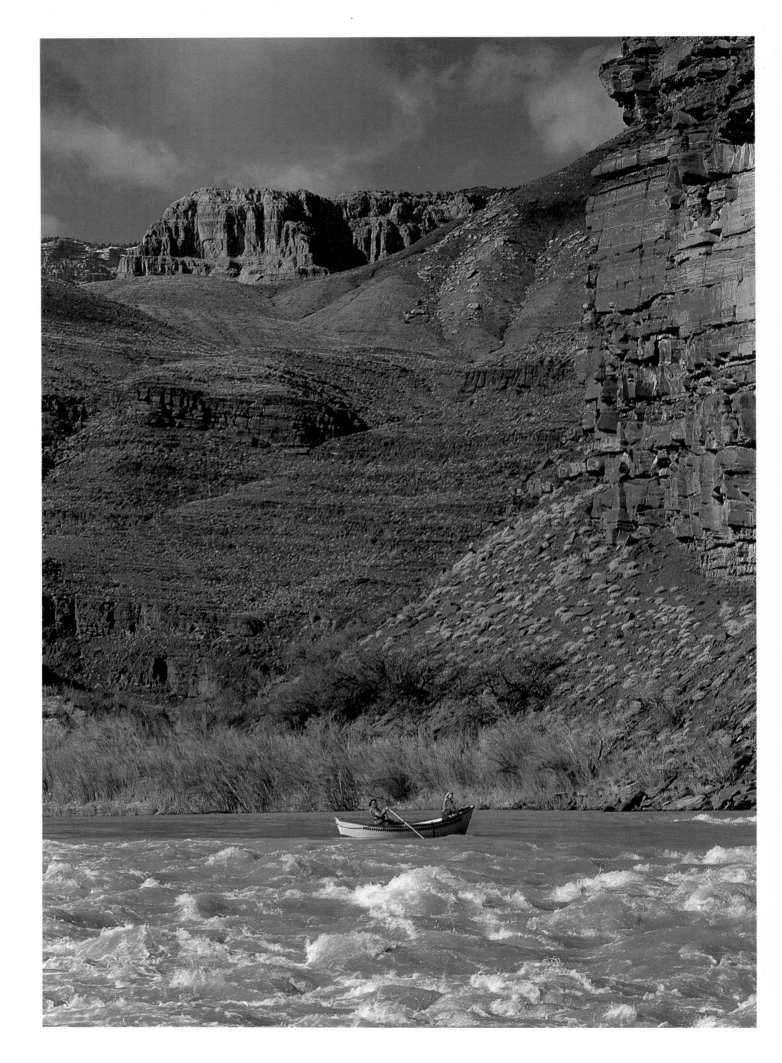

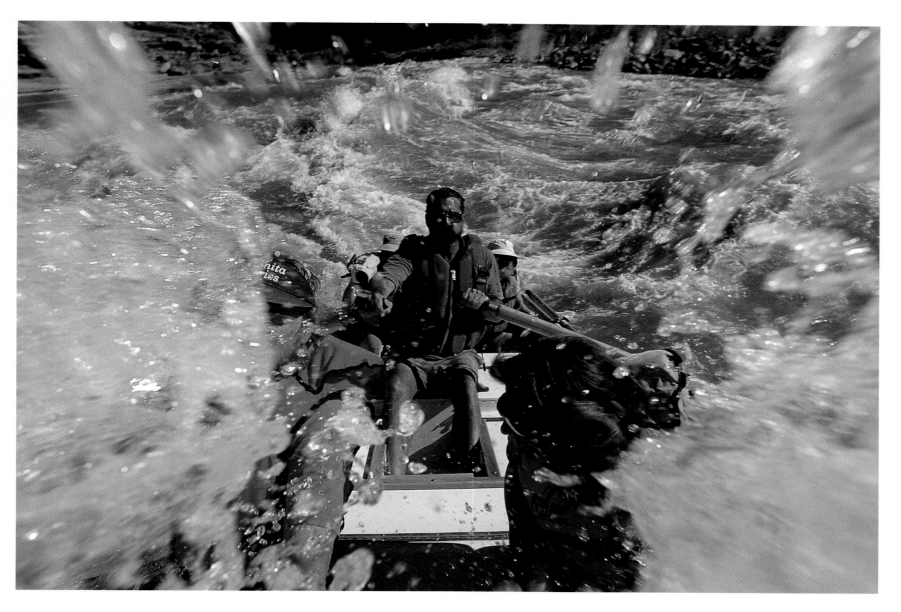

Walls, water, rapids, and rowing are every boatman's dream. Doryman Dusty Teal has it all as he enters Unkar Rapid (*left*); Mike Denoyer plows into a big wave in Forster Rapid (*above*).

Overleaf: Dory craftsman Derald Stewart rides high in Specter Rapid.

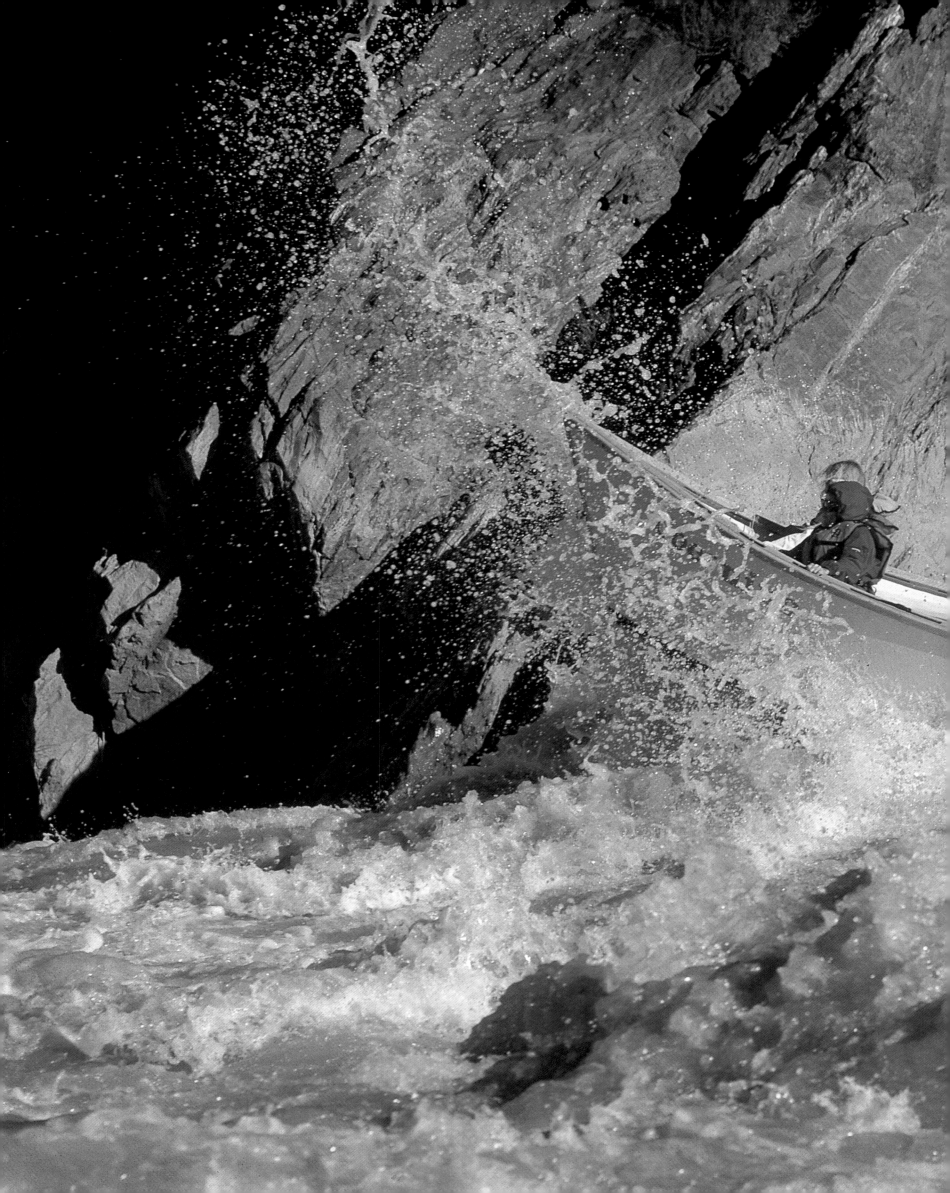

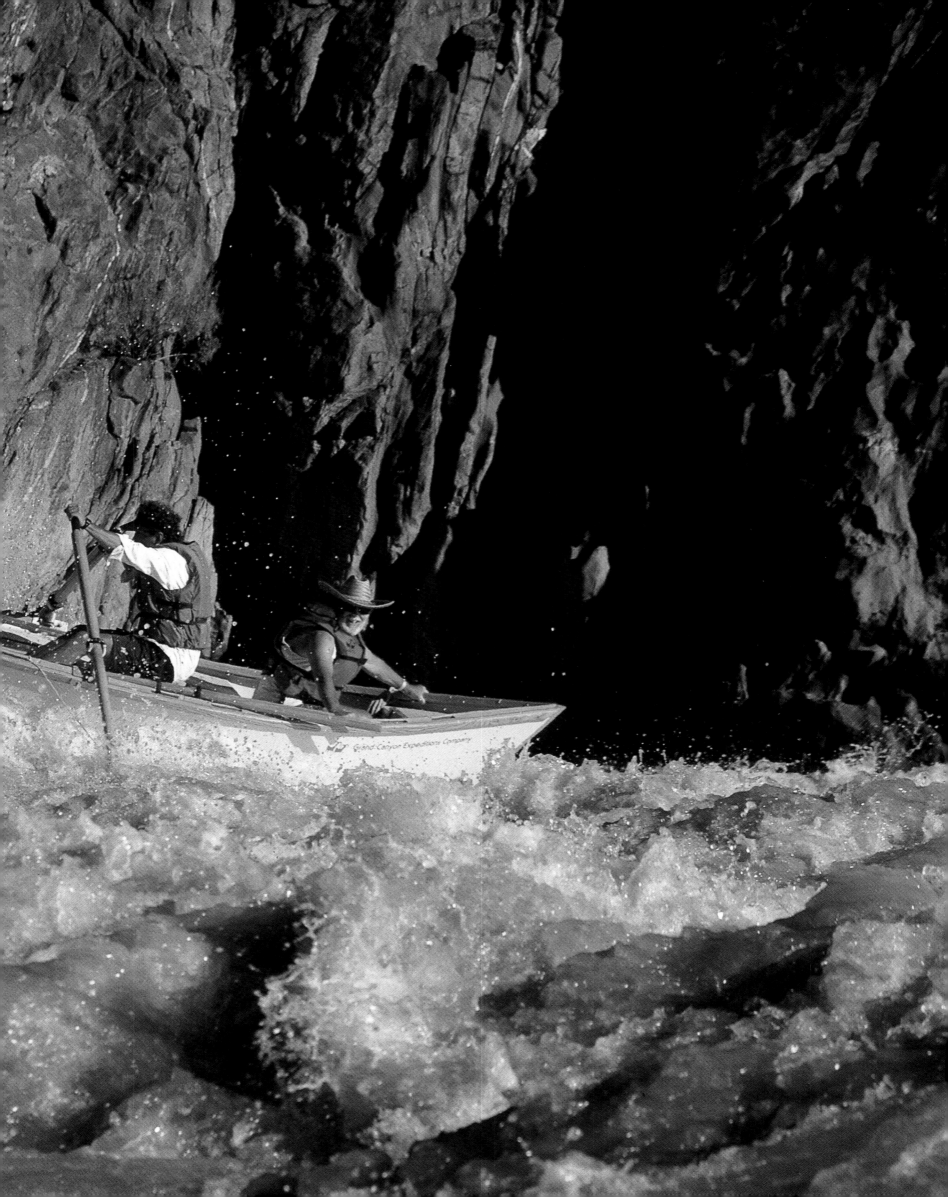

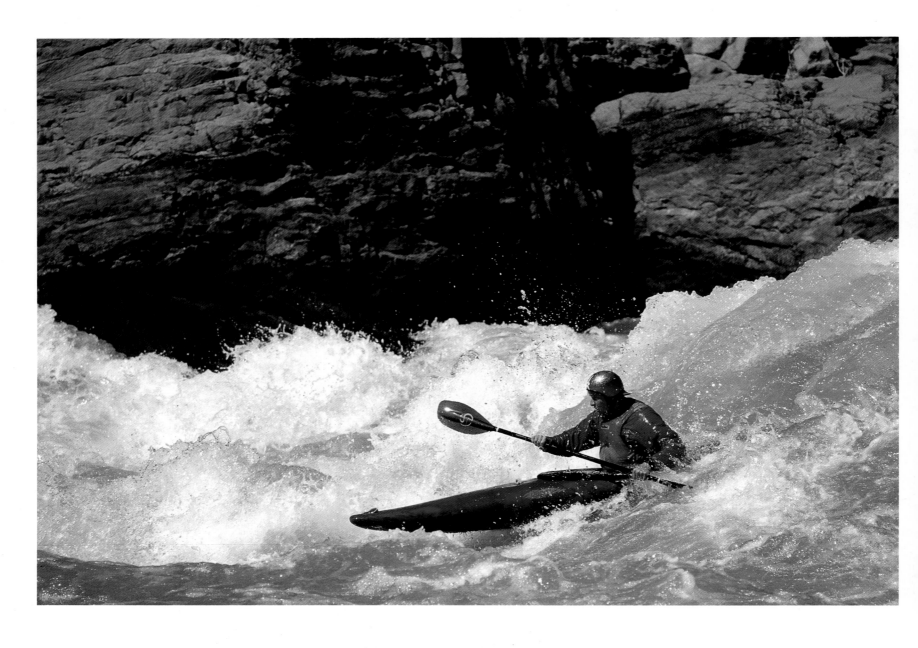

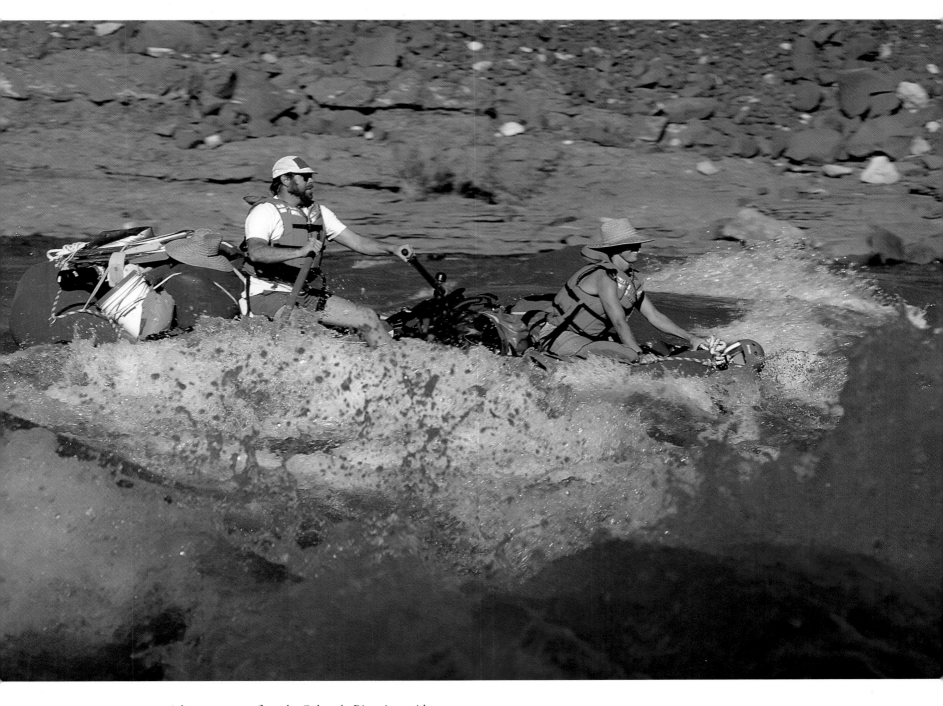

Adventurers can float the Colorado River in a wide variety of boats. A kayak, seen here (*top left*) in Lava Falls Rapid, is one of the most exciting, but you get roller-coaster rides in an S-rig, here (*bottom left*) in Specter Rapid, or a rowing raft, as in this shot (*above*) taken in Soap Creek Rapid.

Top: A dory enters Badger Rapid, the first rapid on a Grand Canyon river trip. *Bottom:* Dories at camp. I find them the most elegant, exciting, and photogenic boats on the river.

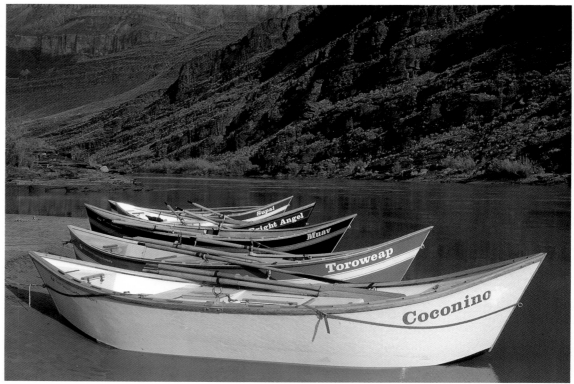

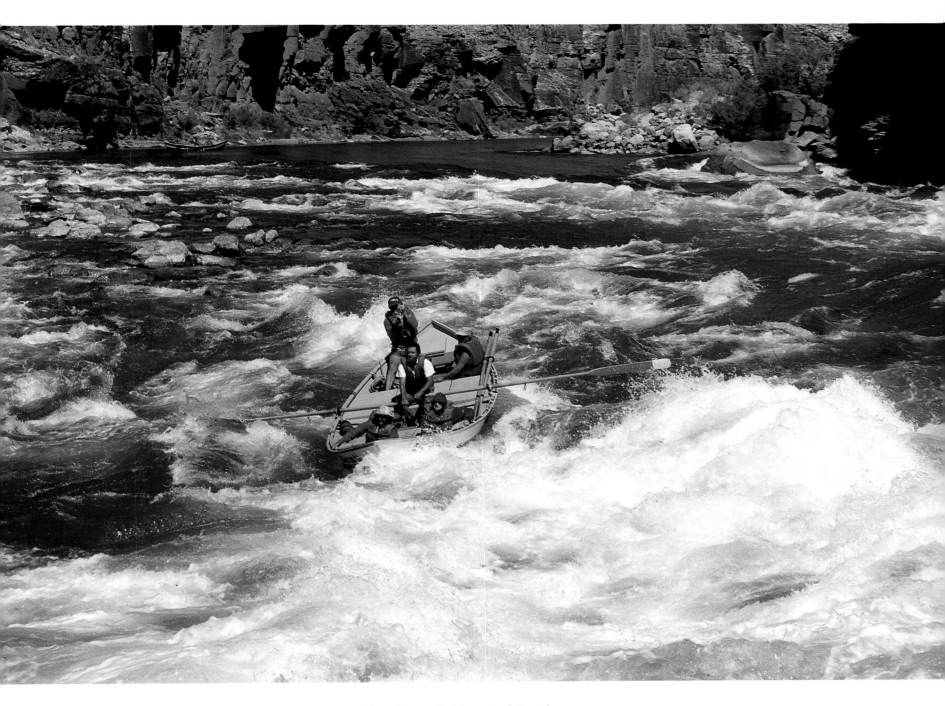

Boatman Tim Whitney in House Rock Rapid.

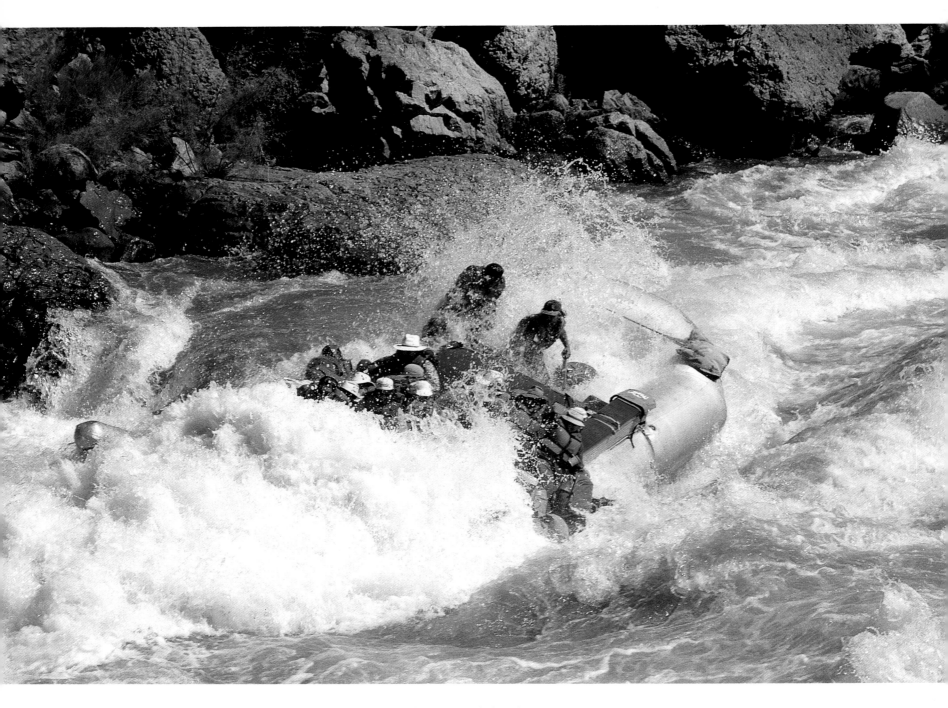

Cleve Anderson at the helm of an S-rig, as seen
from the left bank of the granddaddy of rapids,
Lava Falls.

A passenger's view of the most fearsome wave in
Lava Falls Rapid, the so-called Big Kahuna.

Left: Andy Hutchinson is a blur on a morning run through Soap Creek Rapid. *Below:* Mary Anne Griffin howls with glee, having slipped past the big hole in Upset Rapid, where Emery Kolb flipped in 1923.

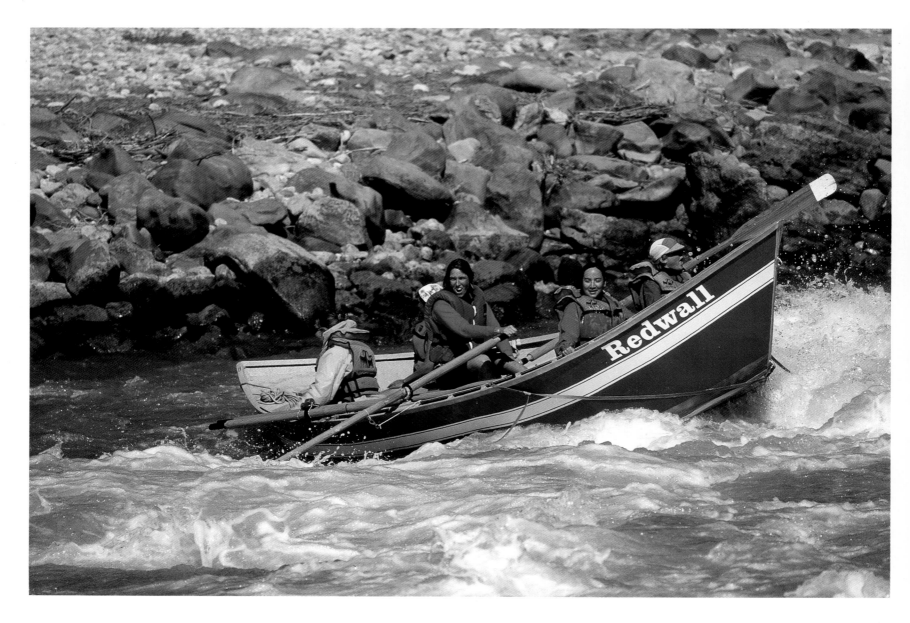

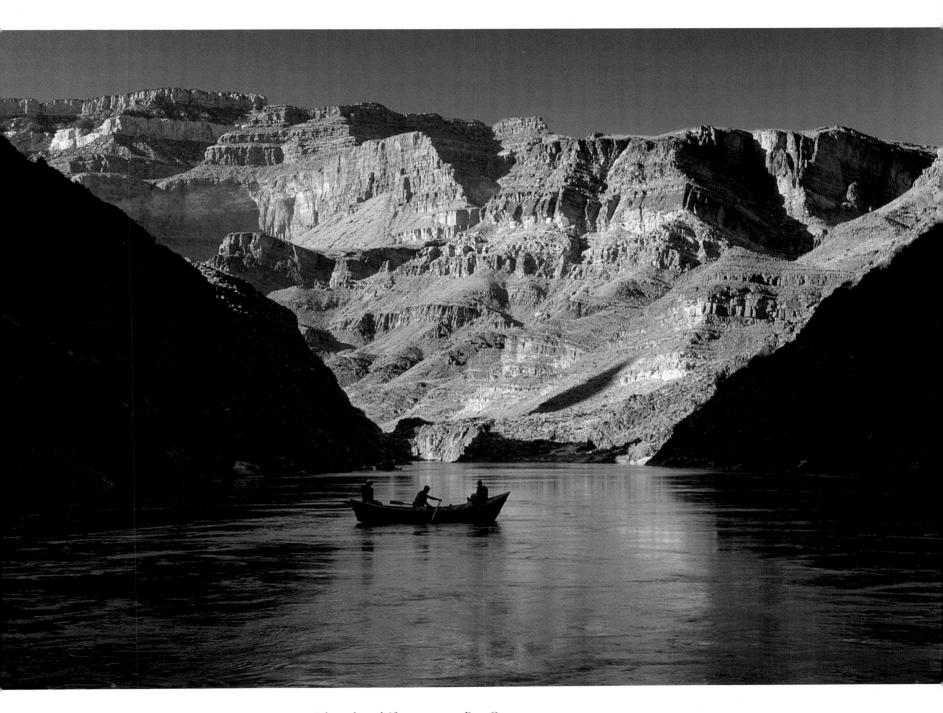

A lone dory drifts to camp at Bass Canyon.

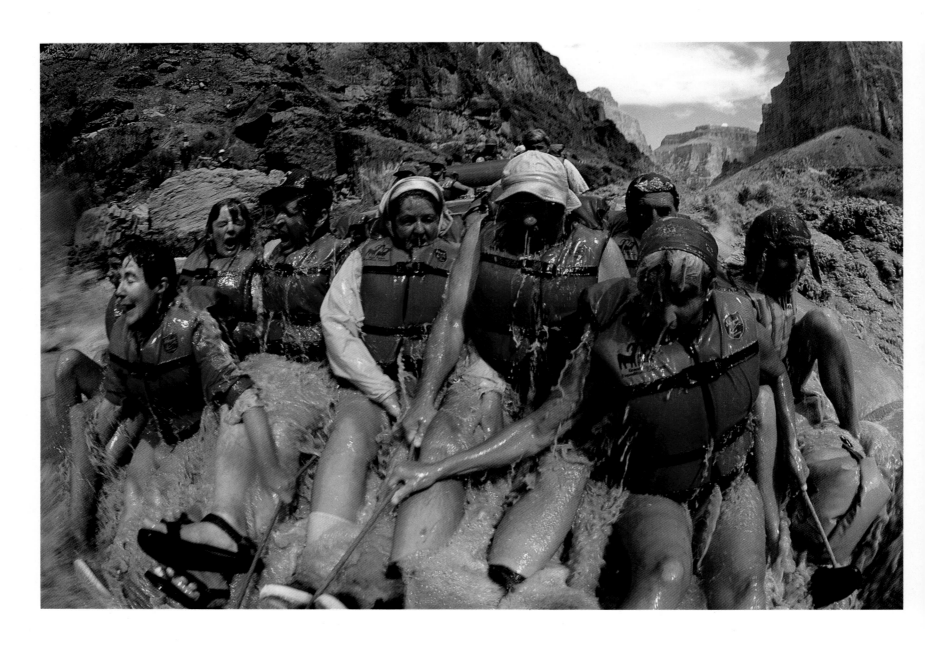

Whether taking the V-wave in the face at Lava
Falls Rapid (*above*) or dressing up for the must-do
mud party at the Little Colorado (*right*), there is
never a dull moment on a river trip.

Boatmen clowning for the camera hold up a piece
of Tapeats Sandstone at Blacktail Canyon (*top left*),
organize the world's largest mooning session, below
Lava Falls Rapid (*bottom left*), and mimic J. W.
Powell at Ross Wheeler Camp (*above*).

Top: Andy Hutchinson drifts and plays in Marble Canyon. *Right:* Don Silva drew the short straw to end up as the face in the "Shorty the Boatman" skit. He's going through the Kahuna wave at Lava Falls Rapid.

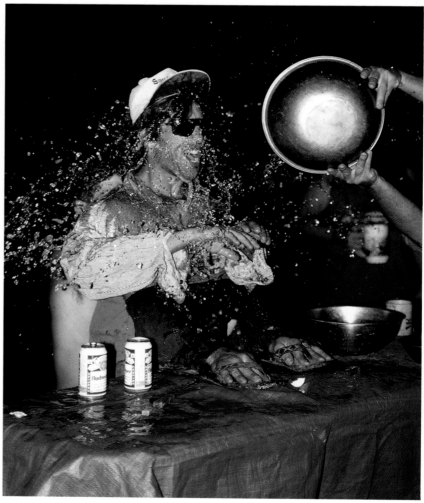

Top: A passenger with the river-worn veteran's patina that develops after six days on the river. *Bottom:* A river pirate at an impromptu costume party.

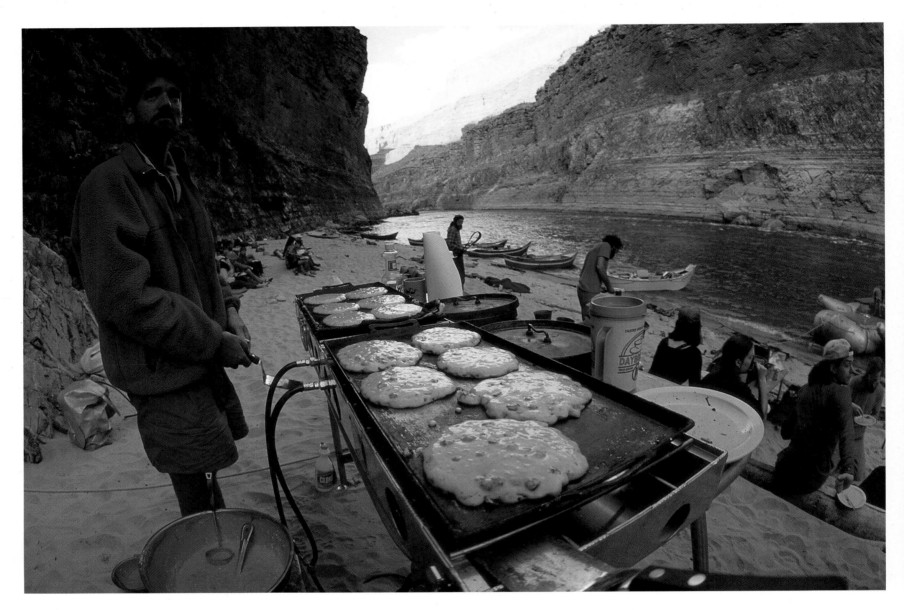

Hearty blueberry pancakes await passengers at
dawn on a commercial river trip.

Right: Friends enjoy
early-morning
mandolin music on a
spring trip.

Other than boats, there are only two ways to get to the river: hiking or riding a mule. *Above:* At many places the river is impossible to reach. *Right:* Most trails follow fault lines down, and along some there are man-made tunnels to allow hikers and riders to pass.

Less than 1 percent of the Grand Canyon's visitors
ever explore the river. The others get the indescrib-
able view from the top, especially glorious at sunset
from Desert View Watchtower (*above*) or at dawn
looking at sunbeams over Cedar Mesa (*right*).

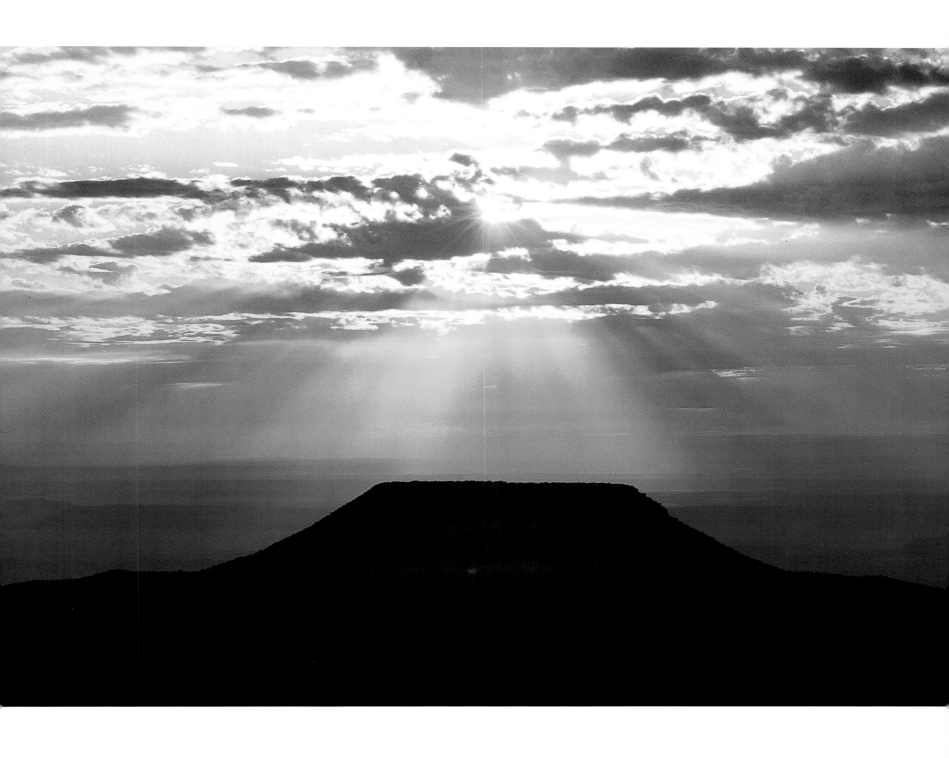

Overleaf: From the Blue Moon Bench, above Marble Canyon, you get a sublime view featuring the heart of the Grand Canyon.

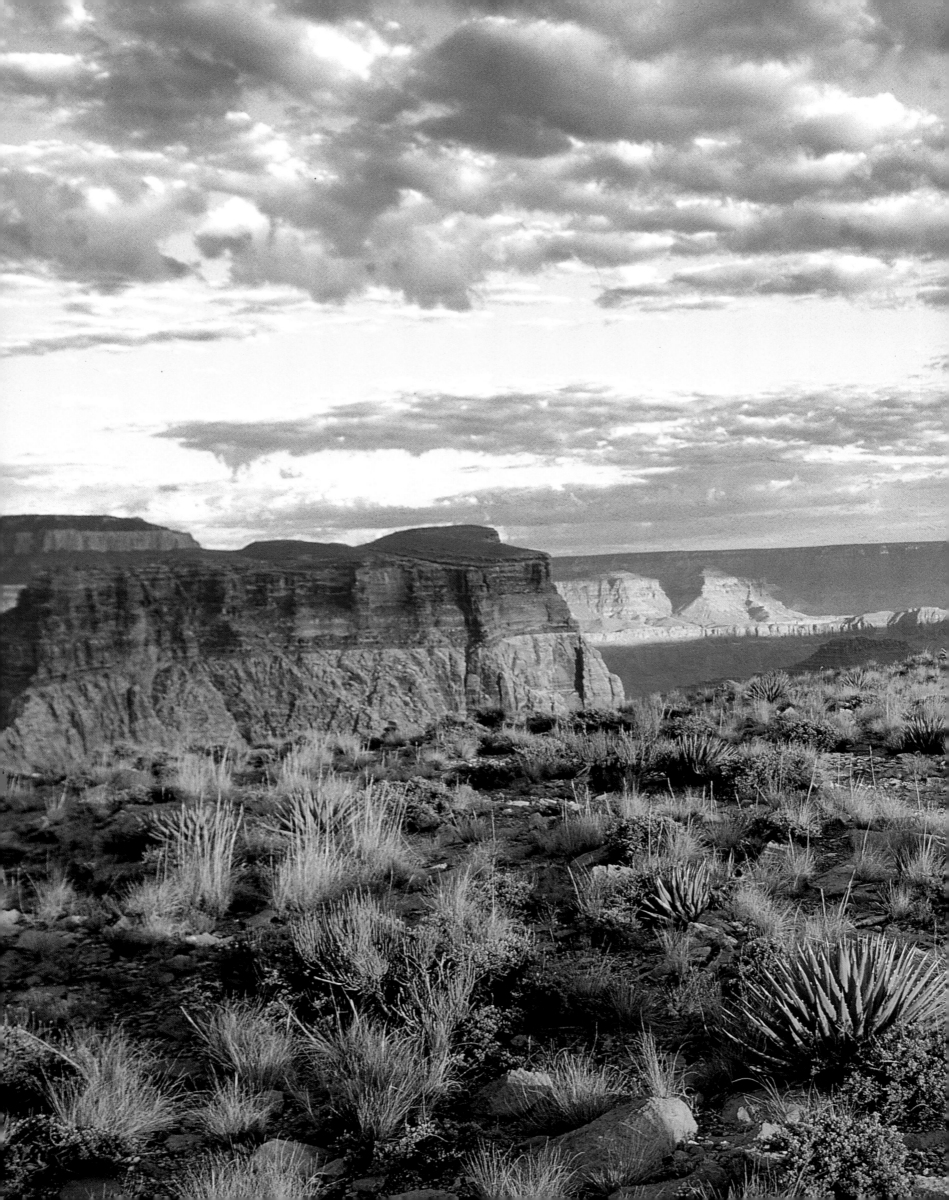

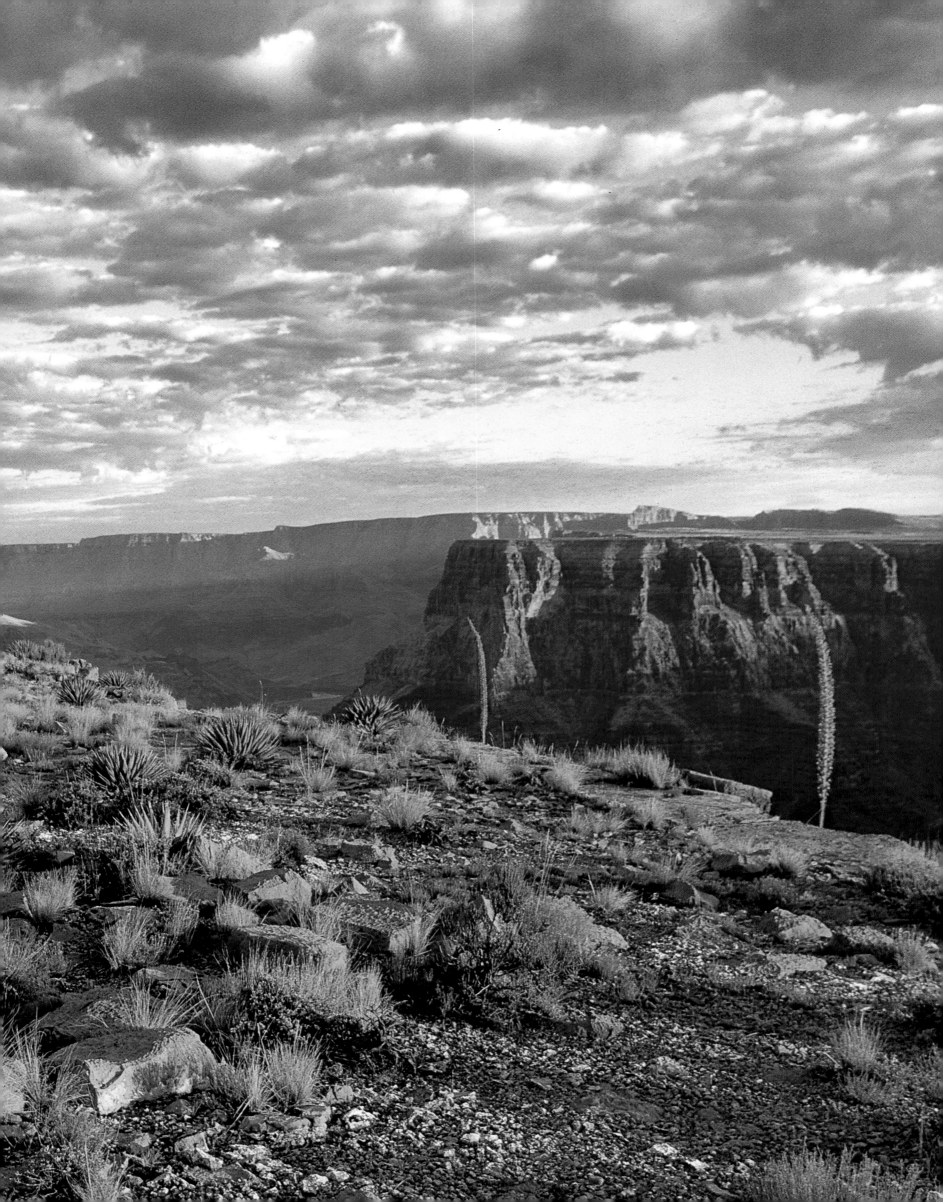

Top: Bison take dust baths in House Rock Valley, above Marble Canyon. *Right:* A desert bighorn sheep in a rare white phase stares at boatmen from her cliffside domain.

Bottom: As soon as campers depart, "Raoul the Raven" comes to sift through the sand for tidbits of food inadvertently dropped and buried. *Top:* Nearby, where campers do not tread, delicate plants cast their morning shadows.

Nodule-like concretions of sandstone and quartzite
decorate the Kaibab Limestone of Jumpup Point.

A mile above the Colorado, golden-yellow aspen
leaves provide fall color on the North Rim.

The setting sun paints Crazy Jug Point with a continuously changing palette of light.

Right: A dory-shaped crescent moon as seen from North Timp Point.

Just below Lava Falls Rapid, a time exposure shows
a moon trail as the moon sets and leaves a bright
glow on the Colorado.

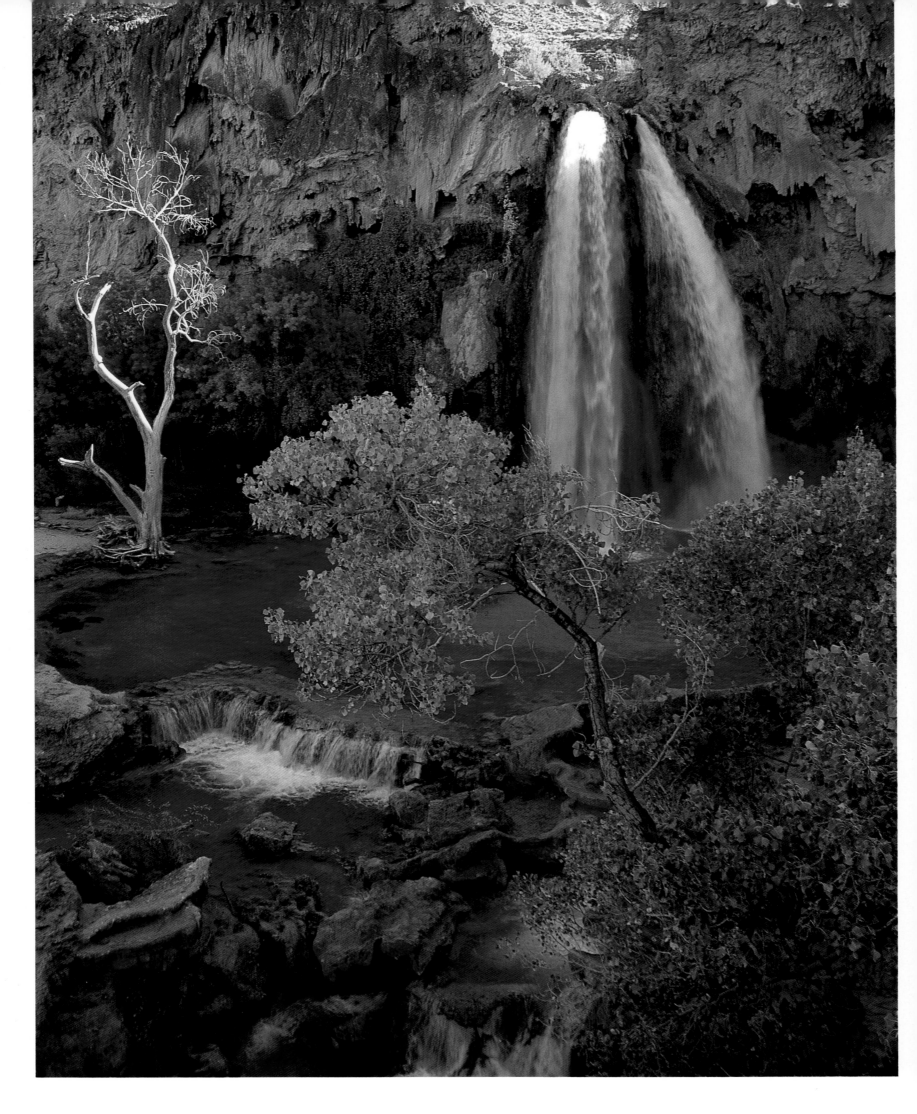

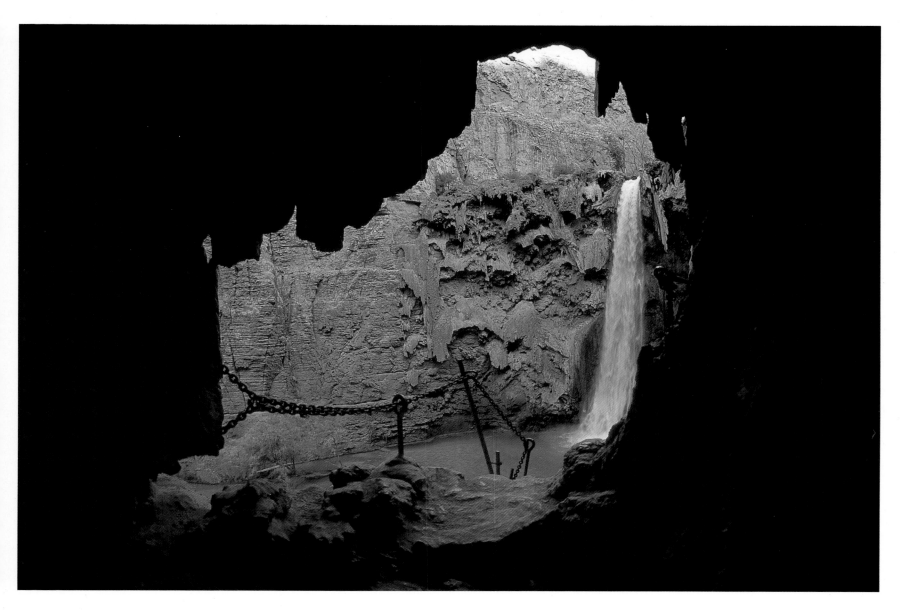

The trail through the travertine to Mooney Falls.

Left: Havasu Falls.

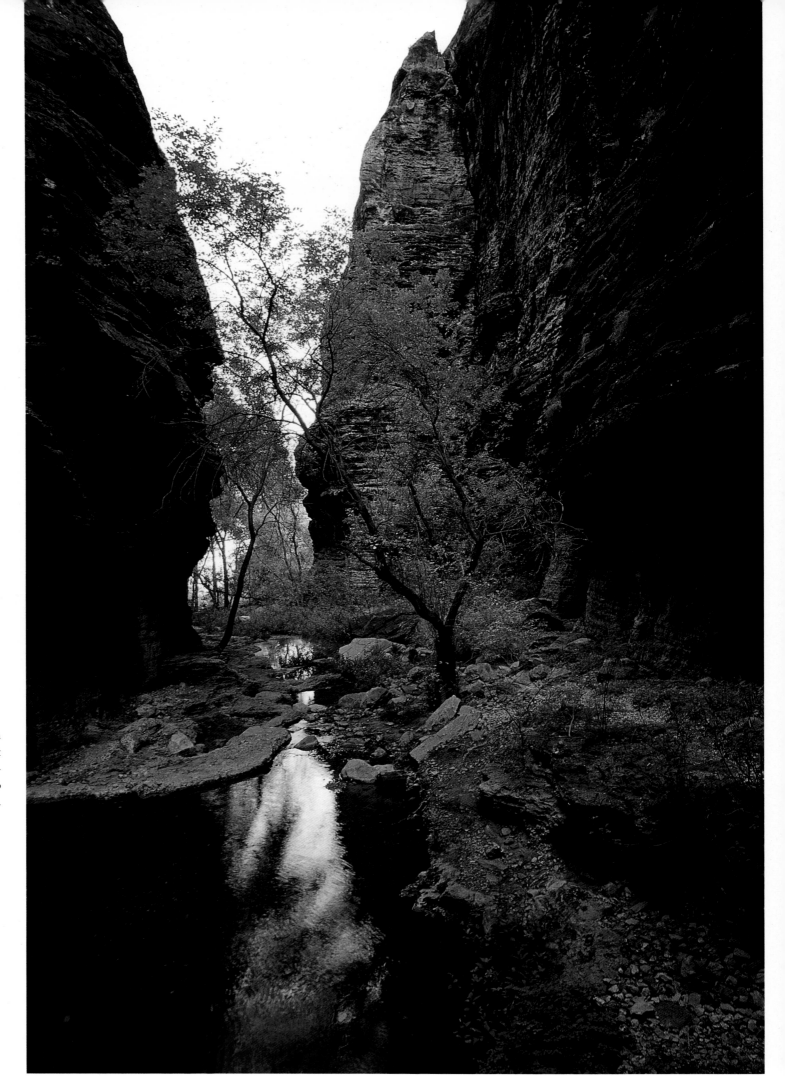

In a side canyon, a spring fills a quiet pool that eventually pours into Havasu Creek.

Where Havasu Creek enters the Colorado River, one begins to see more desert plants, such as this lovely ocotillo in bloom.

Overleaf: Still waters on grayish granite reflect the Redwall Limestone from the canyon walls above.

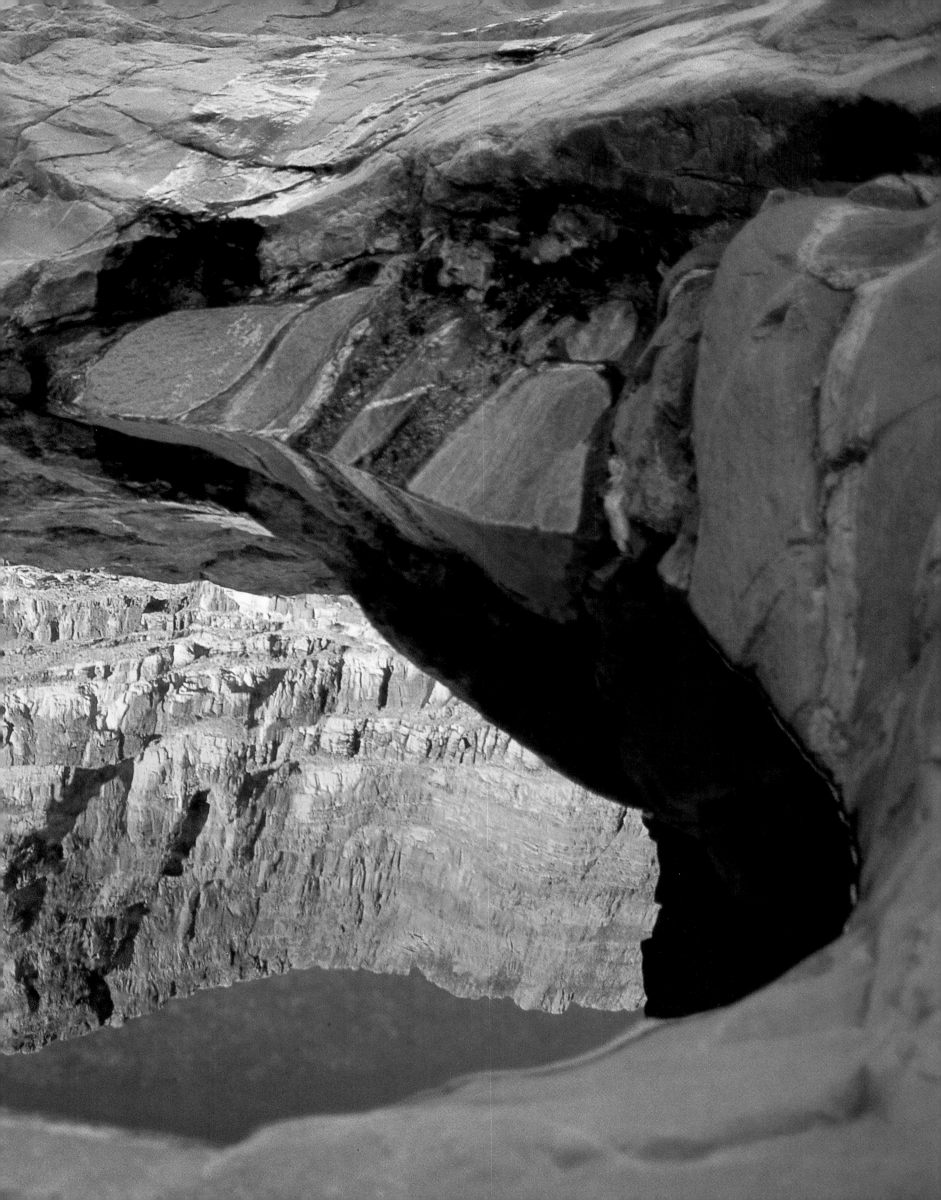

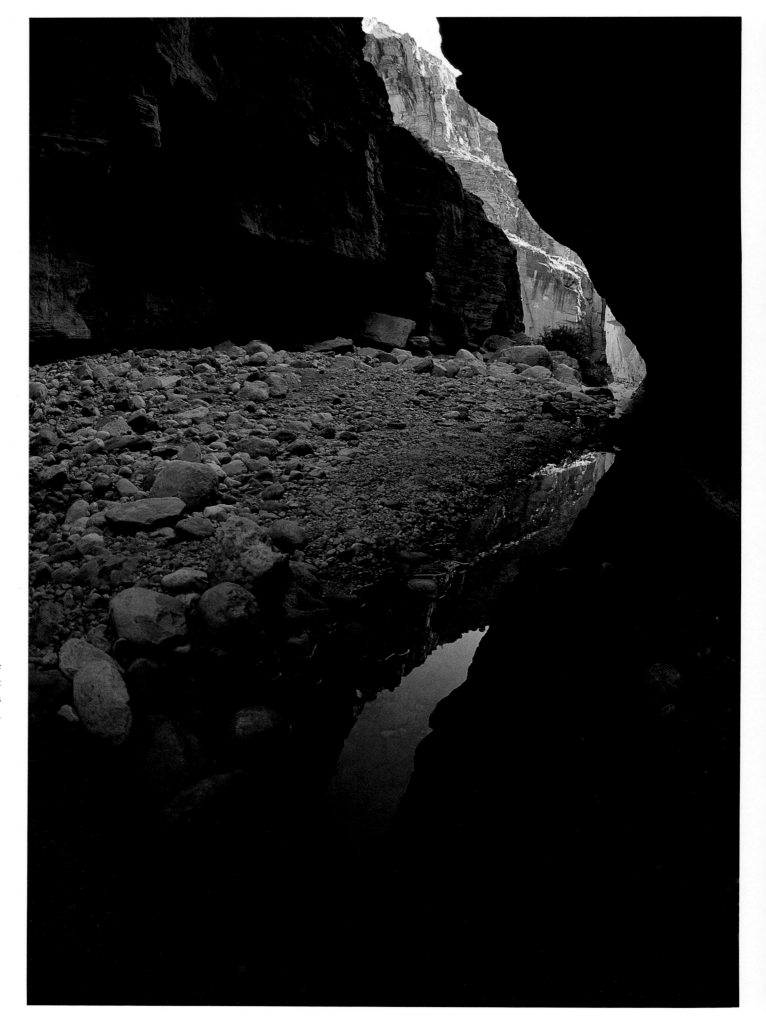

On a hike up a side canyon, one finds tight corridors and trickles of springwater.

On twelve river trips, I have seen only four snakes. One of these was a Hopi rattlesnake eating a sparrow (*top*), and another was a Grand Canyon pink rattler, endemic to the area (*left*).

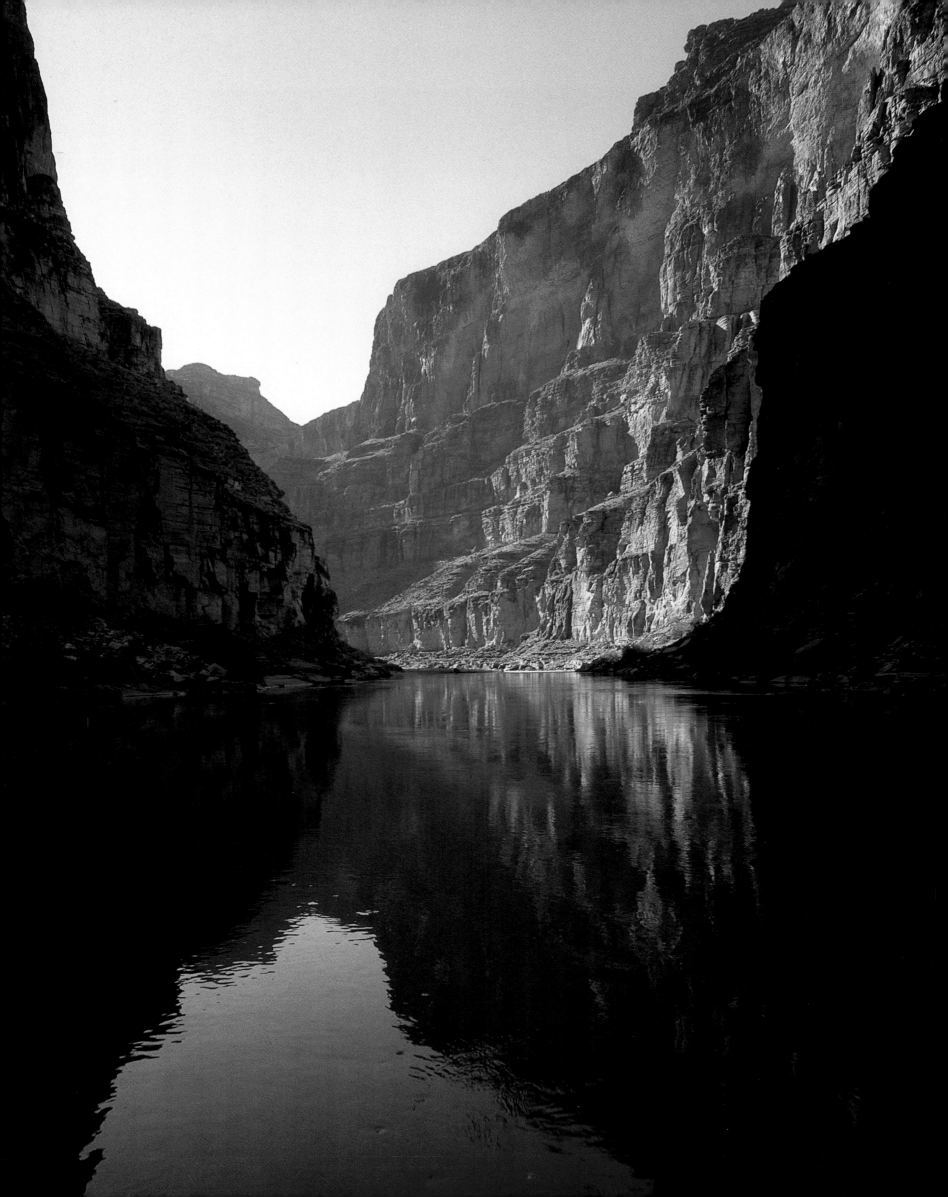

Water is an ever-changing subject in the Canyon. *Left:* River waters near mile 159 may appear still and silty, but they're moving along briskly. The reflected red glow of canyon walls (*above*) contrasts with the artificially green waters below the dam, here in Soap Creek Rapid (*right*).

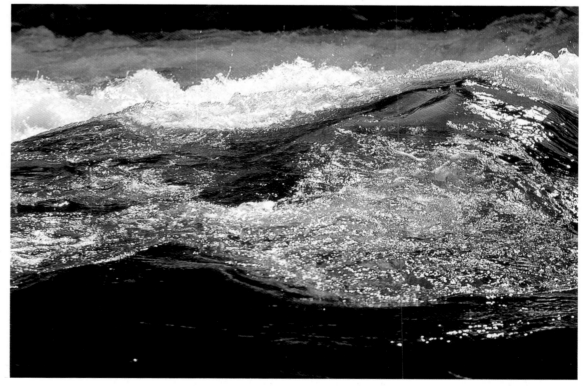

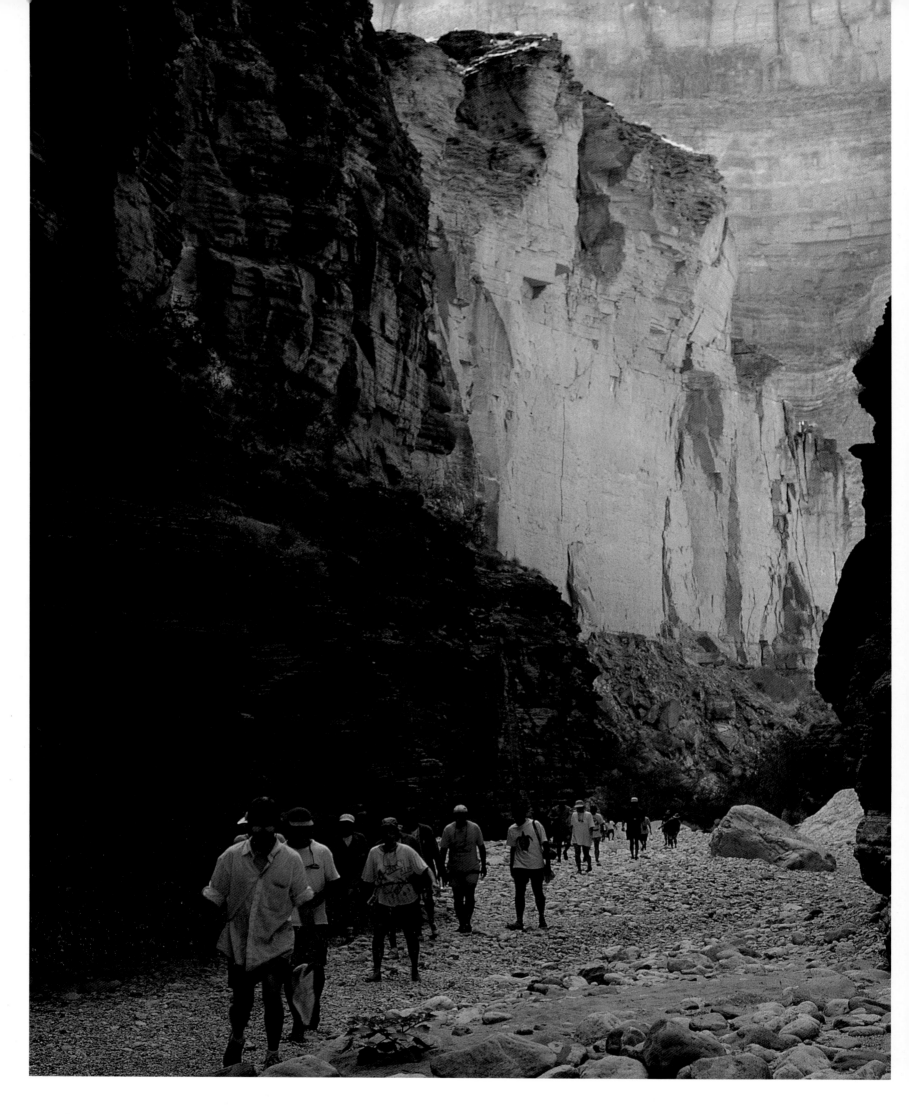

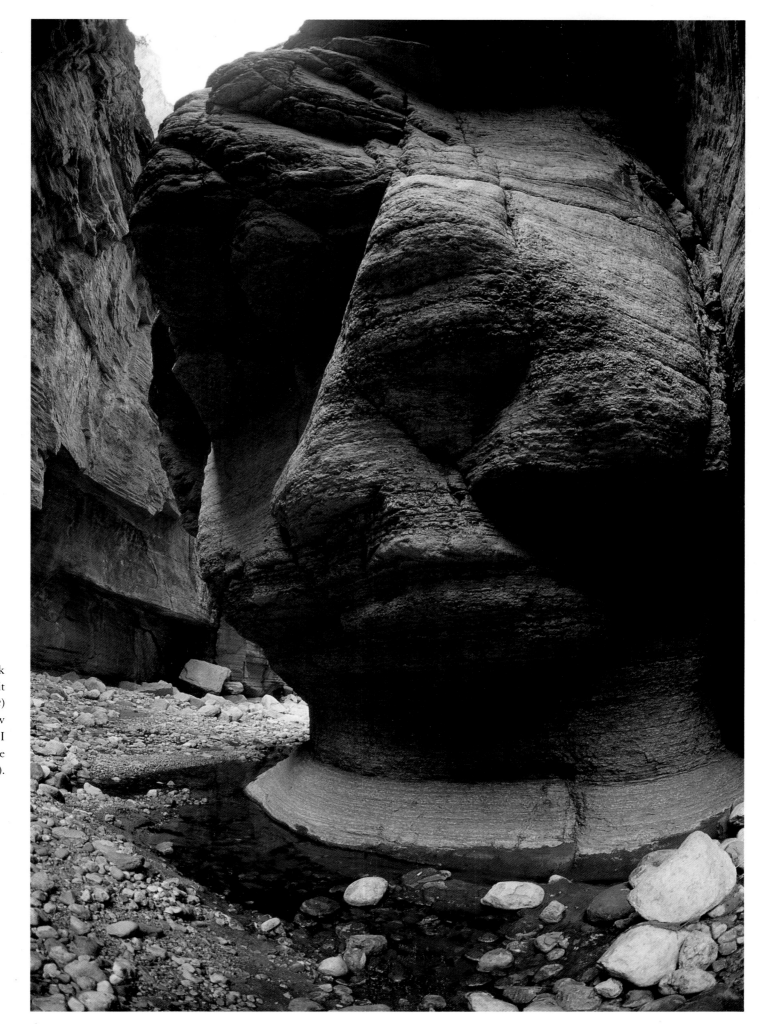

Hikers take a break from the rapids to visit National Canyon (*left*) and perhaps to view the Muav rock face I shot with a fish-eye lens there (*right*).

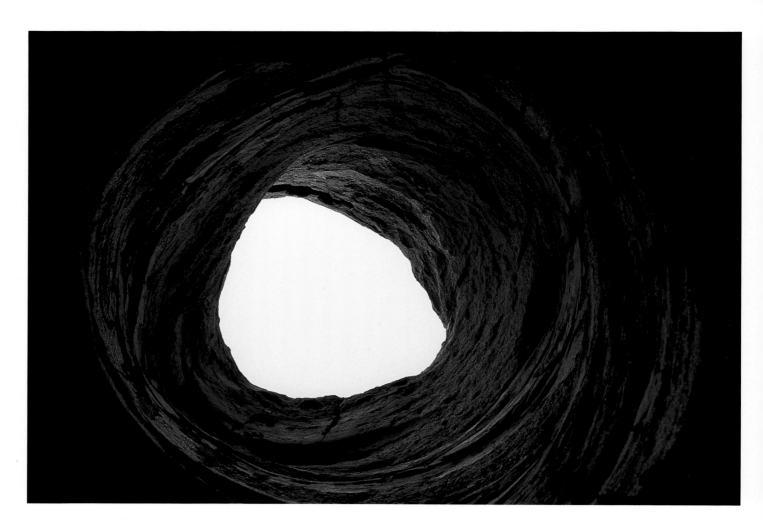

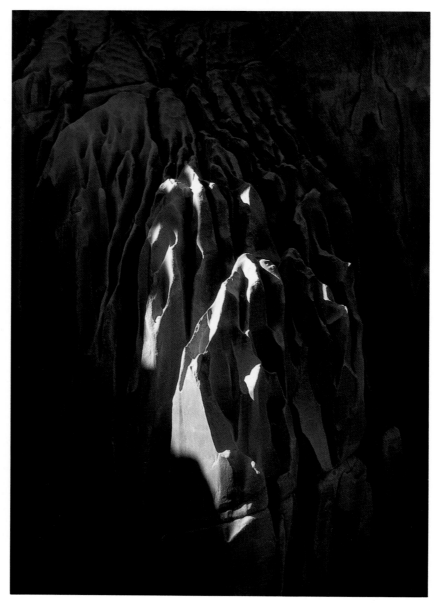

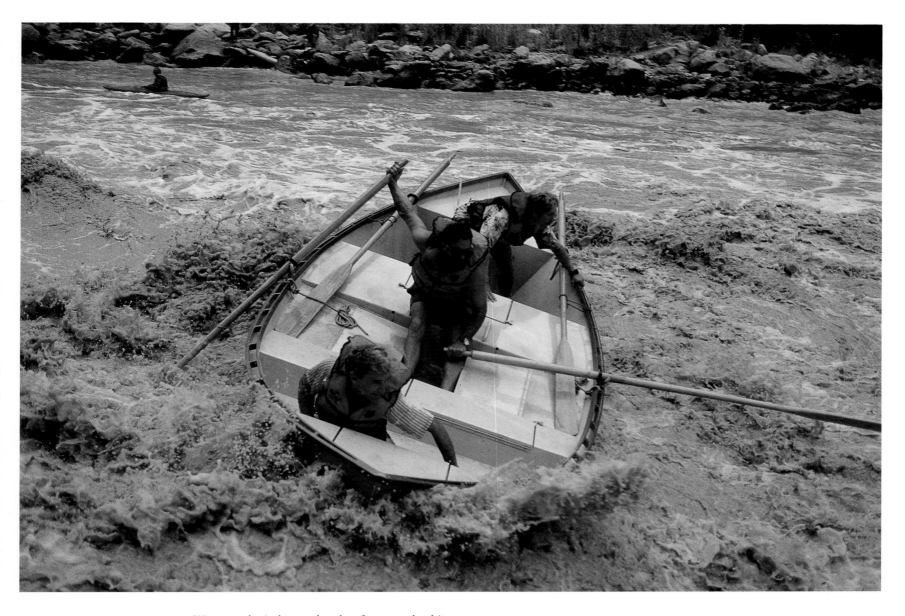

Water- and wind-carved rock—for example, this
manhole formation near Pumpkin Springs (*top left*)
and the fluted Schist at mile 232 (*bottom left*)—show
the river's raw power, which this oarsman (*above*) is
experiencing in Lava Falls Rapid.

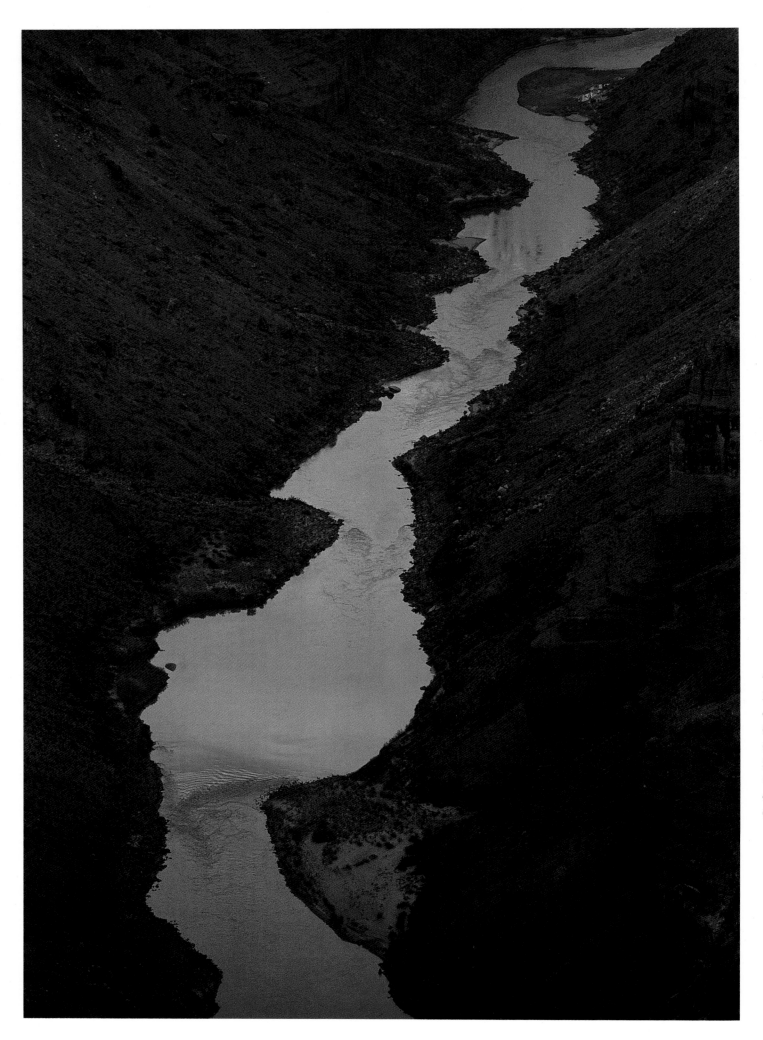

Two miles above Lava Falls Rapid, the Colorado looks peaceful (*left*), but lava flows (*top right*) and debris flows have made this rapid one of the most exciting in the Canyon (*bottom right*).

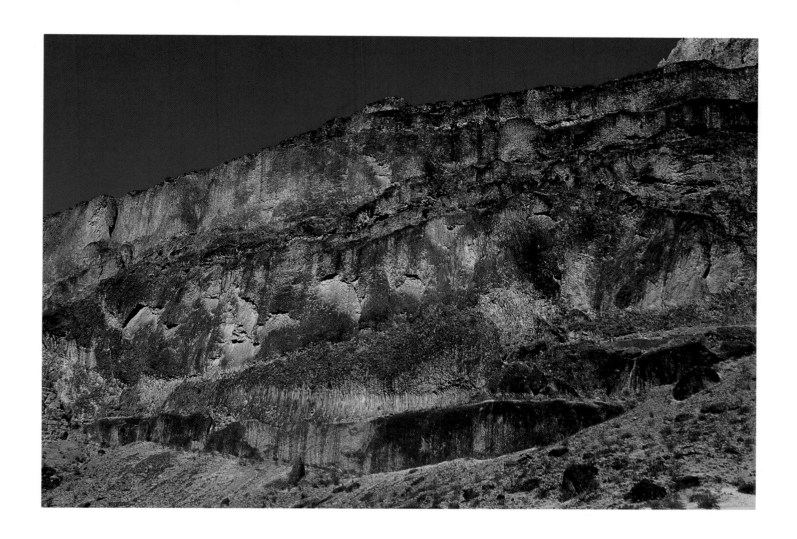

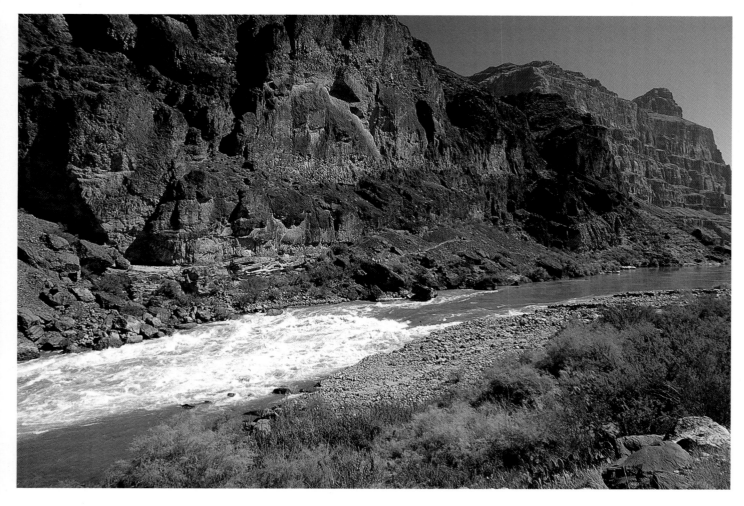

Overleaf: View upriver from Rattlesnake Camp (mile 74) at sunset.

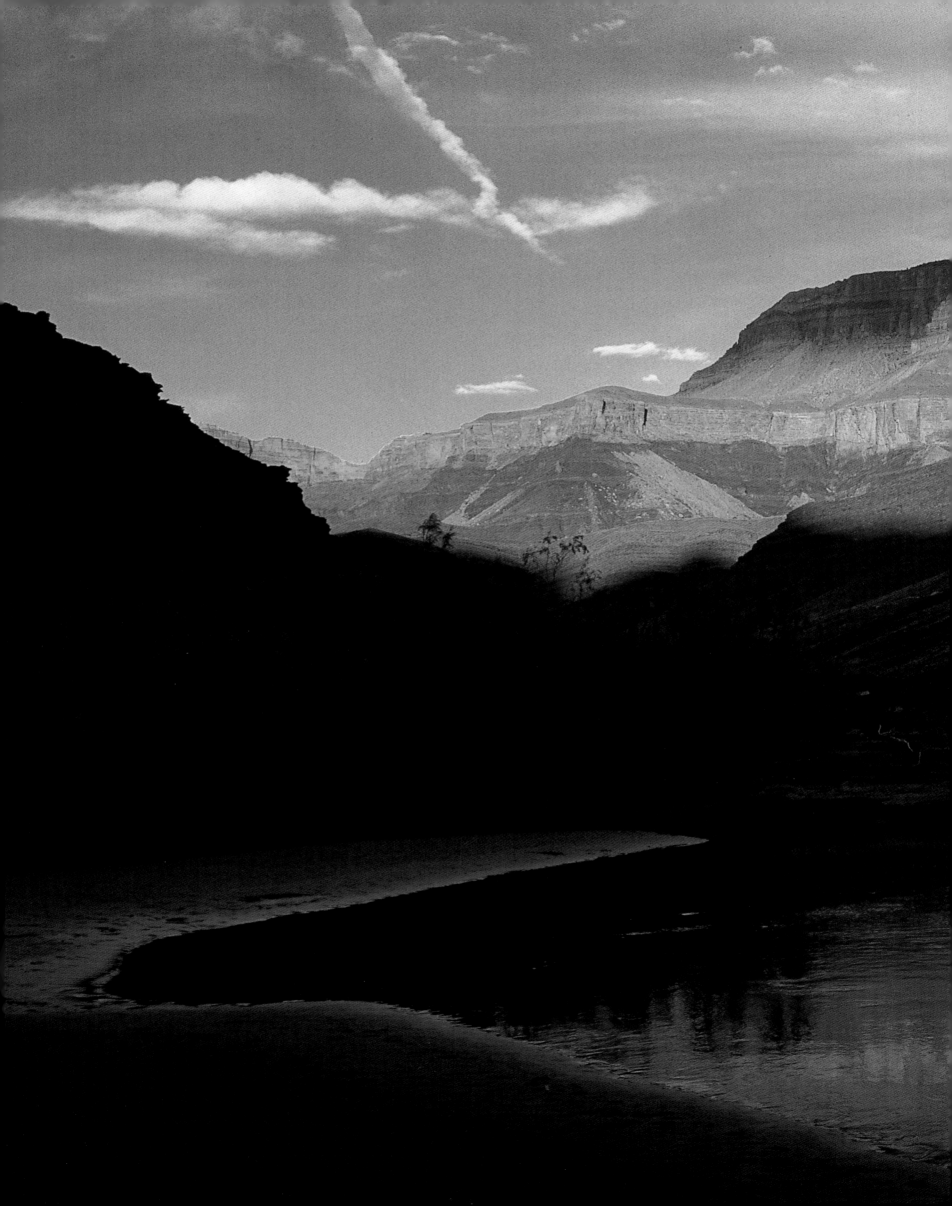

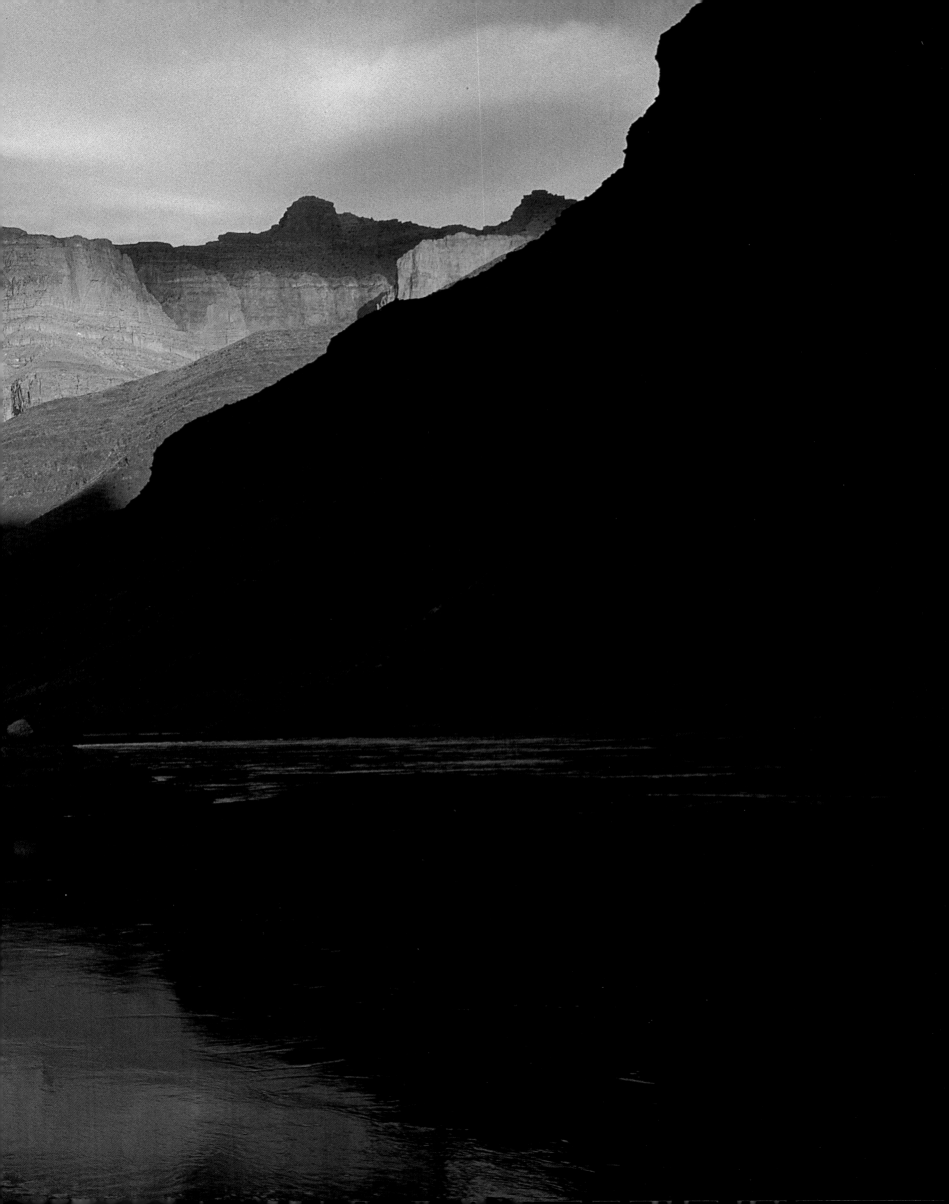

Prickly pear cactus blooms can be yellow (*left*) or
pink (*above*). They peak in April or May.

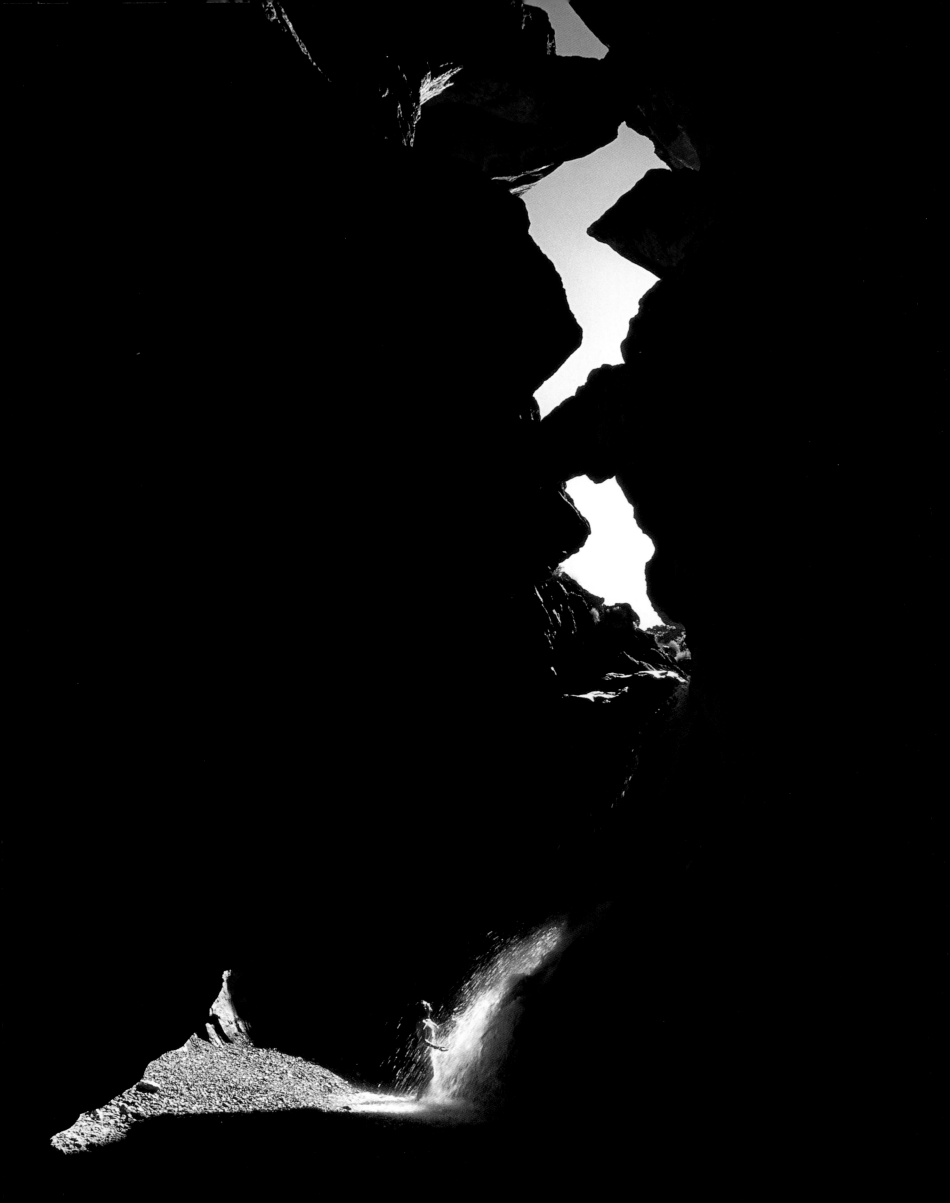

Sacred datura, blooming here in Havasu Canyon, is a member of the nightshade family and will close up in bright light.

Left: A lone hiker bathes in Travertine Canyon, a grotto with numerous falls.

Top: The desert spiny lizard can handle the harsh conditions of the Canyon. *Left:* In a dry spell, the ocotillo loses its leaves to conserve energy. After a rain, it leafs out and produces red flowers.

Right: Travertine Falls
at mile 230.

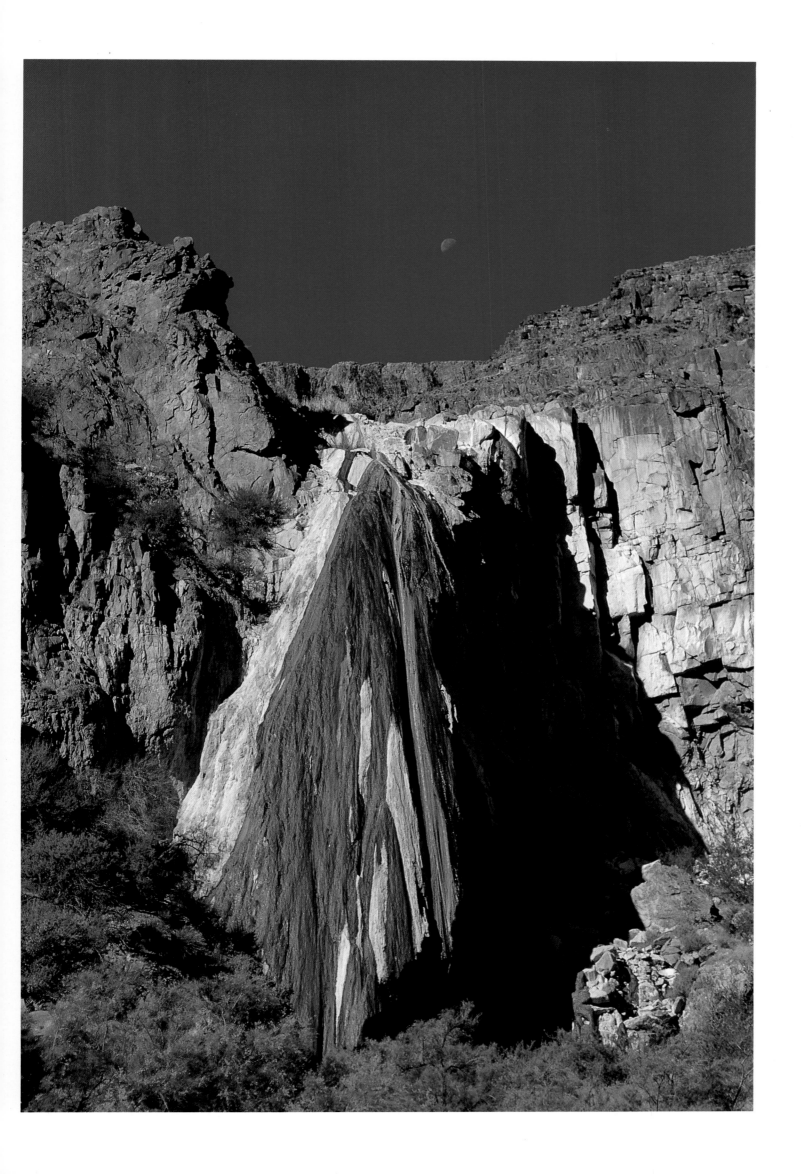

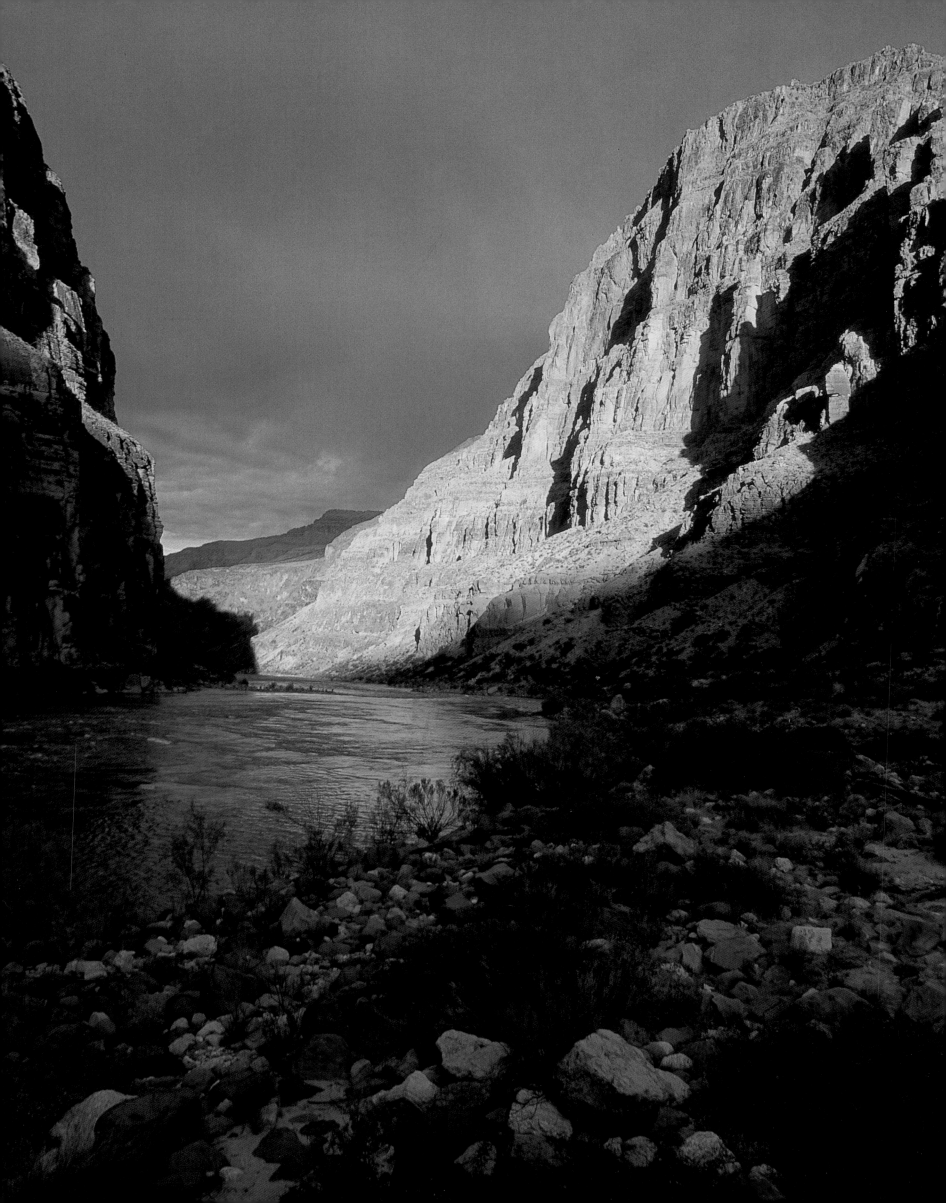

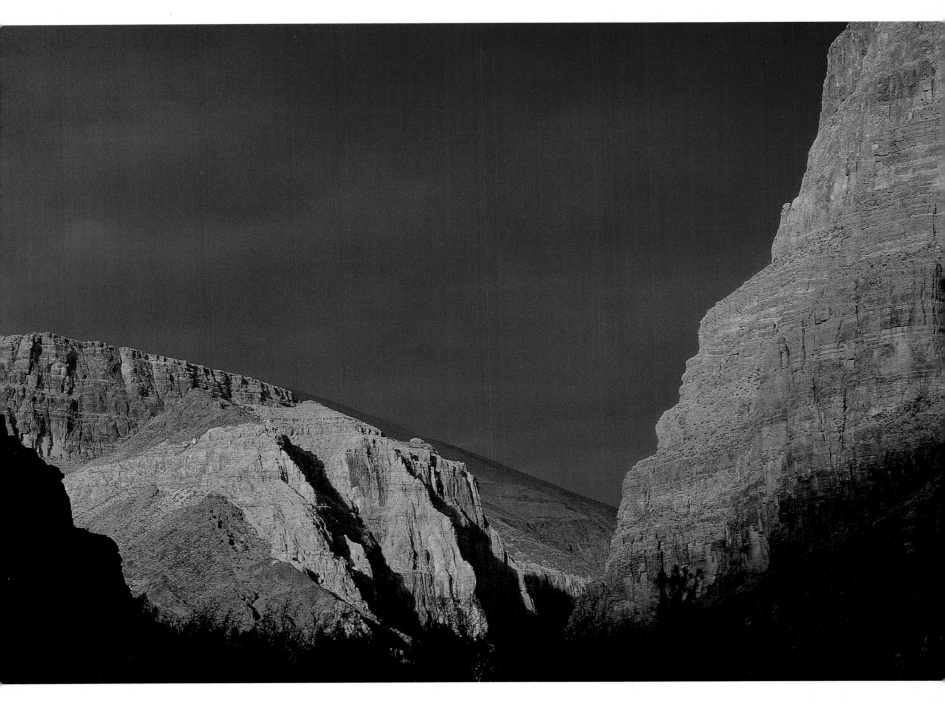

Some folks say all rock walls look the same, but as
the river-watcher gets to know the Canyon, he or
she learns to see the great diversity here of rock for-
mations, plants, and the like. Another contributor
to that diversity is the variety of light and weather
conditions, ranging from lightning (*top left*) to slate-
gray skies (*bottom left*) to the reemergence of the
sun after a storm (*above*).

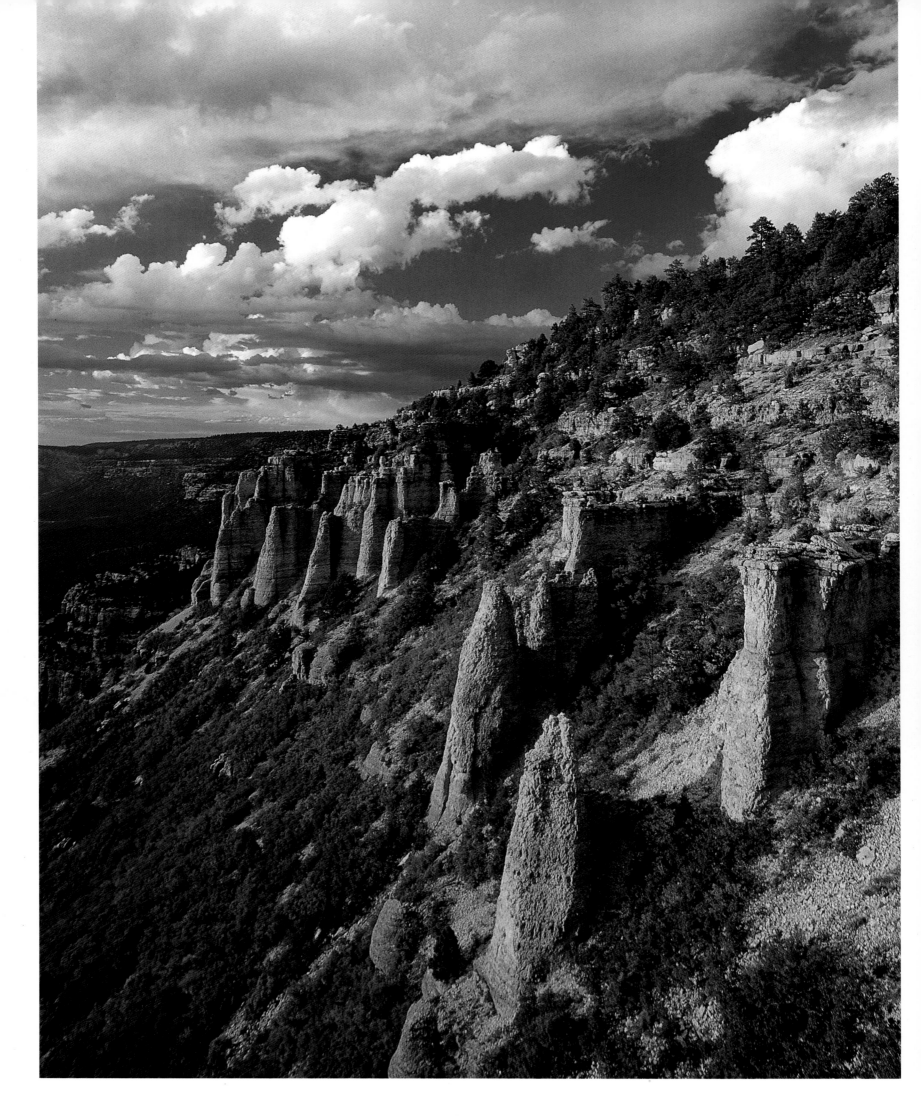

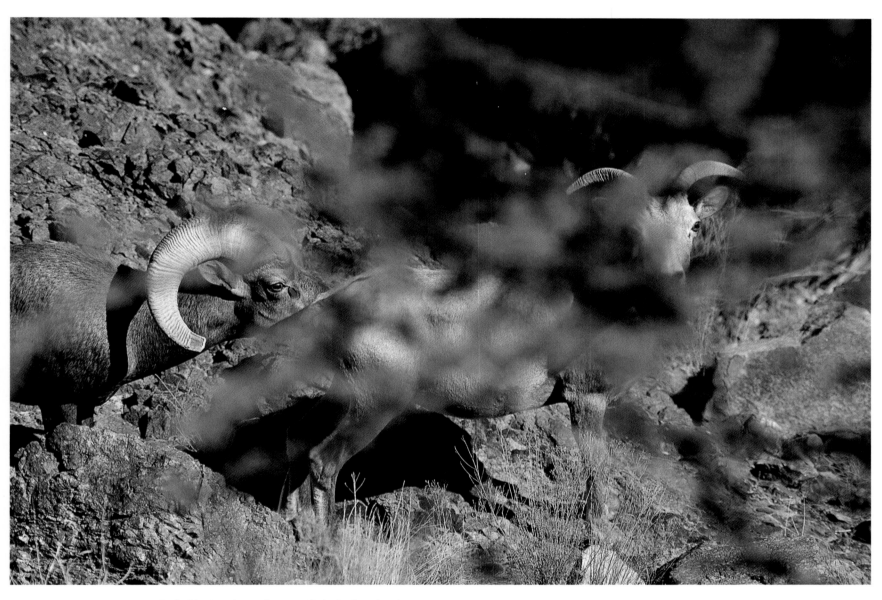

Left: Glorious late-afternoon light bathes the view from Fire Point. *Above:* Desert bighorn ram in pursuit of a ewe. During rut, the normally solitary rams emerge from seclusion to find the herds of ewes.

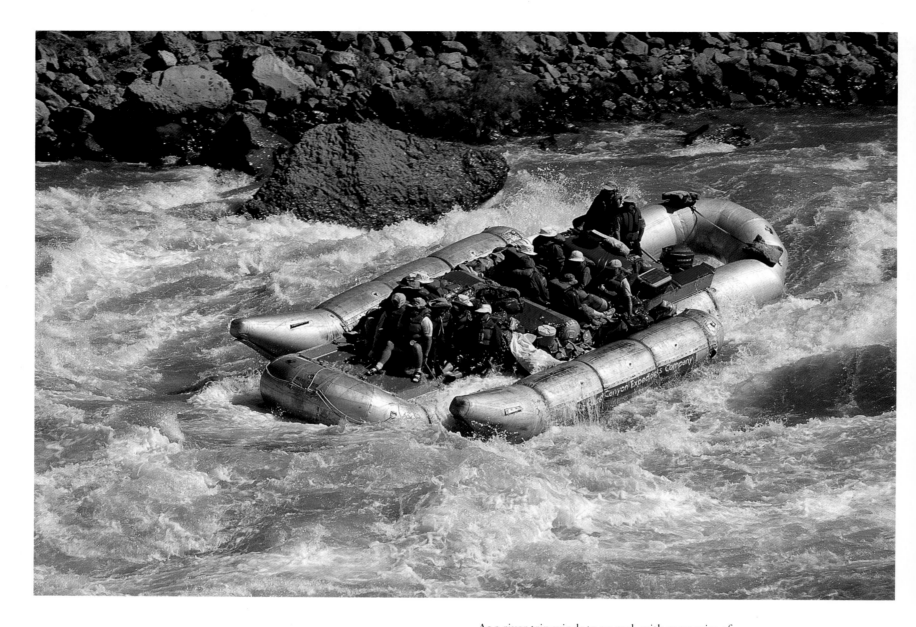

As a river trip winds to an end, with memories of one's S-rig, kayak, dory, rowing rig, canoe, or paddle boat going through exhilarating rapids (*above*), the river adventurer sees the walls widen as he or she approaches the Grand Wash Cliffs and the end of the Grand Canyon (*right*).

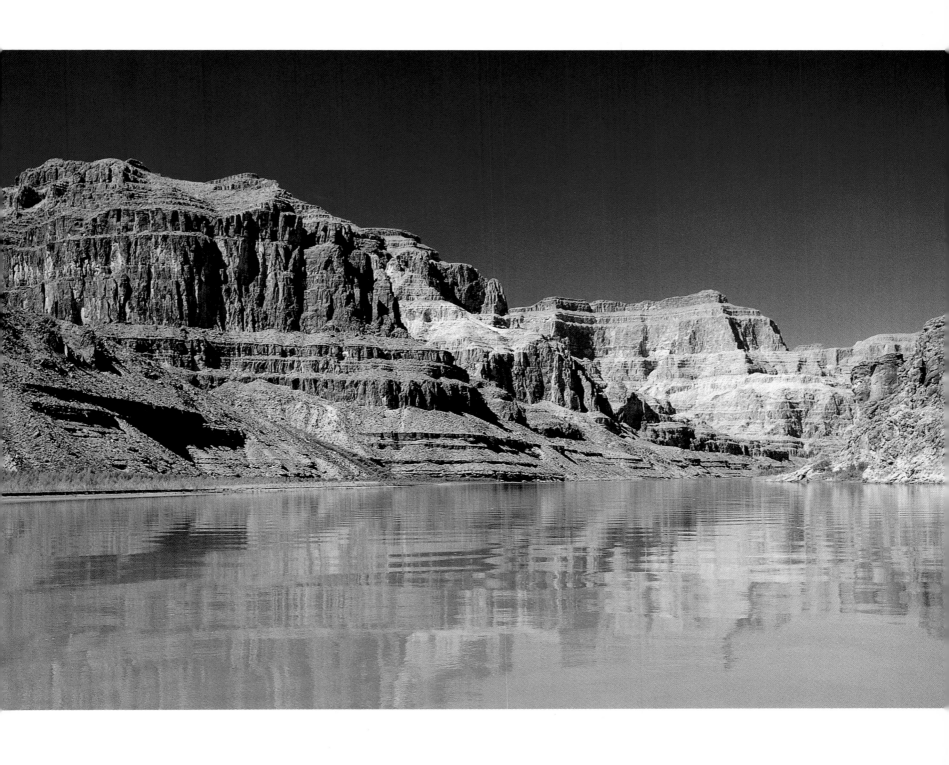

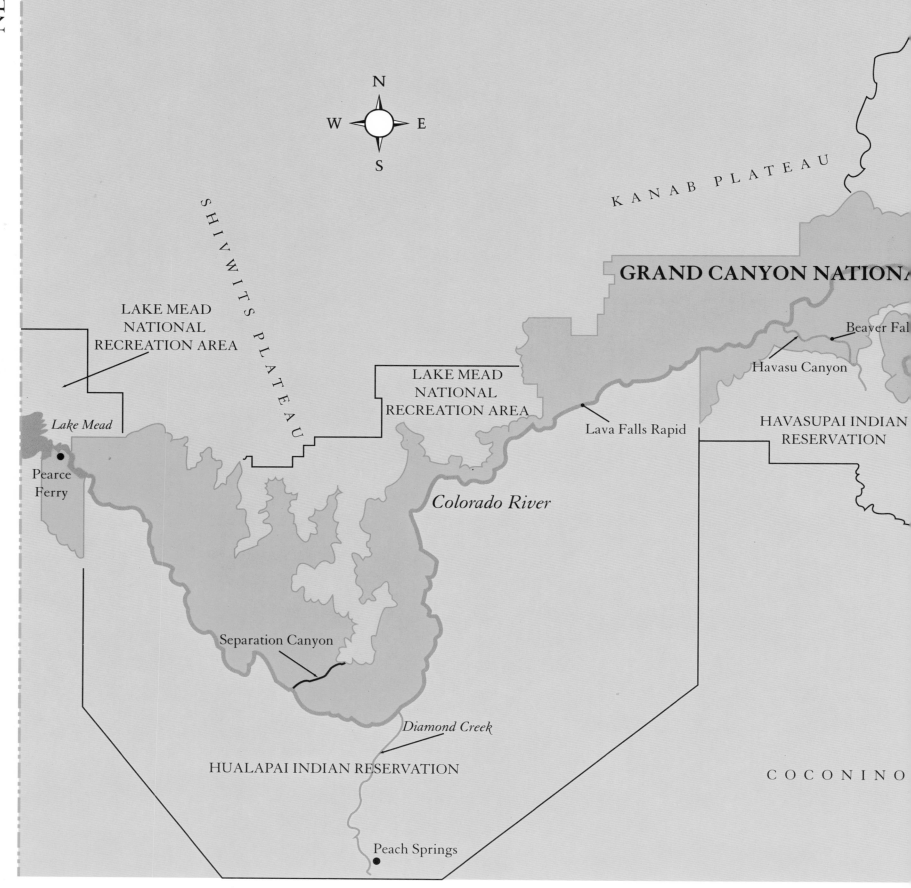

UTAH

ARIZONA

NEVADA

N
W E
S

KANAB PLATEAU

GRAND CANYON NATIONA

SHIVWITS PLATEAU

LAKE MEAD
NATIONAL
RECREATION AREA

Beaver Fal

LAKE MEAD
NATIONAL
RECREATION AREA

Havasu Canyon

Lava Falls Rapid

HAVASUPAI INDIAN
RESERVATION

Lake Mead

Colorado River

Pearce
Ferry

Separation Canyon

Diamond Creek

HUALAPAI INDIAN RESERVATION

COCONINO

Peach Springs